Photography as a Tool

Human Behavior
The Art of Sewing
The Old West
The Emergence of Man
The American Wilderness
The Time-Life Encyclopedia of Gardening
Life Library of Photography
This Fabulous Century
Foods of the World
Time-Life Library of America
Time-Life Library of Art
Great Ages of Man
Life Science Library
The Life History of the United States
Time Reading Program
Life Nature Library
Life World Library
Family Library:
 The Time-Life Book of the Family Car
 The Time-Life Family Legal Guide
 The Time-Life Book of Family Finance

LIFE LIBRARY OF PHOTOGRAPHY

Photography as a Tool

BY THE EDITORS OF TIME-LIFE BOOKS

TIME-LIFE BOOKS, NEW YORK

ON THE COVER: The delicate structure of a snowflake cannot be perceived by the naked eye. But when photographed through a microscope, the flake's fragile design is revealed in all its unexpected complexity. The picture of the snowflake is one of thousands collected by the German author Joseph Hell.

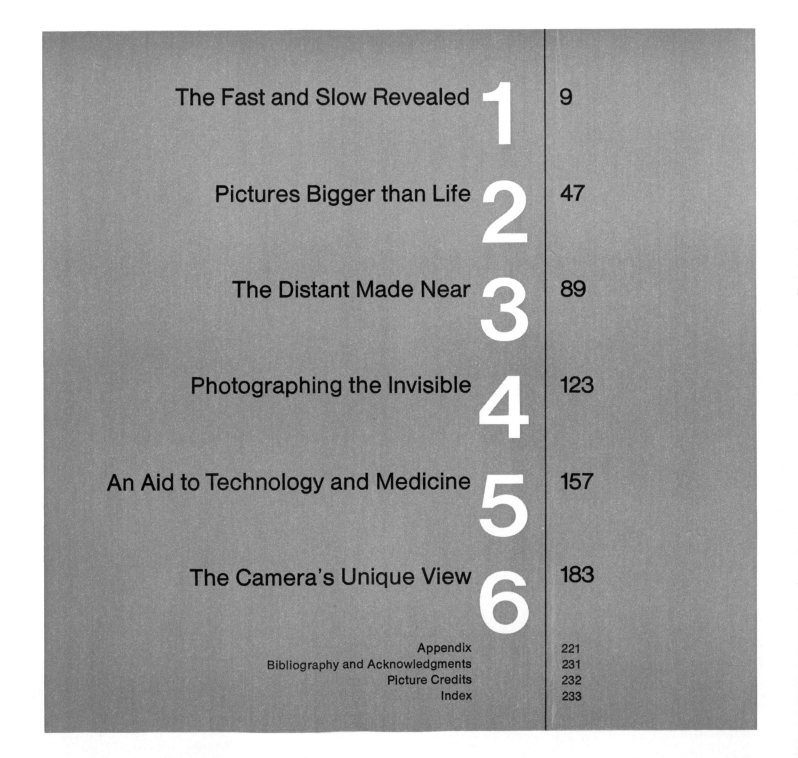

LIFE LIBRARY OF PHOTOGRAPHY

SERIES EDITOR: Richard L. Williams
Editorial Staff for
Photography as a Tool:
Editor: Robert G. Mason
Picture Editor: Simone Daro Gossner
Text Editor: Jay Brennan
Designer: Raymond Ripper
Assistant Designer:
Herbert H. Quarmby
Staff Writers: George Constable,
John Paul Porter, John von Hartz
Chief Researcher: Peggy Bushong
Researchers: Kathleen Brandes, David Harrison,
Monica O. Horne, Sigrid MacRae, Suad McCoy,
Shirley Miller, Don Nelson, Kathryn Ritchell,
Melissa Wanamaker
Art Assistant: Jean Held

Editorial Production
Production Editor: Douglas B. Graham
Assistant Production Editors: Gennaro C.
Esposito, Feliciano Madrid
Quality Director: Robert L. Young
Assistant Quality Director: James J. Cox
Copy Staff: Rosalind Stubenberg (chief),
Barbara Fairchild, Ruth Kelton, Florence Keith,
Pearl Sverdlin
Picture Department: Dolores A. Littles,
Catherine Ireys
Traffic: Carmen McLellan

*Portions of this book were written by Jonathan
Norton Leonard, Frank Kappler and Paul
Trachtman. Valuable aid was provided by these
individuals and departments of Time Inc.: TIME-
LIFE Photo Lab, George Karas, Herbert Orth;
Editorial Production, Norman Airey; Library,
Benjamin Lightman; Picture Collection, Doris
O'Neil; Photo Equipment Supervisor, Albert
Schneider; TIME-LIFE News Service, Murray J.
Gart; Correspondents Elisabeth Kraemer (Bonn),
Maria Vincenza Aloisi (Paris), Margot Hapgood
(London), Ann Natanson (Rome), Mary Johnson
(Stockholm), Frank Iwama (Tokyo).*

Ever since photography was invented, men have been pressing it into service as a tool, dreaming of new ways to make it do what human eyes cannot: of speeding up time or slowing it down to learn how things actually behave; of making visible the things that are too small or too distant or too faint for the unaided eye to see; of utilizing other light waves that, like ultraviolet, are totally invisible to human beings, but are there just the same to register on the eyes of certain insects and on photographic emulsions.

It was inevitable that as photography developed it would become invaluable to science and technology. This book introduces some of the wonders of scientific and industrial photography. But it does not limit itself to the technical side. There remain many areas combining the technical with the esthetic that can be explored by an amateur to the extent that his patience, his ingenuity and his pocketbook permit. And the knife cuts two ways. In recent years, Nina Leen, a professional photographer but a nonscientist, began making photographs of bats. Before long her photographs had helped even experts in the field to understand more clearly many aspects of bat behavior.

Animal studies are, however, only one among many paths to follow. Consider first the matter of speed. Fast modern lenses, fast shutters and fast film emulsions allow the contemporary camera to record action as well as—or even a little better than—the human eye. But there are events that move still faster. How does a rattlesnake strike? How does a bullet smash a light bulb? Events like these transcend the ability of mechanical shutters to record them.

What is needed is a blink of intensely bright light of fantastically short duration. Forget about the shutter's limitations; open it before the light flashes and close it afterwards.

The familiar flashbulb does this, but rather crudely. It can take up to 1/25 second for the material in the bulb to ignite and die. Furthermore, the dying-out takes place somewhat more slowly than the initial flare, and this relatively slow fadeout can destroy the crispness of really fast action. What is needed is a blink that starts and stops almost instantaneously, and can be regulated to last a thousandth, a ten-thousandth, or a millionth of a second as required. Such electronic flash units, commonly known as "strobes," were developed for scientific purposes but they have been exploited for esthetic purposes. Originally, they were very bulky and hideously expensive. But today small, moderately priced units capable of 1/50,000-second flashes can be bought in any photo shop.

What can be done with strobe units is extraordinary, particularly if they are linked to slave units that are spaced around a ballroom or a large arena and triggered to go off in unison with a single master unit activated by the photographer. Such an application is obvious for sporting events. Less so is one that Mrs. Constance P. Warner developed in Washington, D.C.

Having become fascinated by the eyes of birds, particularly by those of some tropical and exotic species in the Washington Zoo, Mrs. Warner decided to photograph them close up. But birds are extremely active; how would she keep them in the pin-point-sharp focus she required? Many of them also have extraordinarily delicate nervous systems and would be incapable of standing the photographic activity going on around them, not to mention the intense heat of floodlights. She solved her problem with master and slave strobes. First, she built a very shallow cage to ensure that while a bird could hop back and forth at will it could do so only in a narrow plane that would keep it in focus. She then hid herself and her camera behind a screen with a peephole for the lens, tripping her shutter whenever the bird presented its body properly in her viewfinder. Her lights were so bright that she could stop down the lens aperture to ensure depth-of-field sharpness, and at the same time were so fast and unobtrusive that they did not alarm the bird at all.

But high-speed picture taking is not the only "technical" area of photography that can be explored profitably by the amateur. There are inexpensive sets of extension rings, or "tubes," that convert ordinary lenses into powerful magnifiers for taking bigger-than-life pictures of insects and flowers. There are simple fittings that attach almost any camera to a microscope for astonishing views of the very tiny, or to a telescope for impressive shots of the incomprehensibly big and distant stars and nebulas. There are "time-lapse" devices that can be built or rented for taking a picture a minute or a picture a day to capture the beauty of a flower unfolding or an apple ripening.

The following pages describe some of these developments. They may suggest ways of taking pictures the like of which no photographer in the world could have made as recently as a generation ago. *The Editors*

The Fast and Slow Revealed

1

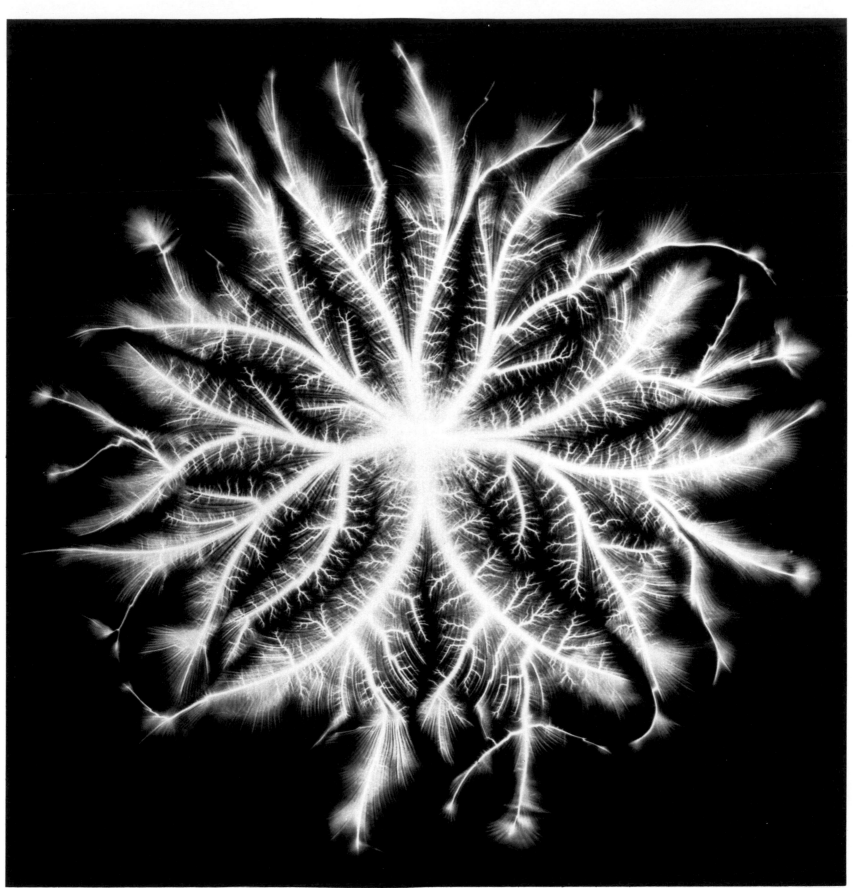

MANFRED KAGE: *Instantaneous image of high-speed electrical spark made directly on film*, 1960

11

The Camera at Work

The earliest cameras took pictures of familiar objects that the human eye could readily see: faces, landscapes, buildings. But photographers quickly realized they possessed a powerful instrument that could also perceive and record innumerable things to which the eye is blind. This made photography an essential tool of science and discovery. Through its magic eye has come a very large part of man's knowledge of the world.

Almost as soon as photography was invented, astronomers put it to work with their telescopes. They recognized that a photographic emulsion is cumulative in its recording of light. Film exposed over long periods—hours, or even days—gathers faint glimmers of light and thus builds up strong images of objects so far away and so dim that the eye gets no hint they exist. Even with the crude materials of the early days of photography, pictures of the heavens revealed many more stars than had ever been known before. Photographs have since provided much of what is known about the universe, bringing into view ever-more-distant parts of the cosmos.

Not only does photography reveal the most distant and biggest objects, stars, it also makes visible the smallest things in the world. Even close up, the eye can barely see objects that are 1/300 inch in diameter. Photography has no such limitation. An ordinary camera connected to an inexpensive microscope can explore the individual cells of living creatures, particles about 1/1000 inch across. Somewhat more complex equipment on more elaborate types of microscopes can penetrate a cell's inner workings and show the molecules of which it is made. In addition, cameras can easily go where eyes cannot, to the bottom of the ocean, for instance, and inside the human body. They can ride on small satellites and photograph the earth moving below. They record cloud formations for weather forecasters, count migrating animals for biologists, detect pollution for ecologists.

The eye can see only visible light—the rainbow colors from violet to red—but photography has much wider sensitivity. It can take pictures with the many other electromagnetic waves of the world—X-rays, ultraviolet, infrared—and even with beams of neutrons. All of these invisible rays gather knowledge inaccessible by ordinary light. (Examples are on pages 136-156.)

Some of the most useful—and beautiful—photographs are those that see not things but time in a way human vision cannot. Modern high-speed shutters and lamps can expand time, making possible the observation and study of actions that are so rapid the eye senses them only as blurs or misses them altogether. It can spread over many pictures events so inconceivably rapid as the first millionths of a second of a nuclear explosion. And photography can also contract time, speeding up extremely slow actions, such as the growth of plants, that proceed at such an imperceptible rate they cannot be detected by the human eye *(page 45)*.

The human eye can be described as a camera that takes about 10 pictures per second and telegraphs to the brain part of the information each picture contains. It cannot work much faster because the sensitive retina at the back of the eyeball that serves as its "film" needs an appreciable time to receive and transmit each impression and get ready for the next one. This repetition rate was fast enough for the primitive hunters for whom nature designed the eye. They may have noticed that certain fast-moving objects, such as the wings of flying insects, could be seen only as blurs, but such minor matters were not important to them. Their eyes kept up nicely with the motions of edible animals and the approach of enemies. That was all they asked for and, indeed, all they needed.

Civilized men ask more. Nature is full of actions too fast for the eye to follow, and early in human history inquisitive individuals began to note the slowness of their eyes. How, they asked, do birds flap their wings? The eye tells something about the process but not enough to explain it. Is lightning really a broad path of fire? How do the muscles of an athlete change shape when he goes over a high jump? How does a falling cat manage to land on its feet? The unaided human eye is helpless to answer such questions, and when men began to construct fast-moving machines, the number of unobservable actions increased enormously. Wheels, cranks and spindles turned into mysterious, sometimes dangerous blurs. As science and industry advanced, the slow-acting human eye fell further and further behind. It did not catch up until the development of modern high-speed photography.

The first true stop-action photographs were taken by a surprisingly modern method. In 1851 William Henry Fox Talbot of England, the inventor of the negative-positive system employed by modern photography, realized that even in sunlight, the strongest light then available, his shutters, lenses and emulsions could not stop the blurring caused by motion. Even if he could devise a very rapid shutter, his lenses admitted so little light and his emulsions were so insensitive that he would not be able to record an image with a brief exposure. Since he could not get a picture by using sunlight and a shutter, he decided to use another light source that went on and off very quickly. He set up a camera with an open shutter in a darkened room and illuminated his subject with a short flash of light, eliminating the shutter. The flash came from the spark produced by a linked series of Leyden jars.

A Leyden jar is merely a cylindrical glass container coated inside and outside with metal foil; the glass separates the two foil surfaces so that they act as a capacitor or electrical storage reservoir. When an electrostatic machine, a device that generates static electricity, is connected to one of the foil surfaces, it pumps into it an electric charge that attracts an equal charge from the other layer of foil. When sufficiently strong, a bright spark jumps

across the gap between electrodes connected to the foil surfaces. It gives quite a lot of light, enough to illuminate brightly a nearby surface, and lasts an extremely short time. Talbot probably did not realize how short the flash was (about 1/100,000 second) but he found it was short enough to "stop" almost any moving object that he could put in front of his camera. His most noted triumph, an apparent miracle at a time when a conventional photograph required a subject to hold rock-still for many minutes, was a picture of a page of the London *Times:* he pasted it to a rapidly rotating disk and got a readable photograph of it as it spun in front of his lens.

Talbot's success seems to have been forgotten for many years, but in the 1880s the Austrian physicist Ernst Mach (after whom the aerodynamic term denoting sonic speeds was named) built another powerful spark apparatus and took pictures of bullets leaving the muzzle of a gun. When the gun was fired, the bullet closed a circuit as it passed between the spark electrodes and the photographic plate. This action tripped the spark, which cast the bullet's shadow on the plate and clearly showed it in silhouette. The photographs also showed hot gases escaping from the muzzle and thin circular sound waves moving outward at mach 1, the speed of sound. These waves cast shadows because they are made of compressed air that bends light differently from ordinary air.

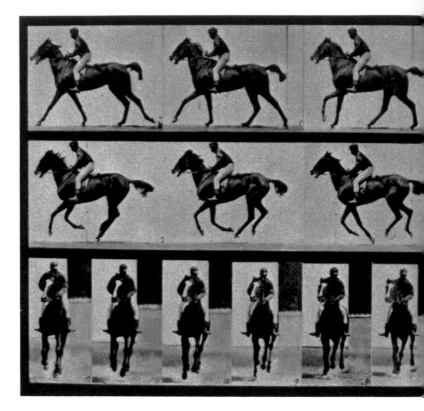

The idea of building up a powerful electrical charge in a capacitor and then suddenly releasing that charge to cause a brilliant flash is the basis of most modern high-speed photography—it is the principle of the electronic flash unit, or strobe light. But strobe photography did not get out of the laboratory until the 1930s. Meanwhile the gradual improvement of lenses, shutters and emulsions made it possible for cameras to take reasonably clear pictures of moving objects outdoors in full sunlight without artificial illumination. The most famous pioneer in this field was Edward James Muggeridge, an adventurous Englishman born in 1830 who began a very checkered career after he emigrated to the United States and upgraded his name to Eadweard Muybridge, which he claimed was the proper Anglo-Saxon form. How he learned photography is not known, but in the 1860s he showed up in California, where he was employed by the United States government to make a photographic survey of the Pacific Coast.

There, about 1872, he was hired by the railroad magnate Leland Stanford, former governor of California, founder of Stanford University and a great lover of horses. Stanford had argued with a man named Frederick MacCrellish about whether or not a trotting horse ever had all four of its hooves off the ground at the same time; Stanford thought that it had. The story, which may be apocryphal, is that Stanford wagered $25,000 to back up his opinion and engaged Muybridge to prove it by photography. The first attempts were not

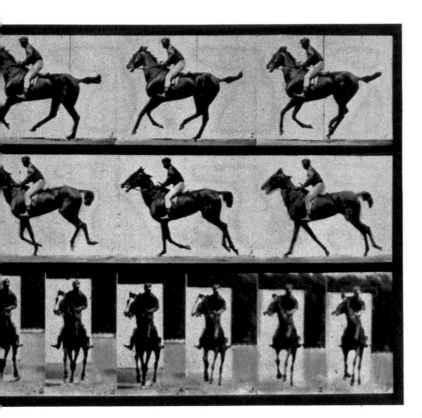

A thoroughbred racehorse canters through this series of stop-action pictures taken by Eadweard Muybridge at the University of Pennsylvania in the mid-1880s. The top two strips show the horse commencing and completing a single 9½-foot stride, beginning at upper right and finishing at far left in the second row (i.e., right to left instead of left to right). In the midst of the canter (second from left, second row) all four of the horse's feet are off the ground. The bottom strip shows a front view of the same stride. When taking pictures of animals moving as fast as this horse, Muybridge sometimes used shutter speeds of 1/2000 second, then extraordinarily swift.

successful ones because the exposure, 1/12 second, showed only a blur.

The first successful pictures Muybridge took were of Stanford's racehorse Occident, which had a famously long stride, trotting in front of a white screen at 22½ miles per hour. This time Muybridge used an improved shutter that gave a much shorter exposure. The negatives were badly underexposed because of the slowness of his plates and lens but some of the pictures showed Occident with all four feet off the ground and thus settled the controversy.

Stanford was delighted but not satisfied. He wanted pictures of horses taken successively through their full stride, so he told Muybridge to go ahead and spend all the money he needed. Probably no photographer had ever had such an offer before. The result was a special track made of grooved rubber to eliminate dust. On one side was a "camera house" 40 feet long, complete with darkroom. On the other was a fence of white cotton cloth marked with numbered vertical lines. At its base was a board with horizontal lines four inches apart to show height above the ground. Twelve cameras (later increased to 24, set 12 inches apart) pointed across the track. Their shutters were tripped in sequence by an electrical system worked out by John D. Isaacs of the Central Pacific Railroad. The sequence started when the horse broke a stretched thread.

This elaborate set-up reputedly cost $40,000. The pictures it got were still underexposed but they were taken at something like 1/1000 second and clearly showed all the different gaits of horses. They were published widely, usually as line drawings based on Muybridge's indistinct pictures, and caused a painful controversy in artistic circles. Many of the famous painters of the time were forced to admit that they had been painting horses all wrong. Their favorite rocking-horse posture, with all four of the horse's feet extended, was demonstrated to be an absurdity.

Muybridge improved his techniques and used faster emulsions and lenses as they came along. Eventually, with the help of the University of Pennsylvania, he got fairly good pictures of a great variety of moving animals, including such exotics as ostriches and baboons, and of men, women and children, usually naked and engaged in many activities, from men fencing to a girl falling face down on a mattress. He took 100,000 negatives in all, and in 1887 the university published 781 large plates, each showing 12 to 36 of his pictures. The price for the full collection was $500 so not many were sold, but Muybridge offered smaller lots that found a wide market. It is interesting to note that in his catalogue the longest list was of "women, nude," 180 of them. Many showed pretty girls with attractive figures, and in that covered-up age, their unabashed nakedness in action roused a good deal of interest.

Most of Muybridge's pictures show rather slow motions, so he could use fairly long exposures and thereby get enough light into his camera to make

good negatives. When he took pictures of faster actions, such as those of running animals, he had to use shorter exposures and his pictures were indistinct because he could not provide sufficient light for the insensitive emulsions of the time. The much faster films that are available today have solved this problem, however, and with the modern mechanical shutters that are standard equipment on good cameras it is a simple matter to take unblurred pictures of many rapidly moving objects—children playing or athletes in action, for example.

While the standard mechanical shutters can stop many kinds of rapid action, they are not nearly fast enough to produce anything but a blur of such subjects as a golf club in mid-swing or a hovering bird flapping its wings. A new approach is necessary. It depends, as Talbot had so clearly foreseen long ago, on brief flashes of light.

Many attempts were made to increase the brightness of electric sparks. Among the most successful workers was Professor A. M. Worthington of Britain, whose spark pictures in 1900 revealed the intricate and beautiful splash shapes formed for fleeting instants by small objects falling into liquids. But his most powerful sparks were too dim for anything except miniature scenes.

The familiar flash bulb, introduced in 1929, was—and still is—excellent for supplying a lot of light for fairly brief exposures, but its burst of light lasts many thousandths of a second. It can be used for really high-speed photography only by teaming its flash with a high-speed shutter that takes a picture during just a small part of the time that the bulb's light lasts.

The big breakthrough in high-speed photography came in 1931 when Harold E. Edgerton, then graduate student in electrical engineering at the Massachusetts Institute of Technology, got interested in observing the behavior of an electric motor subjected to varying loads. The motor rotated too fast to be seen by the human eye, and the available-light devices to make its motion seem to stop did not work well enough. So Edgerton set out to develop a better one. The result was the invaluable electronic strobe light so widely used today. It is now employed mainly as a handy source of bright light, but in special forms it continues to serve its original purpose of stopping fast action.

One of the first photographers to use the strobe light in this way was Gjon Mili, who attended a Cambridge meeting of the Illumination Society with Edgerton in 1937. Edgerton recalls that Mili, then a lighting research engineer for Westinghouse Corp., demonstrated a high-powered mercury arc lamp with such effect that it blew out the fuses in the building where the Society was in session. Edgerton had to wait in the dark until the fuses were replaced, but then he gave a successful demonstration of a two-lamp strobe with enough light output to be used in a studio. Mili was so impressed that he

The man who made ultra-high-speed photography practical, Dr. Harold E. Edgerton, is framed by a large reflector used with his best-known invention, the strobe light. Edgerton is now a professor emeritus at the Massachusetts Institute of Technology, where he did much of his pioneering work in developing modern photographic lighting equipment, including some that is used in deep-sea exploration.

asked Edgerton to bring it to New York, where he worked, for practical trials. Out of this collaboration came a long series of striking high-speed pictures, many of which were published in LIFE magazine. They showed dancers in action as clearly as if they were standing still, and golf balls and tennis balls crushed flat against the swing of club or racket. Some of their most startling effects were gained by firing the strobe repeatedly to take multiple pictures on the same film. Such photographs turned a golf player into an eerie pattern faintly reminiscent of a sea anemone, with his rapidly moving hands and club looking like tentacles arranged in a swirl around his comparatively motionless body *(page 38).*

In his laboratory Edgerton used his magic lamp to dissect familiar, homely actions and revealed in them a wealth of unseen beauty and interest. Caught by the quick flash of his lamp, streams of water flowing from a faucet turned into shiny columns that slowly gathered into droplets resembling balls of glass. He caught cups of coffee or milk at the instant they smashed on a concrete floor, every spurt, drop and fragment immobilized.

As strobes developed they gave more and more light in less and less time and provided a marvelous new tool for analyzing the subtle actions of living creatures. Edgerton himself spent a great deal of time and ingenuity on one of the most mysterious and difficult of such subjects: bats. Since bats lead their active lives in darkness, the flying and hunting habits of most species were almost unknown before the development of strobe-light photography.

Edgerton was not the first to photograph bats, but they had never before been subjected to so much electronic expertise. He set up his apparatus inside the mouth of the Carlsbad Caverns in New Mexico, from which a tremendous horde of about 250,000 bats emerges every night to feed on flying insects. Farther inside the cave he erected a temporary tripod supporting a small, light-colored target about 10 feet from his camera. This was used only for setting up the system. A photoelectric cell pointed toward the target, which was illuminated by a spotlight. Then the cell was adjusted so that it was activated by light reflected from the target. Also pointed at the target was an array of three quick-acting strobe lights enclosed in a reflector to give a rather narrow beam with a flash duration of 70 millionths of a second.

After the apparatus had been tested, the tripod and target were removed and the camera's shutter opened. When a bat flew into the spotlight beam, light reflected from the creature triggered the photocell which in turn set off the brilliant flash of the strobe lights. The bat was caught on film as sharply as if it had been motionless.

Edgerton's photographs solved a problem that had long puzzled zoologists. The Mexican free-tailed bat that inhabits Carlsbad Caverns apparently lacks a membrane stretched between the hind legs that other bats use to

control their flight and to help them scoop their insect prey out of the air. But it has a long, thin tail that appeared to be a purposeless appendage.

Edgerton's detailed pictures of Mexican free-tailed bats in flight showed that when the bat becomes airborne it extends its legs rearward. A loose membrane slides out along the tail forming an efficient control surface. This clever way of furling the tail membrane probably helps conserve body heat and moisture when the bat is not in flight. No one had guessed the secret before Edgerton brought his strobes to the mouth of the bats' cave.

The greatest test of high-speed nature photography is to take razor-sharp pictures of hummingbirds, whose wings beat upwards of 60 times per second, in all their glory of iridescent color and flashing action. This was notably accomplished in 1953 by Crawford H. Greenewalt with the help of elaborate, specially designed equipment. The fact that Greenewalt was at the time president of the Du Pont Company and had at his disposal the company's great technological resources helped a good deal.

Greenewalt developed his system by trying it out on the ruby-throated hummingbird, the only species that inhabits the eastern part of the United States. Then he made expeditions to Brazil, Ecuador, Venezuela, Cuba, Jamaica, Panama, Arizona, California and Colorado in search of more exotic and brilliant subjects. Sometimes he photographed captive birds that had made themselves at home in large aviaries. Some rare species were captured specially for him. One was knocked gently out of the air by an Ecuadorian blowgunner, who used a pellet of soft clay that stunned the bird momentarily but did it no further harm. Many birds were photographed in their native habitats, usually at feeding stations to which they had been habituated by weeks of sugar doles.

Greenewalt's photographs of birds seemingly suspended in flight were beautiful as well as informative. But he was not content with still pictures, so he determined to make motion pictures of hummingbirds that would show how they fly, how fast they fly and how they perform their amazing acrobatics. There was available a high-speed motion-picture camera fast enough to do this, but it had the disadvantage of requiring a half-second or so to get up to full speed. A second is a long time in the life of a hummingbird; by the time the camera got ready to photograph them, the birds, frightened by the camera's buzzing, would be far away.

So Greenewalt encouraged the development of a new, fast-starting camera. The chief cause of the sluggishness of the existing type was the inertia of its 100-foot reel of film, which resisted quick acceleration. The new model avoided this difficulty by discarding the reel and using film that was partly unwound, festooned loosely in a light-tight box. When the camera started into action it had to overcome only the inertia of a short length of film. In a

few thousandths of a second it reached the picture-taking speed of 1,200 frames per second. No shutter was necessary because the film moved continuously and passed the lens so quickly that daylight made no impression. The camera took pictures only during the intermittent, brief flashes of powerful stroboscopic lamps.

Greenewalt enticed the ruby-throated hummingbirds at his home in Delaware to fly in front of his new camera by means of gifts of sugar water. The camera worked so fast that before a bird heard its buzz, many frames of its flight had been taken. The rest of the film often showed the extraordinary acrobatics of the creature's frightened getaway.

Greenewalt was still not satisfied; he wanted to find out how fast a hummingbird can fly and just how much each part of its wing cycle contributes to its support and forward motion during different kinds of flight. So he built an apparatus for the birds that his children called "Daddy's torture chamber": a fan driving a stream of air through an 18-inch pipe at speeds up to 30 miles per hour. The birds, he found, did not consider it a torture chamber. When he placed a sugar-bearing feeding station close to the outlet of the wind pipe, they quickly learned to come to it, and they continued to come after he put the fan in motion. Apparently they considered it fun. When they had become accustomed to the fan's powerful roar they did not hear—or at least were not alarmed by—the camera's buzz.

To reach their food the birds had to fly upwind to the feeder and keep flying while they sucked the sugar syrup out of it with their tubular tongues. Greenewalt could control and measure the speed of the air stream, so he could tell how fast each bird pictured was flying by how fast the air was moving. The top speed for a female ruby-throated hummingbird proved to be about 27 miles per hour.

With the facilities at his disposal, Greenewalt was able to develop and use strobes with greater speed than those normally used today by most amateur and even professional photographers. Most ordinary strobes are all right for photographing people who are not doing anything too vigorous, but their flashes last several thousandths of a second, and during this time a bird's wing, for example, moves so much that its outlines are blurred. Many an amateur has been disappointed by the poor nature pictures he gets with his new strobe. In most cases they are no better than pictures taken in sunlight with the fastest speed of the shutter on his camera.

The chief cause of the slowness of ordinary strobes is their capacitors, which are conveniently small in size, weight and cost but which do not give up their electric charge quickly enough. However, a number of strobes equipped to give high-speed flashes are available *(pages 30-31)*. They are moderately expensive, but their flash durations can be as brief as 1/15,000 or

even 1/50,000 second, which is a speed fast enough to take photographs of small birds in flight, pictures of bursting balloons, of splashes, etc.

While an ordinary strobe's flash of several thousandths of a second is too slow for fast-action photography, it is still quite brief. And it is very brilliant. This makes a strobe light handy for the kind of photography that, instead of expanding time, contracts it. Many natural actions escape human observation not because they are too fast but because they are so slow that the eye does not see them happening, noticing only the cumulative effect after a considerable passage of time. Cameras are more patient and attentive. They can stare at a slow action for any desirable length of time, taking pictures of it periodically, one second, one hour or many days apart. When a series of such pictures is seen, the slow action comes to vivid life. Everyone knows, for instance, that a rose opens from a tight green bud, but the eye cannot catch it in the act. The time-lapse camera using the brief flash of a strobe light has no trouble at all.

Taking time-lapse pictures is not quite as simple as it sounds. The camera must look at the subject from exactly the same distance and angle during each shot. With indoor subjects, such as a flower opening in a vase, this is no great problem, but outdoor subjects must be protected from wind and other influences that might make them move in relation to the camera. Sometimes such sheltering care has unforeseen results. One photographer, for instance, wanted to take a time-lapse sequence of a ripening apple. He built a small, glass-walled house around a branch of an apple tree and arranged his camera in front of a promising young apple. The apple grew all right, but it refused to turn red. Next season he tried another variety of apple, with no better results. Finally he discovered that the glass of the camera house was excluding the ultraviolet rays needed to make the apple turn color. The following year, instead of glass he used transparent plastic, which transmits ultraviolet and got lively pictures of the ripening of a red apple.

Lighting is always a problem with time-lapse pictures; if it varies, the changes due to the passage of time may be obscured. With indoor subjects, lighting can be kept constant by excluding natural light and always using the same number of artificial lights in the same positions. Even better is a strobe light so powerful that it conceals any variation of natural lighting.

Time-lapse pictures of nature require little special equipment, but scenes outdoors are high tests of a photographer's skill. If he wants to record the development of a thundercloud, he must take a picture every few seconds while keeping the camera adjusted to suit rapidly changing light conditions. When recording the blooming of a flower bed or flowering tree, he must try to avoid distracting effects such as shadows that appear in pictures taken when

the sun was shining but not when it was hidden behind clouds. Time-lapse photography is a fascinating activity, but not an easy one, and certainly not for an impatient man.

Time-lapse and high-speed photography of nature have attracted many serious amateurs, who have made outstanding pictures. While special equipment may be required, it can be managed by nonprofessionals. This is not true of very high-speed photography. For stopping the fastest action, a great deal of complicated—and expensive—gear is needed. If the subject is not self-illuminating it must be photographed by means of light that falls upon it, and this is best accomplished by bright flashes that last so short a time that they eliminate the need of a fast-acting camera shutter.

Specially designed strobe lamps can be made to give flashes as brief as a millionth of a second. This is short enough to photograph bullets and more than short enough for such comparatively sluggish subjects as golf balls squashed against the club head. Faster actions require shorter flashes. Flashes as brief as 10 billionths of a second are possible with air-gap sparks, which are bright enough to take shadow pictures of high-velocity bullets passing directly between the spark and the film. These show not only the bullet but small specks that it has dislodged from material that it has passed through. The particles are traveling almost as fast as the bullet but their tiny shadows are as sharp as if they were motionless.

Short-exposure single pictures are easier to take than motion pictures whose individual frames follow in rapid succession. One difficulty is "holdover," the result of the fact that the gas-filled strobe tubes do not shut off instantaneously after the first surge of current has passed. The gas in them remains ionized and therefore conductive, so current that is intended to recharge the capacitor continues to flow through them, giving a steady and comparatively dim light that is useless for the purpose intended and eventually damages the lamp. The cure for holdover is some sort of rapidly acting switch that starts and stops the current at the desired rate. Probably the most effective switch is a kind of vacuum tube called a hydrogen thyratron, which can make a strobe light give as many as 10,000 flashes per second.

Even such brief flashes may not prevent blurring caused by rapid movement of the film through the camera. It must travel continuously, not stopping and starting for each picture, as in an ordinary movie camera. This problem can be solved by placing a rotating mirror or prism behind the camera lens to make the image it forms move along with the film. One model uses a square block of glass rotating in such a way that it keeps an image almost perfectly steady on each moving frame, then forms another moving image on the next frame. Such cameras take more than 10,000 pictures per second. When they are used in conjunction with a strobe light there must be some device to

make sure that the light flashes when the camera is prepared to take a picture. An ingenious device to synchronize camera and flash uses a small permanent magnet held near the sprocket wheel that moves the film. As each steel sprocket tooth passes the magnet, it affects the magnet's field and causes an electric pulse to be generated in a coil. The pulses keep step with the motion of the film and signal when it is in the correct position for the strobe light to fire and take a picture.

Some rapidly moving objects—including most explosions—produce a great deal of light of their own, so high-speed photographs of them can be taken without additional illumination. The problem here is to fit the camera with a shutter that stays open a millionth of a second or less. This is not easy; no ordinary mechanical shutter is fast enough. A shutter-like effect, however, can be provided by a rotating mirror that casts light successively on many small lenses arranged on the inside of a curved surface so that each acts like a separate camera. If the mirror turns fast enough (upwards of 10,000 revolutions per second) and the lenses are sufficiently numerous, such a camera can take pictures at the rate of 200 million per second, each picture exposed for 100 billionths of a second. The pictures, however, are not of very good quality, and for obvious reasons it is hard to start the picture series at the correct instant to catch the most interesting part of a brief explosive action.

Another way to take ultrashort exposure pictures of brilliant objects is to use an electro-optical shutter with no mechanical moving parts to limit its speed. Such shutters depend on the fact that magnetic and electric fields can affect light that is passing through certain materials. Since the field can be applied in a few hundred billionths of a second, it can actuate a device that acts as an ultrafast shutter.

The best-known electro-optical shutter is the Kerr cell, named after the Scottish physicist John Kerr, who discovered in 1875 that when an electric field is applied to a substance, its molecules will align themselves in such a way that entering light waves will refract in two different directions.

This sounds like a small effect, but on it can be built a very effective quick-acting shutter. At one end, where the light enters, is a sheet of polarizing material that alters the plane of vibration of its waves to, say, the horizontal. At the other end is another polarizing sheet turned at a 90° angle so as not to permit horizontally polarized waves to pass. Acting together, the two sheets block all light.

Between them, however, is a glass container holding a liquid such as nitrobenzene, with two metal electrodes at the container sides. When electric charges are imposed on the electrodes, the nitrobenzene changes the polarization of the light in a manner that permits a substantial portion

Demonstrating the power of the camera to record events that man could not otherwise see, a frame from a 35mm motion-picture film shows the roof of a wooden house peeling off, the façade falling in and the chimney about to collapse from the shock waves of an atomic-bomb blast. Part of a March 17, 1953, test at Yucca Flats, Nevada, the house was placed only 3,500 feet from ground zero. The ultra-high-speed movie camera, protected by a lead sheath, was trained on the house from a distance of 60 feet. This frame was made one and two-thirds seconds after detonation; the house was totally demolished instants later.

it to pass through the second polarizing sheet. The Kerr cell is now open for picture taking. Shutters using this principle—or a similar one that employs magnetic fields and glass elements instead of electric fields and nitrobenzene—can open and close in a few millionths of a second. Clear pictures of ultrarapid events, such as thin wires exploding when a heavy electric current is suddenly sent through them, have been taken at this exposure.

Perhaps the most spectacular pictures taken with an electro-optical shutter are of the early stages of nuclear test explosions in the open air. Many of them were taken for the Atomic Energy Commission by Edgerton, Germeshausen and Grier, Inc., a company founded by Professor Edgerton and two associates. There was no lack of light; in its early stages a nuclear fireball is many times brighter than the sun. The difficulty of photographing it came from the rapidity of its expansion. The fireball of even a comparatively weak explosion reaches 90 feet in diameter in 1/10,000 second, and the fastest growth is during the first millionths of a second.

To photograph a typical explosion where the bomb was in a small housing on top of a tower, the EG&G apparatus consisted of a cluster of cameras at the safe distance of 10 miles or more. They had mechanical capping shutters that opened one second before the bomb was scheduled to explode, and behind these were electro-optical shutters capable of opening and closing at ultrafast speeds. Controlled by circuits that took different times to act, each camera took its picture at a slightly different time. Then, since electro-optical shutters are not completely opaque, a second capping shutter went into operation to keep the flood of light from the fireball from spoiling the picture. It had to act very quickly, so it consisted of a glass plate covered with a network of thin lead wires, which vaporized when a pulse of electricity was sent through it. The vapor quickly coated the glass with an opaque layer of lead to obstruct the late-coming light.

The first picture, shot a millionth of a second after "Time Zero," shows the bomb enclosure looking like a little hut with a dim light in its window. The light is the first evidence of the cataclysmic event that is happening inside. In the next picture, millionths of a second later, the fireball is beginning to burst out of the hut. For a while it remains somewhat irregular, distorted by the inertia of heavy materials in the detonating mechanism, but a few millionths of a second afterward all such objects are vaporized, and the fireball forms a smooth expanding sphere that eats up the tower and turns it to vapor, too. Without the help of an ultrafast shutter, no human eye would ever have seen the first few moments of the youth of a nuclear fireball. □

Jonathan Norton Leonard

Using Photography to Manipulate Time

Much of the world is made of things in motion. But a great many of them are moving too fast for the eye to perceive or too slowly for their motion to be noticed. A multitude of images of one object, eclipsed by time, exists beyond the range of human vision, making up actions as swift as the wing beat of a hummingbird hovering to feed, or as intricately drawn out as the growth of petals when a bud untolds.

But photography, expanding time by stopping fast action with brief exposures, or contracting it by compressing slow action with repeated exposures, has provided ways to capture images that exist for only millionths of a second and others that take months to materialize. Used in these ways the camera has proved an indispensable tool of almost inexhaustible application. Engineers and scientists, golf pros and football coaches, ballet lovers and bird watchers have all gained new insights from high-speed photography, whether they take the pictures themselves or only study them. Such photographs, beyond their practical importance, have also added a new and surprising dimension to our appreciation of the world, revealing beautiful patterns in events as brief as the splash of one drop of milk *(opposite)*.

It is possible to stop fast action with an ordinary camera, using an exposure of about 1/1000 second (normally the top speed of mechanical shutters). But in such photographs, the finest details of a fast-moving subject may remain quite imperceptible. The extraordinary crownlike structure that is revealed in a milk drop by the pictures shown on the opposite page required special equipment, and the separate events in the detonation of an explosive can be caught only by complex, ultra-high-speed cameras capable of making exposures of billionths of a second. Most high-speed photographs are made by controlling the duration of a light flash that exposes the film. The device generally used is the strobe light, or electronic flash, developed by Dr. Harold E. Edgerton of M.I.T. It produces exposures thousands of times faster than a mechanical shutter.

Stopping a single instant of action with a split-second flash of light from strobe lamps is only one of the techniques photographers use to manipulate time. Rapidly repeated flashes of light—from stroboscopic units—can be used to make multiple exposures that follow a moving subject over infinitesimal distances along its path. If the exposures are repeated at a slower rate, they reveal the most subtle changes in a subject that appears motionless. And long exposure of a moving light source—made by holding open the shutter—can result in equally remarkable photographs showing unseen patterns traced in time. Each of these techniques presents a stimulating challenge to any photographer. High-speed strobes *(pages 30-31)* can be expensive, but there is no mystery about their use. And even without special equipment, the camera can be used in ways that transcend the limits of time. ☐

In this historic series of photographs, taken ▶ about 1938 by Dr. Harold E. Edgerton in an early investigation, at the Massachusetts Institute of Technology, of the possibilities of high-speed stroboscopic photography, a drop of milk splashes into a shallow saucer (opposite, 1). Surface tension holding the drop together is shattered (2), and the drop breaks into droplets held together by surface tension of their own, forming a crown (3) and then a coronet pattern (4). The tips of the coronet separate (5) and finally fly free (6) as another drop falls to begin the sequence all over again. To obtain these pictures, Edgerton used special equipment that provided 6,000 flashes per second, each flash lasting approximately 1/1,000,000 second.

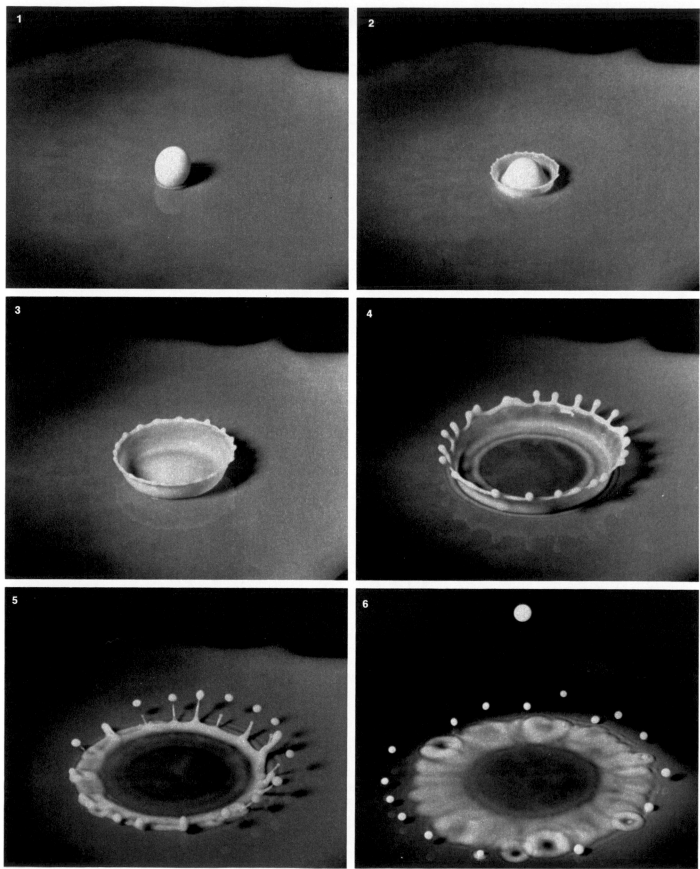

HAROLD E. EDGERTON: *Drop of Milk Splashing into a Saucer,* 1938

A Moment Frozen

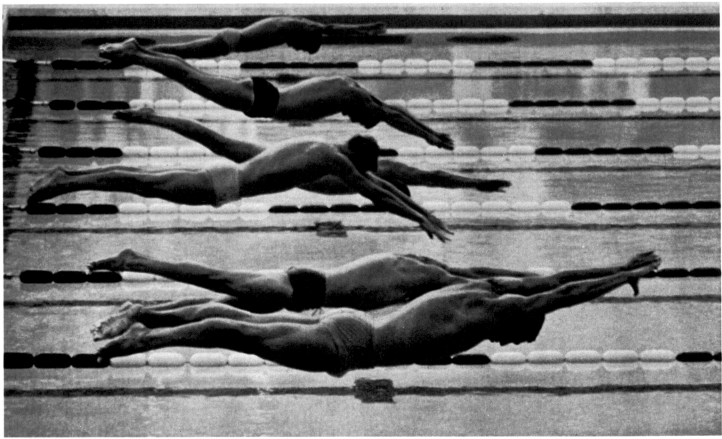

JAMES WHITMORE: *400-Meter Olympics Race, Rome,* 1960

The kinds of cameras many amateurs use all the time can stop fast motion for unusual action shots. The Olympic swimmers above, photographed during the 1960 games in Rome, were stopped in mid-dive, just before hitting the water for a 400-meter race, by James Whitmore with a 35mm. The girl swimmer opposite creates an arc of water droplets that are caught by Krzysztof Kamiński with a 2¼ x 2¼ reflex camera at the moment she rises above the water and tosses her wet hair.

Both photographs, made with exposures of 1/1000 second, are challenges to the mechanical shutter's ability to freeze action. For each, the motion is rapid and across the field of view, so that the image created by the lens is shifting over the film very rapidly. From other angles, fast-moving images shift less on the film; and moving the camera with the action so that the subject is always kept in the center of the camera's viewfinder—panning—keeps the image stationary on the film. Both expedients are helpful for getting blur-free shots of moving subjects, particularly when dim light prevents the use of a camera's highest shutter speed.

These international swimmers are halted in mid-air by James Whitmore's shutter at 1/1000 second as they plunge into the pool at Rome in 1960. Since the pool is outdoors and this race was in daylight, Whitmore was able to use his fast shutter speed without artificial illumination.

With a toss of her drenched hair, a girl swimmer ▶ at the Baltic seacoast town of Danzig, Poland, leaves a watery trail, stopped by the fast shutter of photographer Krzysztof Kamiński. Kamiński titled his lady "Aphrodite" because the Greek goddess of love and beauty was, according to some legends, born of the sea.

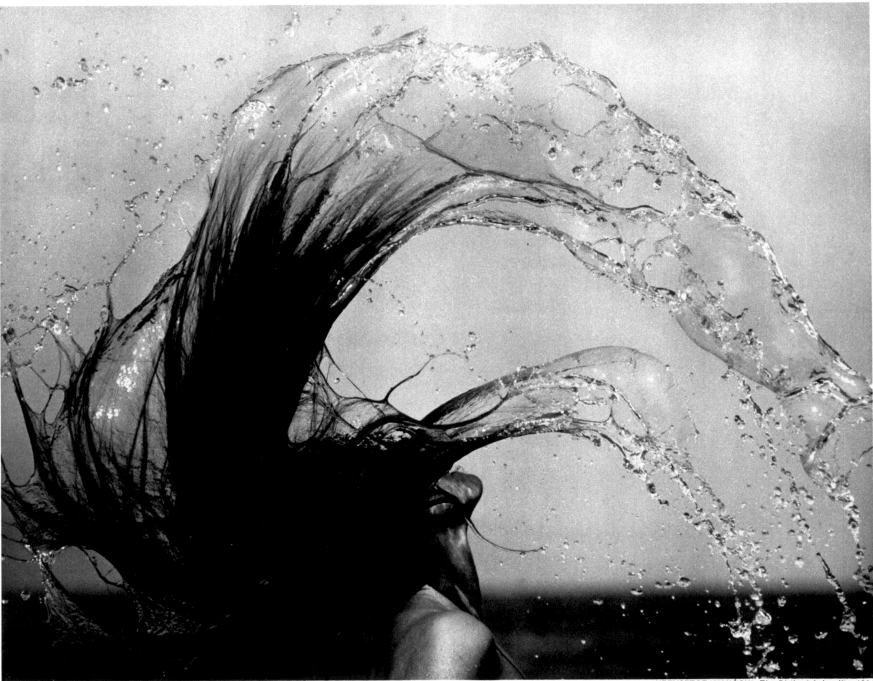

KRZYSZTOF KAMIŃSKI: *The Birth of Aphrodite*, 1964

Actions Faster than the Shutter's Click

Tips on Stopping Action

Using a strobe to freeze movement is little different from using it simply as a handy source of bright light. The same methods are employed for calculating exposure from the guide number listed in the unit's instruction sheet, and the general principles of lighting a subject apply. However, the even illumination of bounce-lighting, with the flash aimed at ceiling or wall, may work for high-speed shots with some units but not with others (pages 30-31); certain types automatically lengthen the duration of their flashes as distance increases between the strobe and the first reflecting surface hit by the light rays—a bounced flash may turn out to be too long to stop fast motion. Some other points to bear in mind:

What action can be stopped. The 1/1000-second or shorter flash provided by most units will freeze nearly any human activity—swimming, diving, prizefighting, dancing, jumping. To stop birds' wings, bursting balloons or splashing water, a flash shorter than 1/15,000 second is needed; many amateur units can also provide that. But it takes special equipment to catch a golf ball at the moment it is squashed by a club head (1/100,000 second) or to stop a bullet in flight (1/1,000,000 second).

Adjusting flash duration. The simplest way to get flashes of higher speed is to connect an additional number of lamps to the same basic unit (some units are manufactured to operate several lamps at once; others can be adapted to do so). This reduces the voltage available to each lamp tube, reducing its light output—and also the time it stays lit.

The problem of ghosts. The stopping ability of a strobe depends on the fact that the film is exposed only to the very brief flash of light from the lamp. If other light, on for a longer period of time, is also present, it too can create an image on the film—a blurred ghost of the frozen strobe image. This is seldom a difficulty when shooting staged pictures indoors—the room illumination can readily be kept so dim that it will not affect the film. But general illumination is obviously not so easy to control when taking pictures at sporting events and outdoors, and avoiding ghosts under those conditions requires special precautions that depend on the kind of camera shutter being used (see below).

Avoiding ghosts with a leaf-type shutter. The solution for cameras with leaf-type (between-the-lens) shutters, such as studio view cameras, twin-lens reflexes and many others, is very simple: use a shutter speed of 1/500 second. This will block most of the general illumination but none of the strobe light.

Avoiding ghosts with a focal-plane shutter. This type of shutter is used on nearly all single-lens reflexes as well as some rangefinder cameras, and with such equipment there is no real solution, only dodges that may help under certain conditions. The reason is that most focal-plane shutters must be synchronized with flash at a shutter speed of 1/60 second or slower. (Because of the way such a shutter is made, only at these slow speeds can the entire negative be exposed at the same instant for flash illumination; higher speeds would leave parts of the film blank.) But 1/60 second is too slow to block much of the general illumination that causes ghosts. Closing down the lens aperture is little help; this blocks strobe illumination as much as it does general illumination. For black-and-white shots indoors where the illumination comes from incandescent lamps, a blue filter is effective; it blocks the red light that predominates in incandescent illumination, while having far less effect on the daylight-white light from a strobe. Another useful trick is to shoot action pictures in extremely dim light: ask the tennis player to demonstrate his form for the camera at dusk.

Automatic triggers. With some practice, it is possible to learn to anticipate action and set off a strobe manually at the precise instant the action occurs. But automatic triggers are generally necessary. Only the strobe need be controlled for such pictures, since they are generally shot in a darkened room, the shutter being opened manually (as for a time exposure) before the action begins and then closed manually immediately after the strobe fires. The most popular automatic trigger consists of a photoelectric cell in an electronic switching circuit; when a moving object interrupts a beam of light aimed at the cell, the circuit instantly fires the strobe. The strobe is wired to the trigger circuit through the little plug that ordinarily connects the strobe to the camera shutter. Simpler automatic switches can also be rigged to the strobe's camera plug: two strips of metal foil can be arranged so that they are forced into contact, completing the circuit, when a moving object strikes the strips.

While many fast actions can be stopped with a shutter, photographing the same subjects with the very brief flash of a high-speed electronic flash, or strobe, can give far sharper, more detailed pictures. The difference can be seen by comparing the photographs of the Olympic swimmers on the preceding two pages, made with the use of a shutter, and the extraordinary photograph opposite, stopping a swimmer halfway through her perfect dive into the water, made with a high-speed strobe.

Besides outdoor exposures, strobes make it possible to take stop-action photographs indoors, where illumination adequate for very high speeds would be difficult to provide.

Although the most powerful, professional strobe units can cost well over a thousand dollars, and are "portable" only with the help of a few assistants, many simpler, lightweight units are now available at moderate prices (pages 30-31), making strobe lighting a practical choice for any photographer interested in taking high-speed pictures.

Stopping the splash of a young diver as ▶ she enters the water, photographer George Silk used a strobe that gave a flash of 1/4350 second. The picture was made from a window at water level, catching both the underwater turbulence and the symmetrical spray about the girl's legs. To be able to adjust his timing so that he caught the action at the desired moment, Silk needed to see results as the shooting progressed. He solved that problem by using Polaroid Type 55 P/N film (ASA 50), which provides an instant print for reference and also a permanent fine-grain negative for later enlargement.

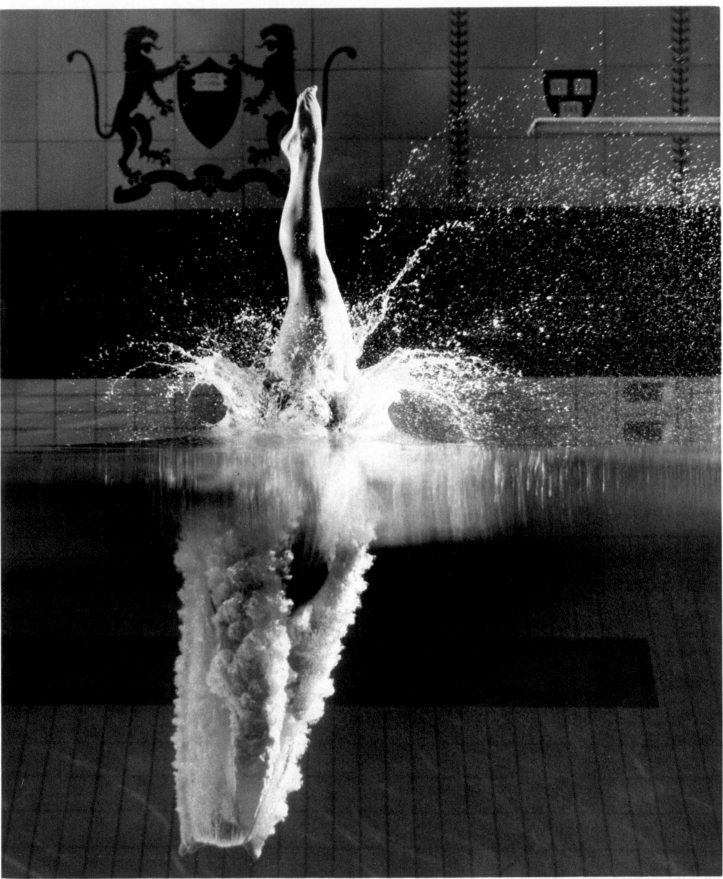

GEORGE SILK: *Young Diver*, 1962

Flash Units for High-Speed Photographs

Not every strobe can shoot action pictures. Some models are designed only to serve as sources of bright light, and their flashes last too long to stop rapid motion. All the units pictured opposite, however, provide flashes of 1/1000 second or shorter, enough to freeze most human motions, and some can achieve the very high speeds required for photographing fast-moving animals. Despite great differences in operating capacity, all strobes work on the same principle. Each unit has a tube (or several) of strong glass with a metal electrode at each end. Air is drawn out of the tube and replaced with a small amount of xenon gas. This gas is a poor conductor of electricity but can be forced to carry electricity between the electrodes by passing a high-voltage pulse through a thin wire wrapped in a few turns around the tube. The pulse is enough to affect a few of the gas atoms in the tube, unbalancing them electrically so that they have a net electrical charge. These charged atoms, or ions, surge violently to the tube's positive and negative electrodes, ionizing other atoms as they jostle through the gas. The presence of the ions makes the gas a conductor and enables a heavy charge of electricity, stored in a device called a capacitor, to flow between the electrodes. In a few millionths of a second, the current heats the gas so much that it gives a brief but enormously brilliant flash of light.

Besides the xenon tube (which in some units may be bent into a "U" or coil to concentrate the light), the components of a strobe light are the capacitor; the power source, usually a battery, although many units can also operate on house current; a triggering unit, which is activated by the camera's shutter mechanism and a reflector.

Although the units shown opposite all work in this way, they differ greatly in the brightness of the light they can produce (indicated roughly by their power as measured in watt-seconds), their versatility, the recharging time between flashes, the duration of flashes —and their prices, which range from $20 to $1,500. The Nikon Speedlight (9) can be equipped with a ringlight, a circular strobe light that fits around the lens for extreme close-ups. Two special-purpose units are the Ultima Ring Lite (5), limited to close-up work, and the Wein Cronoscope (6), which gives up to 30 flashes per second, each lasting 1/15,000 second.

Several of the units shown can provide flashes of varying duration. The Honeywell units (2 and 8), for example, have automatic sensing devices to adjust the duration of their flashes (and thus the amount of light released) automatically as distance from the subject changes; at close range, where only a small amount of light is needed and the flash can be very brief, either can provide a flash as short as 1/50,000 second. The Strobmatic 500 (3) and both Ascorlights permit shortening of flash duration by the expedient of hooking up more lamps to the basic unit. This reduces the amount of light each lamp produces, cutting its flash time. The Ascorlight 660 (1), used by many professionals, provides flashes between 1/450 and 1/2000 second. Units like the Ascorlight 660 are not portable in the usual sense, but they can be sent someplace and set up. LIFE, for example, often shipped 16 of the 60-pound strobes to cover a big sports event.

1 | **Ascorlight 660: 800 watt-seconds; flash 1/450-1/2000 second**

2 | **Honeywell Auto/Strobonar 880: 100 watt-seconds; flash 1/500-1/50,000 second**

3 | **Strobmatic 500: 200 watt-seconds; flash 1/850-1/1900 second**

4 | **Ascor 444: 200 watt-seconds; flash 1/1000 second**

5 | **Ultima Ring Lite RL-100B: 20 watt-seconds; flash 1/1000 second**

6 | **Wein Cronoscope WP-10RF: 10 watt-seconds; flash 1/15,000 second, up to 30 flashes per second**

7 | **Capro FL 4: 30 watt-seconds; flash 1/1000 second**

8 | **Honeywell Auto/Strobonar 330: 50 watt-seconds; flash 1/1000-1/50,000 second**

9 | **Nikon Speedlight: 50 watt-seconds; flash 1/2000 second**

10 | **Ringlight accessories for Nikon Speedlight**

11 | **Spiratone Spiralite SR: 50 watt-seconds; flash 1/1000 second**

12 | **Singer Graflex Strobe 250: 75 watt-seconds; flash 1/1500 second**

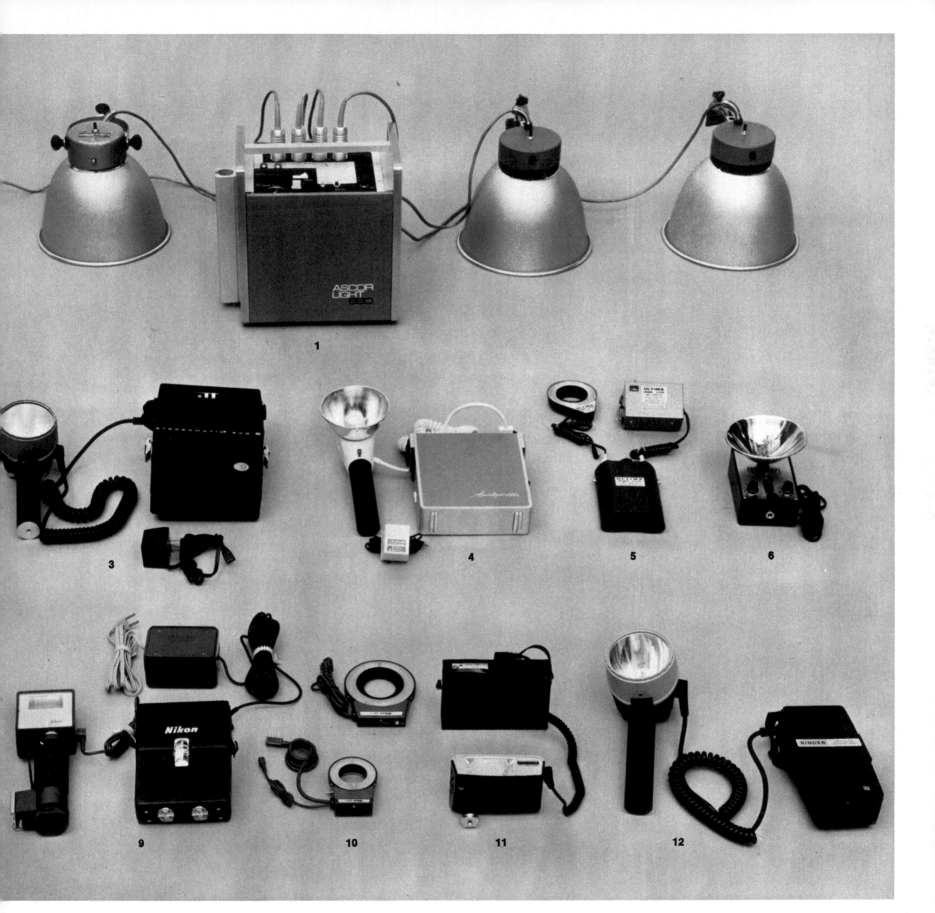

Fleeting Images in Flight

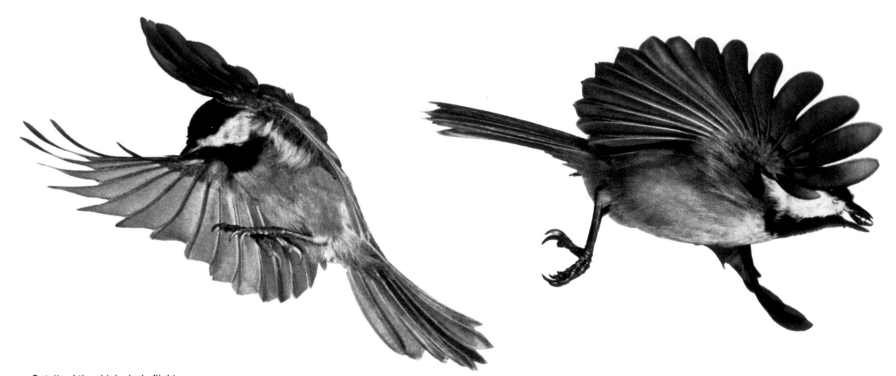

Details of the chickadee's flight were photographed by Crawford Greenewalt. To stop the action of the birds' wings, beating at 30 times a second, Greenewalt used a strobe flash of 1/30,000 second. These pictures —published here for the first time—show, from left to right, a bird's wings halfway through a downbeat, starting a downbeat, approaching a landing and completing an upbeat.

The extraordinary ballet of birds in flight has been a perennial source of fascination to photographers as well as naturalists. The instant exposures permitted by high-speed strobe units have allowed the detailed study of aerial maneuverings that otherwise could never have been detected, as illustrated by the stop-action photographs of chickadees on these two pages, taken by Crawford H. Greenewalt, former president and chairman of the board of the Du Pont Company. Greenewalt later spent more than seven years stalking some 300 species of hummingbirds

with strobe lights and special equipment. He began with chickadees that visited a feeder outside his home at Wilmington, Delaware, and found that his equipment could stop the birds' very rapid wing action. But once he produced equally satisfactory pictures of a ruby-throated hummingbird, his fascination with these extraordinary little birds led him to photograph many species, tracked down across the United States and Latin America.

The heart of Greenewalt's photographic apparatus was a three-lamp strobe unit, designed with much assis-

tance from Harold Edgerton and other technically minded friends, that gave an extremely brilliant flash lasting only 1/30,000 of a second. At this speed, Greenewalt could get stop action photographs of any hummingbird, even those whose wings beat 80 times a second. The strobes' brightness (equivalent to the light of 50,000 hundred-watt bulbs) permitted the use of a lens stopped down to f/32, which provided sufficient depth of field to give sharp pictures whatever the wing position. It also allowed Greenewalt to take his pictures in full daylight when humming-

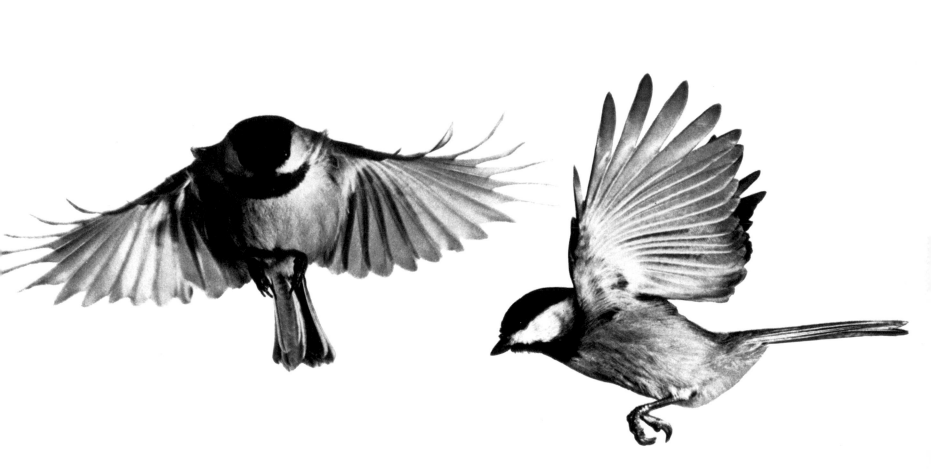

CRAWFORD H. GREENEWALT: *Chickadees in Flight,* 1955

birds are active (with the small aperture and the camera shutter set at 1/500 second, the natural light made almost no impression on the film during the brief period the shutter was open).

Tripping the camera manually was unsatisfactory, since the human reaction time of a tenth of a second was longer than the birds took to pass through the camera's field. It was necessary to develop a photoelectric cell device, adjusted to open and close the camera's shutter and fire the strobe when a bird flew through a beam of light. But advancing the film after each shot was still a problem because the birds were frightened at his every approach to the camera, and operation was slow due to the waiting period necessary to assure the birds that Greenewalt had really gone away. Fortunately, he found that birds paid no attention to any amount of equipment set up near their feeding station, and quickly got used to the strobe flash. So his later cameras were fitted with electric motors to advance the film after each shot. All Greenewalt had to do then was sit back and watch the jewel-bright birds take their own pictures.

From these extraordinary experiments, Greenewalt was able to demonstrate that, as he described it in a book entitled *Hummingbirds,* "A hummingbird is much like a helicopter in its flight performance." It is the tilt of a helicopter's rotor that determines whether it hovers or moves forward or backward. Greenewalt's photographs perceptively demonstrated that the hummingbird similarly tilts the plane of its wing-beat to fly forward or back, or to hover in stationary flight—a fact that would otherwise have remained forever concealed in the flashing blur of the bird's wings.

Stopping a Bullet in Mid-Air

Bullets moving as fast as 15,000 miles per hour have been stopped and studied in a great variety of photographic situations—bursting from gun barrels, shattering against metal plates, passing through light bulbs or even piercing balloons *(right).* Such stop-action photographs have often proved the only way to study the characteristics of a bullet in flight, and some of the information gained from such photographs has been completely unexpected.

When Harold Edgerton employed a strobe-lamp exposure of a millionth of a second to photograph a .22-caliber bullet as it struck a steel block, the photograph revealed that the bullet liquefies for an instant, losing its shape as it compresses upon itself, much as in the pattern of the splashing milk drop shown on page 25. It then solidifies again into the fragments of the shattered bullet. Without the aid of high-speed photography, this discovery that a bullet "splashes" on impact might never have been made. □

A .22-caliber rifle bullet, traveling at a speed of 1,200 feet per second, is stopped (far right) after tearing through three balloons suspended from a string. The balloons are seen in successive stages of shredding. The exposure that captured this instant of action lasted 1/2,000,000 second.

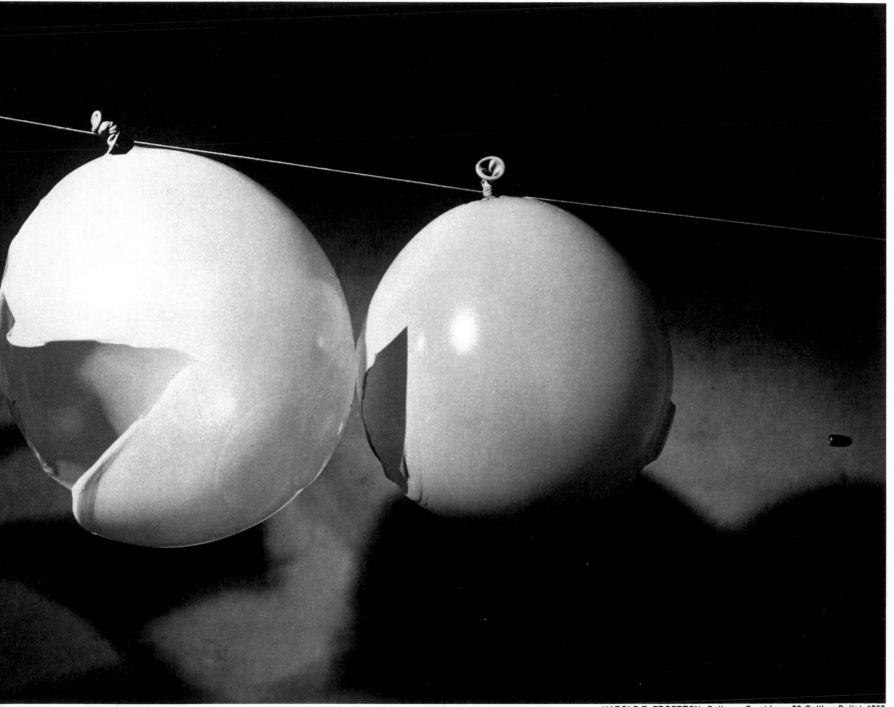

HAROLD E. EDGERTON: *Balloons Burst by a .22-Caliber Bullet*, 1959

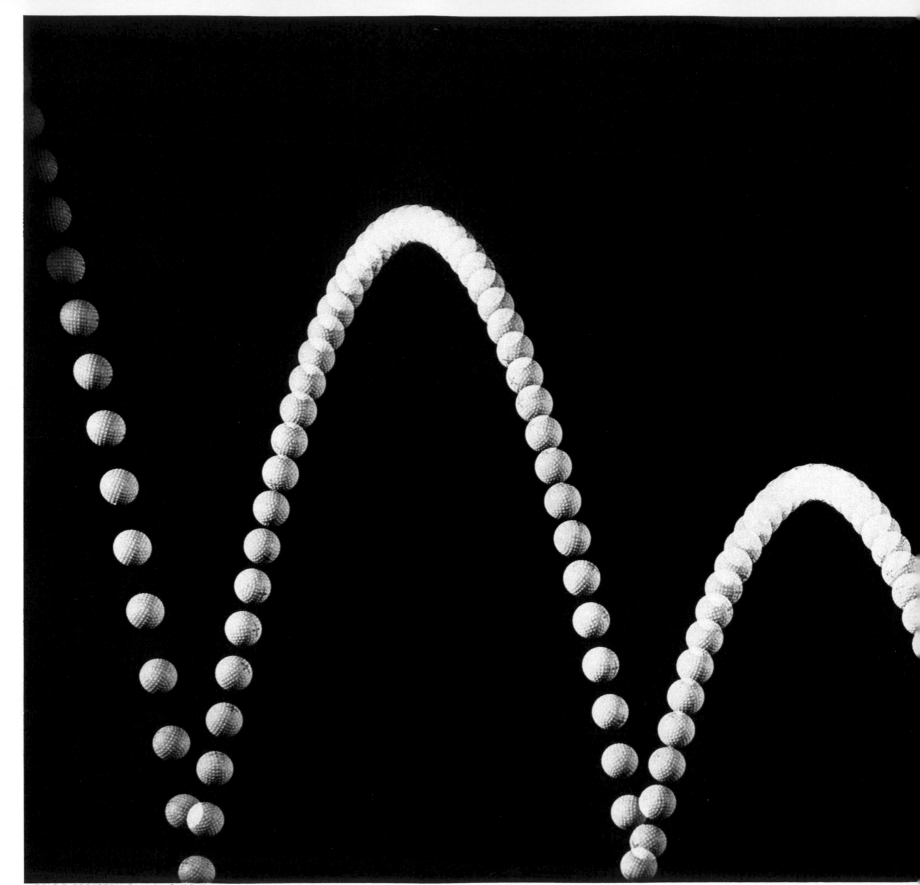

HAROLD E. EDGERTON: *Bouncing Golf Ball*, 1959

With a special strobe flashing at a constant rate to give repeated exposures of less than 1/100,000 second, this stop-action sequence taken by Dr. Harold E. Edgerton exactly records the decreasing velocity and height of the bounce of a golf ball. As the ball first plunges downward at left, each image is separated by a space that shows the distance traveled between exposures. But as the ball loses energy and slows toward the tops of the bounces, the images begin to overlap because the ball has moved a shorter distance between exposures. Finally, in the slow-moving bounce at right, the arc of the ball becomes one continuous row of blended images.

Stop-action photography has proved to be more than a descriptive tool for revealing things the eye cannot see; it can also help analyze and measure them. While a single flash of a strobe lamp may stop a moving subject anywhere along its path, a rapid succession of such flashes can produce a multiple exposure that reveals many facts about how the subject was moving. Since the time between exposures is fixed and known, calculations of velocity, acceleration and distance are easily made from such a photograph.

The multiple exposure of a bouncing golf ball *(opposite),* for example, shows the precise rate at which the ball loses speed and height with each succeeding bounce. Similarly, from a multiple exposure of a golfer's swing *(following page),* it is possible to calculate not only the velocities of the club and the ball, but also such facts as how long the stroke took, the spin and angle of departure of the ball, and the twist of the club head after impact.

Such photographs have found wide application in sports and other human endeavors where technique and form play an important part. They also have become an important analytical instrument of science, providing, in a sense, a visual calculus of motion. They have been used to settle many old disputes, for example whether a golfer's follow-through is important (it is not; the ball instantly takes off when struck), or whether the kick of a pistol affects the accuracy of a shot (it does not; the kick occurs when the bullet is several feet beyond the barrel).

High-speed multiple exposures have found a host of scientific applications, many of them unusual. One gave a clear view of the "archer's paradox," the way the arrow flexes past a bow as the bow is stretched for firing. And in another, multiple exposures of a cat's free fall, for example, showing how the cat maneuvers to land on its feet, have been used by space scientists in teaching astronauts similar contortions for maneuvering under the weightless conditions of space flight.

Split-Second Studies of a Swing

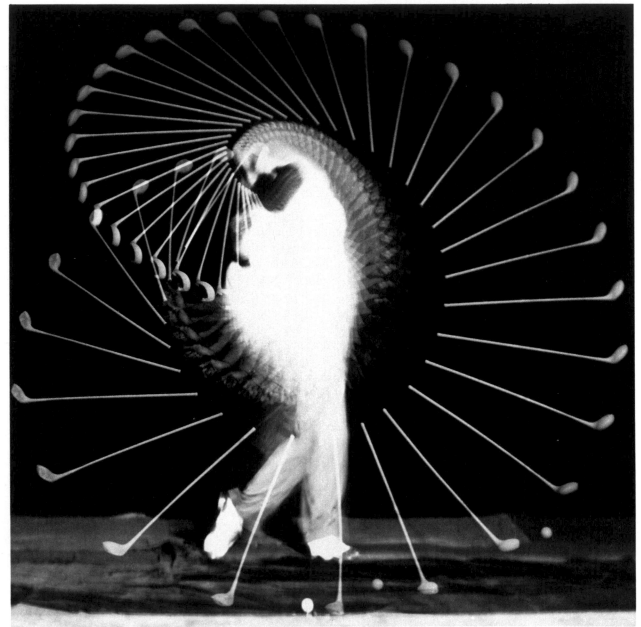

HAROLD E. EDGERTON: *Densmore Shute,* 1938

*The golf stroke of Densmore Shute,
photographed in this multiple exposure with a
1/100,000-second strobe flash every 1/100
second, shows that follow-through has no effect,
since the ball instantly leaves the club.*

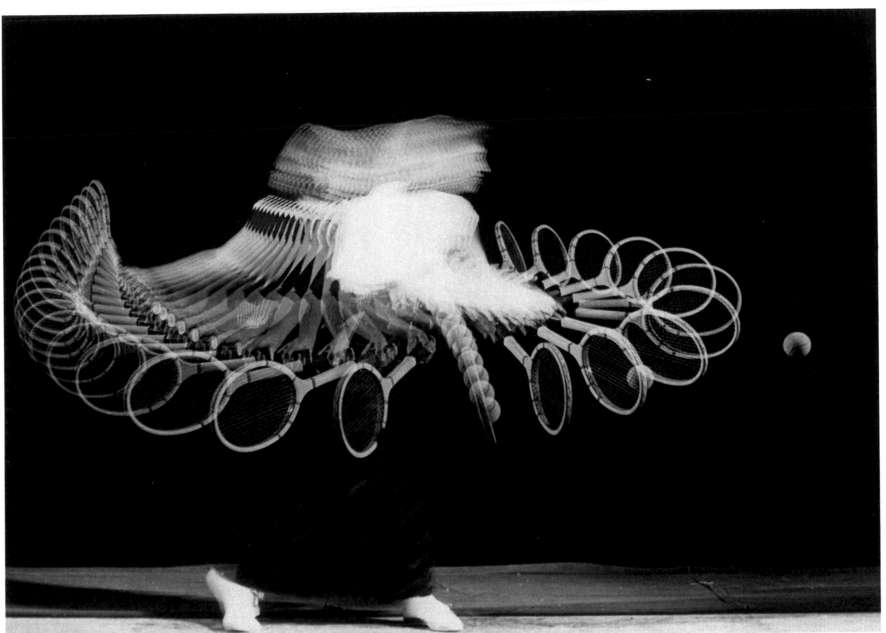

HAROLD E. EDGERTON: *Gussie Moran*, 1949

*How Gussie Moran's forehand speeds up before
she hits a ball is shown by 1/100,000-second
flashes fired 1/60 second apart. Miss Moran's
famed legs and lace panties are hidden by velvet
to give a dark background for the racket images.*

Making High-Speed Multiple Exposures

In taking pictures of extremely fast-moving subjects with strobe lights, a frequent problem is that of triggering the flash, or sequence of flashes, rapidly enough so that the subject is in front of the camera when the lights expose the film. If the subject being photographed requires a 1/10,000-second exposure, a tenth of a second's reaction time before a photographer's hand can trigger his strobes may be much too long.

In stopping the action of a golf club *(page 38)* at the precise moment of impact with a ball, for example, Edgerton once tried triggering the strobe with a microphone placed to pick up the sound of the impact. But sound travels so slowly that his pictures showed the ball well on its way, instead of capturing the impact. He got the picture he wanted by using a photoelectric cell, or electric eye, to set off the strobe.

This technique is now common in high-speed photography when instant triggering of the strobe is critical. In effect, the subject takes its own picture, without the intervention of the photographer's hand or eye. The photograph on the opposite page, a high-speed multiple exposure of a falling cup, was taken with a series of electric eyes placed in the path of the cup, setting off a strobe at fixed intervals, as shown in the diagram on this page. Each flash of the strobe lasted only 1/5000 second, and the shutter was held open throughout the second it took the cup to fall and bounce off a foam rubber pad. ☐

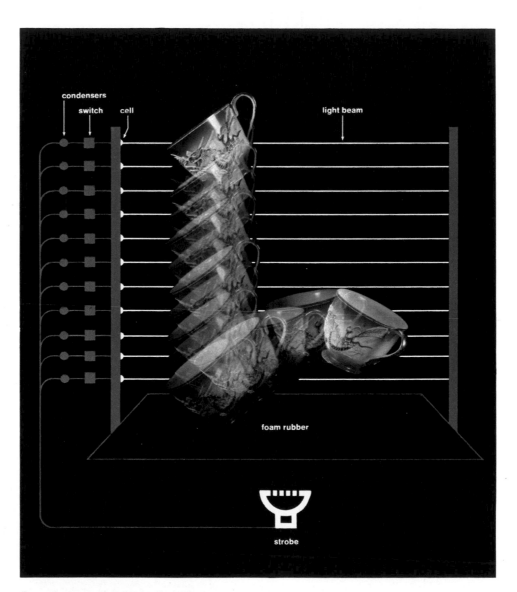

To produce a multiple image of a falling cup, photographer Lou Carrano set in place 11 photoelectric cells, spaced vertically at fixed intervals as shown above. Each cell received a narrow beam of light from a lamp opposite it and was connected to an electronic switch that would trigger a strobe when the beam to the cell was broken. After setting up a black velvet background and a foam rubber mat at the bottom, Carrano darkened the room and dropped the cup past the battery of electric eyes. As the cup hit each line of light, it set off a strobe, producing the multiple exposure opposite.

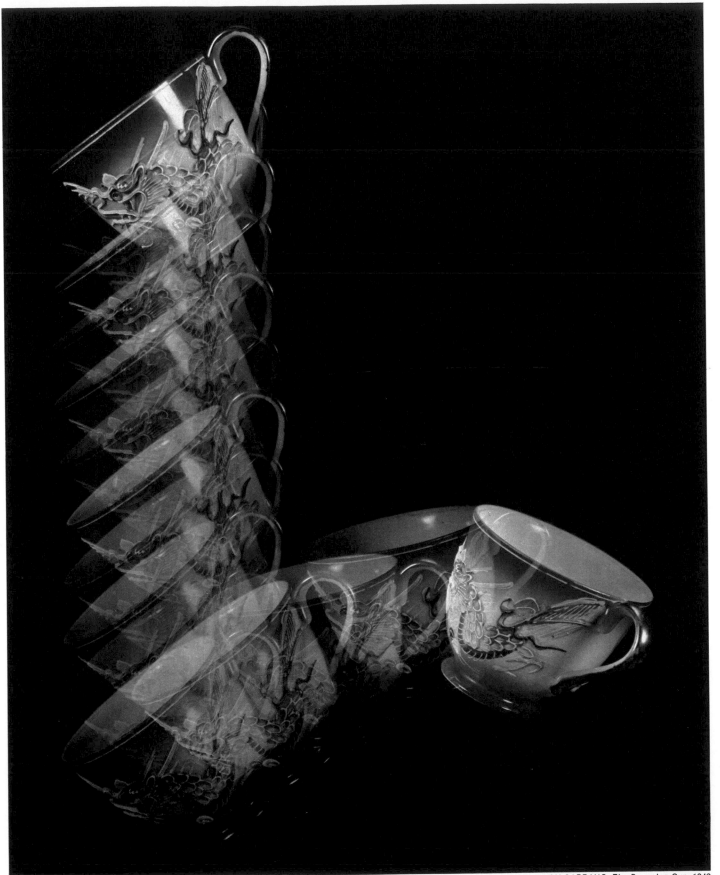

LOU CARRANO: *The Bouncing Cup,* 1949

Holding Patterns in Time

The time exposure is not a new photographic technique, nor does it require strobes or special equipment. When used to capture or compose images in motion, as in the photographs of moving light sources on these pages, long exposures become an important method of photographically manipulating time to record patterns the eye does not see in a single image.

Barbara Morgan, who made the photograph at right, began making her rhythmic "moving light designs" after devoting five years to photographing the modern dancer Martha Graham. "I started my flashlight swinging in my darkened studio," she recalls, "in front of an open shuttered camera, to build up images in time on a single negative." Dressed in a black gown and hood, so as not to record her own image on the film, she created the thicker lines by moving her flashlight slowly, the finer lines by moving it rapidly.

Naturally occurring patterns of light, captured in a long exposure, can produce equally fascinating and esthetic photographs. The streaked and stringy patterns of automobile lights on highways, for example, have been photographed with striking effect. Robert Mayer's montage of airport lights *(opposite),* photographed from a landing plane, is a dramatic blend of movements that only the camera can hold together in a single pattern.

A moving light design (right) was made by Barbara Morgan with a flashlight in front of an open shutter in a darkened studio. Mrs. Morgan says the title refers to a state of being in Buddhist thought, reflecting a concept of wholeness and continuity. Total exposure time for the photograph was about 3 seconds.

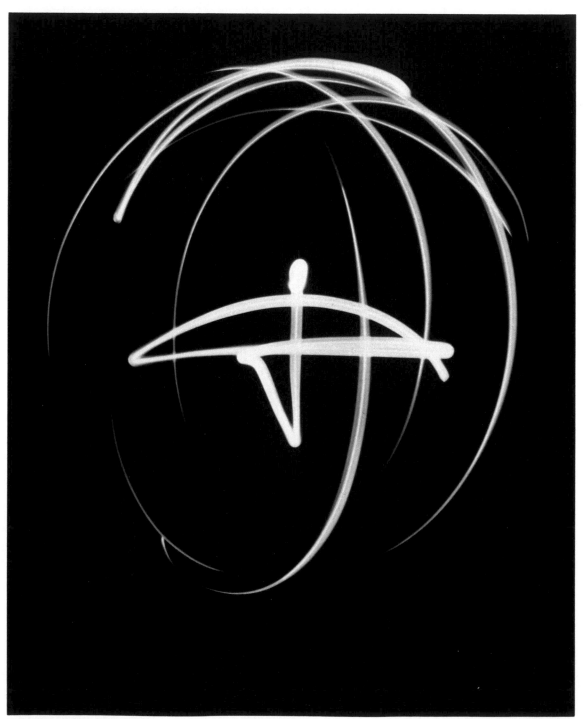

BARBARA MORGAN: *Samadhi,* 1940

A time exposure of 10 seconds captures
the cumulative patterns of lights at LaGuardia
airport in New York, as photographed from
a landing plane. The blue wavy lines at bottom
were traced by runway lights, the orange
and yellow patterns by the lights of buildings,
and by trucks shuttling about the runways.

ROBERT MAYER: *Aerial Abstract*, 1969

The Slow Revealed

Time-lapse photography is a technique for contracting time to record movements and capture images that pass too slowly for the human eye to discern. Astronomers, by focusing their cameras on a distant star at fixed intervals over many years, can detect wobbles in its path that reveal the number of satellites orbiting about it. Scientists have used the same technique in studying the growth of crystals under a microscope, or capturing in a single set of photographs all the stages in the life cycle of a plant or an insect. And because time-lapse photographs can provide a point of reference that ordinary observation does not, they reveal the slow, wayward migration of nerve cells in the living tissue of an animal's brain.

The rising and dipping of the midnight sun over Norway was recorded by Emil Schulthess and Emil Spühler in time-lapse photography at hourly intervals as it remained in the sky for a full 24 hours. To the human eye the sun would appear motionless at any point in this time sequence. But the time-lapse photographs provide a precise record of its path across the sky, following its movement from horizon to horizon.

In one of the more unusual applications of the technique, time-lapse photographs of a blossoming rose were used to settle a patent suit over a process for freeze-drying penicillin. The freeze-drying process required several hours, too long for it to be demonstrated in a courtroom. Photographer Henry Lester proposed to record the process in time-lapse photographs, but lawyers for the pharmaceutical firm involved in the litigation feared the court would not accept such pictures as an accurate representation. The exposures would seem too short, and the intervals between each frame too long, the lawyers feared, to establish the continuity of the process. So Lester set up his equipment before a rosebud. With a tripod-mounted camera and a strobe adjusted to flash every two minutes, he exposed 720 frames a day for six days while the rosebud filled out and burst into bloom. A sampling of the photographs *(opposite)* not only convinced the company's lawyers that the technique would provide an indisputable record of the process, but also persuaded the pharmaceutical firm's adversaries that their case would be lost if brought to trial. The suit was settled out of court, and Lester never had to photograph the freeze-drying process itself. □

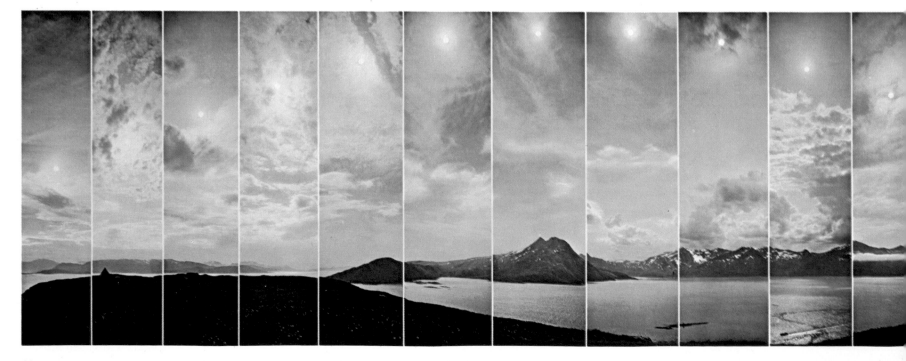

The transformation of a rose from bud to blossom is recorded in six time-lapse photographs, part of a considerably longer sequence of pictures. These exposures were made every two hours. A strobe light with a flash of 1/10,000 second provided illumination; ordinary floodlights turned on repeatedly might have harmed the flower with their heat.

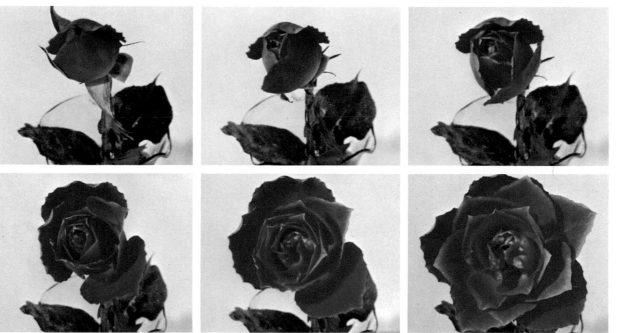

The spectacle of the midnight sun occurs every year in the sky over northern Scandinavia. These time-lapse photographs were made on a Norwegian island far above the Arctic Circle. Exposures ranged from 1/60 second at f/16 to 1/15 second at f/8, and the interval between exposures was precisely one hour. The sequence of exposures shows the sun in the sky for all 24 hours of the day and night.

HENRY LESTER: *Blooming Rose*, 1943

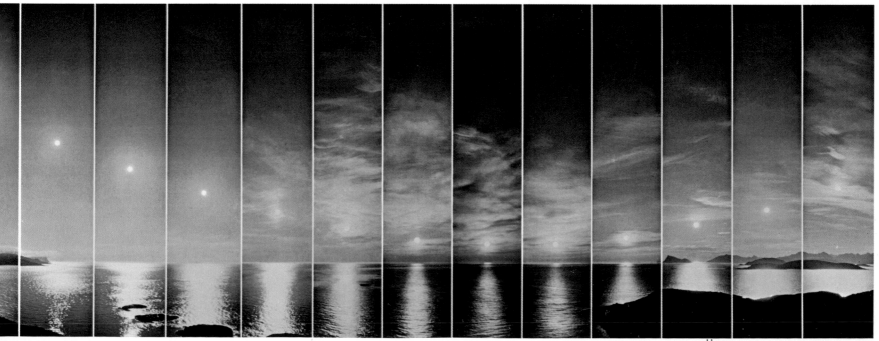

EMIL SCHULTHESS and EMIL SPÜHLER: *A Day of Never-setting Sun*, 1950

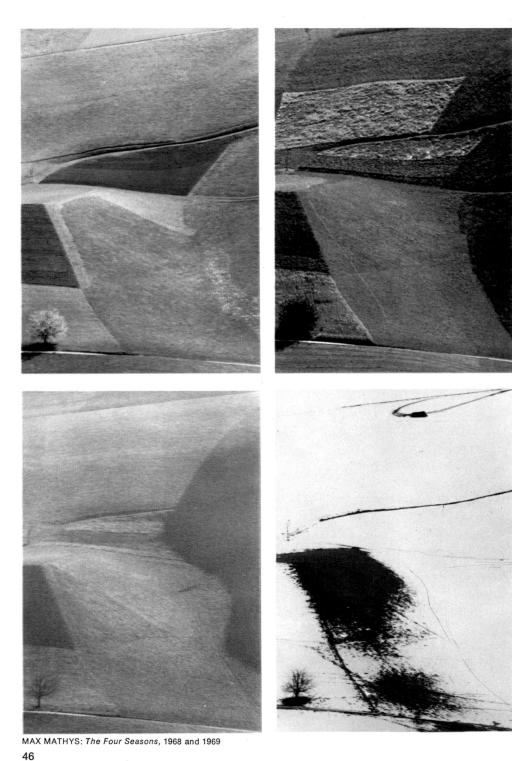

A portrait of the four seasons is revealed
in these long-scale time-lapse photographs of a
field in the Emmenthal Valley of Switzerland.
The photograph at top left was made in April, at
top right in August, at bottom left in October and
at bottom right in February. In each case the
camera was placed at precisely the same point
(note the tree in the bottom left corner of
each picture), at the same time of day—about
two o'clock in the afternoon—and, with the
exception of the October picture, shot at
1/60 second at f/18, at the same exposure, 1/125
second at f/11. By its manipulation of time,
the camera made visible at a single glance the
slow sweep of a whole year in nature.

MAX MATHYS: *The Four Seasons*, 1968 and 1969

Pictures Bigger than Life 2

ERWIN MÜLLER: *Field Ion Photomicrograph of Iridium Crystal,* 1969; magnified 350,000X, here enlarged to 2,250,000 times actual size

Photographing the Very Small

Photography gives microscopes a memory. It is the indispensable tool that enables scientists to make lasting records of the all-too-brief glimpses they get of the infinitesimal world before the microscope's lens. For the photographer, magnified pictures of this world of the very small offer subjects full of surprise and beauty. Photographs of ordinary objects can reveal unsuspected designs, shapes and colors: the symmetry of tiny flower buds like those shown on pages 52-53; the complexities of a sliver of wood *(page 68);* the iridescent hues in the head of a dragonfly *(page 83).* The methods can be simple *(pages 58-59 and 68-71)* and require only a moderate investment in special equipment.

To the scientist using elaborate microscopes and cameras such magnified pictures serve a utilitarian purpose (though many of the scientists' photographs are strikingly beautiful as well). The world of the small can be fragile; tiny botanical specimens wither, living cells sandwiched in glass soon die, atoms are so elusive that they must be magnified millions of times to be pictured. Photographs provide a lasting record of these ephemeral phenomena before they disappear. A record is necessary also because such images can generally be seen in the microscope by only one person at a time. To be fully studied and understood, the images must be captured and disseminated among many scientists, teachers and students. Only through photography can accurate records be provided for protracted analysis and study.

Magnified pictures, whether taken by amateurs for pleasure or scientists for study, are of two kinds: photomacrographs and photomicrographs. The boundaries of the two classifications, though they overlap a bit, are determined by the size of the object being photographed, by the kind of equipment needed to take the picture and by the intended purpose of the picture. These terms should not be confused with microphotography, which is the process for making very small pictures *(pages 166-167).*

Photomacrographs *(pages 52-59)* are pictures of moderate enlargement, usually up to 10 to 30 times life size, of small objects that ordinarily would be viewed through a magnifying glass. A camera lens works like a magnifying glass and can be used to provide the same kinds of enlarged views—of the structure of a tiny seashell, for example. And for photomacrographs, the camera lens itself is generally used, aided perhaps by some simple attachments, but not connected to a microscope.

Photomicrographs *(pages 60-77)* are pictures of objects that have been magnified from about 10 times life size up into the millions—objects so small that they must be photographed through a microscope. In making photomicrographs the microscope takes the place of the camera lens, although it is possible in some instances to connect a camera to a microscope and get acceptable pictures without removing the camera lens *(page 71).*

Microscopes used for research photomicrography may be so large and complex that a single one can take up much of a laboratory bench. Some employ unusual methods of manipulating light waves to create magnified views, while others do not work with light waves at all but create their images from beams of electrically charged atoms or atomic particles. Yet among the most interesting photomicrographs are those made with the small easy-to-use optical microscopes familiar to generations of high-school biology students. (Inexpensive versions of this instrument, sold in hobby shops for $25 or less, are somewhat less versatile and precise but quite serviceable for occasional photomicroscopy.)

With most such instruments, the subject can be made to look quite dark against a white background—a bright field view—or it can be made to look bright against a dark background—a dark field view—and reveal completely new aspects of its structure. And if polarized light is used, startling color effects appear, particularly in certain minerals and biological specimens.

Magnified views of these kinds introduce a strange element of confusion. They seldom contain anything that indicates their true size. And photography has the unique and invaluable ability to depict the size of microscopic objects on two different scales of measurement at the same time. The first scale is the original magnification of the object into an image on film. But if a larger picture of the object is wanted, the image can be blown up by making an ordinary darkroom enlargement. This gives the object a secondary measurement: the original magnification remains the same but now the object is depicted proportionately larger. Thus a nylon fiber photographed at a magnification of 100 times (100X in scientific shorthand) and then enlarged photographically 10 more times will be 1,000 times life size.

The ability to record the basic structure of things as they really are is photography's ultimate contribution to the science of microscopy. And it was this ability that led Robert Koch, the great German bacteriologist, to persuade his fellow scientists in the 1870s to forsake artists' drawings in favor of photomicrographs. "Drawings of microscopic objects are very seldom true to nature," said Koch. "They are always more beautiful than the original."

Koch was only half right. What photography has proved is that the original in nature is more beautiful than any microscopist had imagined. □

Magnifying with the Camera Lens

A photomacrograph takes up where an extreme close-up leaves off. As in the seven times life-size view of the buds of a viburnum shrub at right, it makes details big enough to be seen clearly —details that would otherwise have to be viewed through a magnifying glass. But the magnification is still small enough that the subject is seen whole, without having to be cut into paper-thin slices to fit between microscope slides.

To make a photomacrograph, special lenses or lens attachments can be used, or, if the regular camera lens is removable, it will serve. The lens must be extended from the camera body—or more precisely, from the film inside the camera—by means of a tube or bellows. Extending the lens farther from the film has a magnifying effect, just as it would with an ordinary magnifying glass. This happens because the farther away the lens is moved from the film, the more space there is for the image-forming light beam to spread out as it goes from the lens to the film. Tube and bellows lens extensions are available as accessories for most cameras. The bellows permits adjustment of the lens extension to achieve various degrees of magnification; the tubes are rigid and each gives a predetermined degree of magnification, depending on its length, for a particular lens.

The focal length of the lens also plays a part in the magnification. A lens with a short focal length can be focused nearer to the subject, and therefore gives a larger image, than a lens with a longer focal length. (The reverse is true, of course, when the lenses are used in the normal way, without exten-

sions.) Besides a means for extending the lens, there is one other prerequisite for taking photomacrographs: a camera that permits a direct, through-the-lens view of the subject while focusing, that is, either a single-lens reflex or a view camera with a ground-glass focusing screen. A direct view is essential because magnification of a subject reduces the camera's depth of field drastically. Focusing is therefore so critical that it cannot be done by measuring distances and must be checked by viewing the image itself.

The procedure for taking life-size or larger-than-life pictures is much like that in extreme close-up photography. Pictures can be taken outdoors, but more often it is desirable to collect specimens and photograph them later indoors, where focusing, background and lighting can be more easily controlled. However, no elaborate studio is needed. All of the photomacrographs on these and the following pages were made by a New York photographer, Ralph Weiss, in his apartment. (For instructions on do-it-yourself photomacrography, see pages 58-59.) Weiss collected the specimens in a nearby park and on trips to the country, and for the first three pictures *(pages 53-55),* used a vintage 4 x 5 Graflex studio view camera with a 6½-inch f/6.8 lens (a separate bellows attachment was not needed). The pictures of Queen Anne's lace *(page 56)* and kohlrabi *(page 57)* were taken on a smaller film size, 35mm, using an Exacta single-lens reflex camera with a 55mm f/1.9 lens, extended by a bellows for the Queen Anne's lace, a tube for the kohlrabi.

RALPH WEISS: *Maple Leaf Viburnum*, 1968; magnified 1.3X, here enlarged to 7X

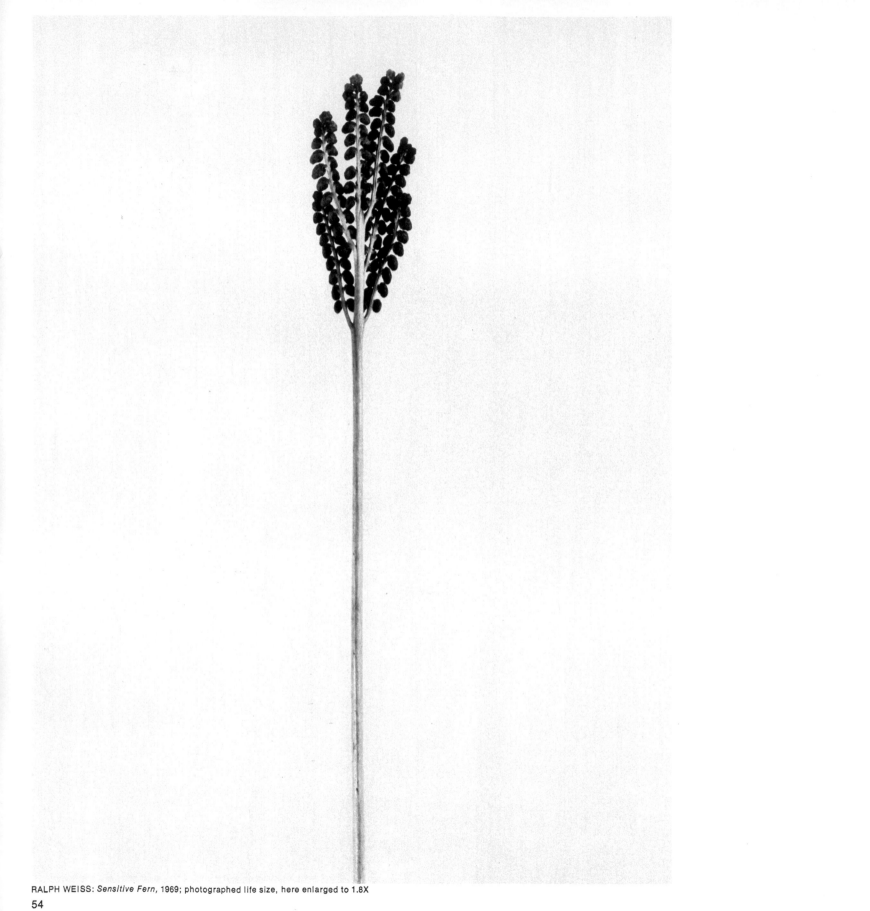

RALPH WEISS: *Sensitive Fern,* 1969; photographed life size, here enlarged to 1.8X

RALPH WEISS: *Jimson Weed Seed Pod*, 1968; photographed life size, here enlarged to 3.5X

RALPH WEISS: *Queen Anne's Lace,* 1966; magnified 1.2X, here enlarged to 11.2X

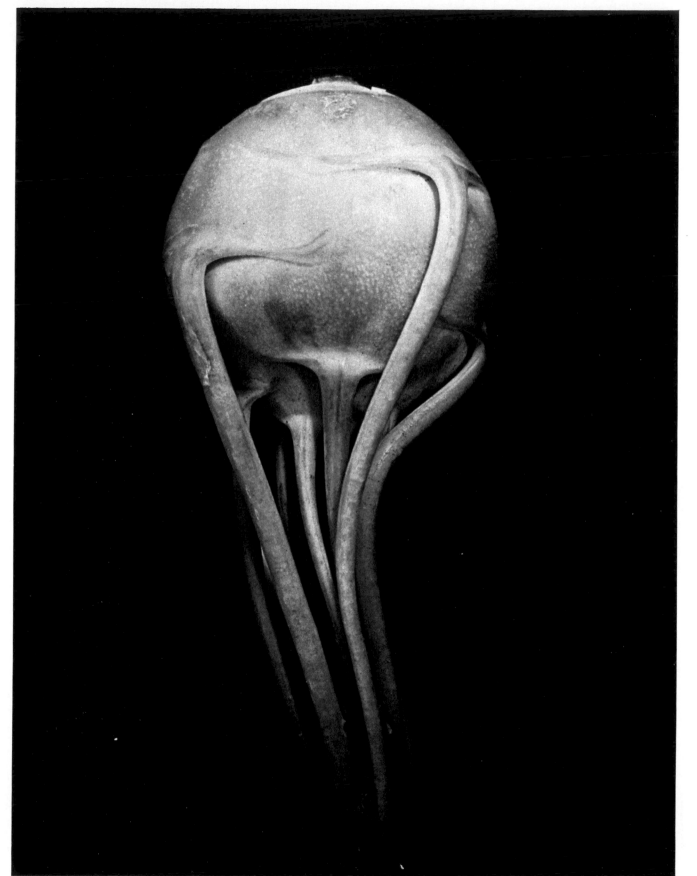

RALPH WEISS: *Kohlrabi*, 1966; magnified .6X, here enlarged to 3.4X

How to Take Larger-than-Life-Size Pictures

Shooting larger-than-life photographs of such things as fruit flies is an everyday assignment for the laboratory headed by Lewis W. Koster, at The Rockefeller University, the outstanding research institution in New York City. But gear similar to that used for his unusual pictures can readily be duplicated by an amateur in his own home, as Koster demonstrates on these pages.

The only camera accessory needed is a long cable release and a bellows that extends the lens to magnify the specimen being photographed. The bellows is attached to the camera (here a Nikon F 35mm single-lens reflex). The camera's regular 50mm lens is then attached to the bellows. This bellows and lens combination can give a magnification up to 3.8 times actual size, depending on how far the bellows is extended. For magnifications above four or five times life size, special "macro" lenses should be used, since with a regular camera lens image quality will deteriorate at increased lens-to-film distances. An arrangement similar to that shown here for 35mm cameras is also used with larger, view-type portable or studio cameras that have built-in bellows.

To hold the specimen for proper lighting, Koster suggests a piece of nonreflecting glass—the kind sometimes used in picture frames and obtainable at a glazier's. The glass is supported at the corners by blocks of wood. The reason for raising the glass in this manner is to separate the specimen from the background—which shows through the glass—so that the background appears out of focus, smooth and evenly lighted, unmarked by shadows from the specimen. A piece of cloth, cardboard or other nonreflecting material, spread flat underneath the glass, serves well. Use light material for a dark specimen (and vice versa) to provide contrast.

In this setup, in which the specimen is opaque, two light sources are used. A photoflood is directed below the platform to light the background evenly. Adjust the brightness of the illumination to achieve the background contrast desired. Above the platform a small, bright, clear (unfrosted) bulb lights the specimen. An ordinary desk-type high-intensity lamp, as shown in the pictures at right, is ideal. If the specimen were semitransparent, such as a leaf with an interesting vein structure, all of the lighting could be directed on the background so that it would bounce off and then be reflected upward through the specimen.

Once the platform and lighting have been prepared, the camera is mounted on a sturdy tripod that is equipped with a short extension arm (such as the ball-and-socket accessory shown) so that the camera can be tilted down directly over the specimen. The picture is then composed and focused in the viewfinder of the SLR (or in the ground glass, if a view camera is used). The exposure time is calculated by taking a light-meter reading as close as possible to the specimen. The incident type of light meter shown is best. However, an allowance must be made for the extension of the lens, which radically decreases the amount of light reaching the film. A rule of thumb is to increase the exposure four times (two f-stops) for a life-size picture. But it is necessary to bracket widely, making a series of exposures above and below the calculated reading for good results. □

1 | *After removing the camera's lens, mount the bellows on the tripod. Fit the camera to the back of the bellows, the lens to the front. Sometimes the camera itself goes on the tripod.*

2 | *On cardboard or cloth background material, erect four supports (about eight inches high) and on top of these place a piece of nonreflecting glass. Tilt the camera over the platform.*

3 | *Looking through the viewfinder, compose the picture by pushing the specimen (here a bit of juniper) under the lens with a probe. Focus with the bellows adjustment knob.*

4 | *Light the specimen from one side with a small, clear bulb, positioning a bit of cardboard opposite it to reflect light into shadows. Then light the background evenly with a flood.*

5 | *Swing the camera aside and take a light reading just above the specimen. Figure the exposure and further adjust this exposure to allow for the bellows extension (see text).*

6 | *Swing the camera back and fine-focus with the bellows adjustment knob. Set the aperture and press the cable release. The payoff of this demonstration is the picture at right.*

Juniper, 1970; photographed life size, here enlarged to 7X

Photographs through the Microscope

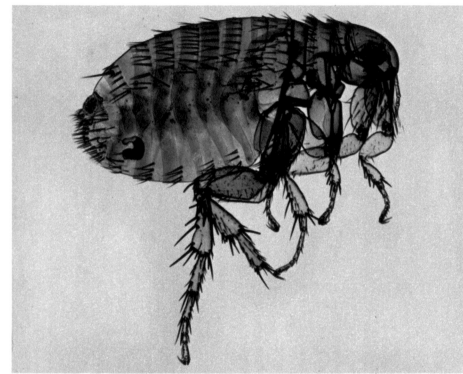

LEWIS W. KOSTER: *Egyptian Rat Flea,* 1967; magnified 27X, here enlarged to 55X

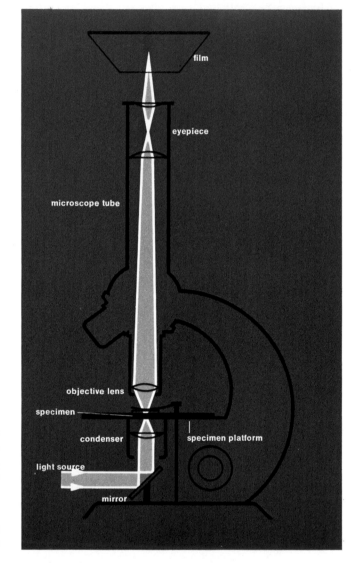

film

eyepiece

microscope tube

objective lens

specimen

condenser

specimen platform

light source

mirror

Beyond the reach of the extension tubes and special lenses that enable a camera to make pictures several times life size is a whole world of startling images too small to be evident to the human eye—but easily reached by connecting the camera to a microscope. This may be done either with the lens left on the camera, or by taking it off and slipping the camera over an attachment on a standard light microscope (other, more complex instruments may not use light at all). The clarity and detail of the result depend largely on how the specimen being photographed is illuminated—and lighting for photomicrography is a world of its own. Different systems can be used to control the direction and quality of the light, de-pending on the specimen being viewed.

The most common system, illustrated on this and the opposite page, is bright-field illumination. With it, the subject is fully illuminated by direct beams of light that flood the specimen over the entire field of view.

The direction from which the light is aimed varies with the specimen. For specimens that are semitransparent, such as the insect shown above, the light is aimed upward and transmitted through the specimen *(diagram, right).* For specimens that are not transparent, such as metals, it is necessary to direct the light downward *(diagram and pic-ture, opposite).* Such "incident" light is then reflected back to the microscope objective lens to create the image.

To photograph a specimen with the use of bright-field transmitted light, the light is directed into an angled mirror that is attached to the bottom of the microscope. This mirror deflects the light beam upward into a condenser lens. The condenser concentrates the beam and sends it through the specimen. Rays of light from all parts of the specimen now travel upward into the objective lens, which focuses the rays into a magnified image of the specimen within the microscope's eyepiece. The upper element of the eyepiece magnifies this image once again and transmits it to the film in the camera.

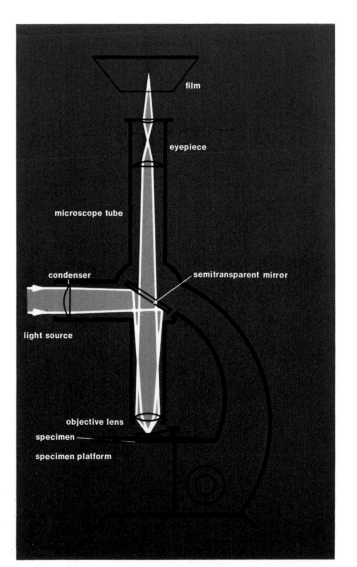

film

eyepiece

microscope tube

condenser

semitransparent mirror

light source

objective lens

specimen

specimen platform

EUGENE S. ROBINSON: *Annealed and Etched Brass,* 1970; magnified 61.5X, here enlarged to 135X

To illuminate a specimen with bright-field incident light, the light beam goes through a condenser lens to a semitransparent mirror inside the microscope tube. The mirror deflects the light down to the specimen. Rays of light, reflected up from the specimen into the objective lens, are focused and sent on to the eyepiece and to the film in the same way as transmitted light. The size of the image recorded on the film, in both cases, is determined by the lenses used and by the distance between film and eyepiece: the greater this distance, the larger the image.

Details on a Dark Background

LEWIS W. KOSTER: *Egyptian Rat Flea*, 1967; magnified 27X, here enlarged to 55X

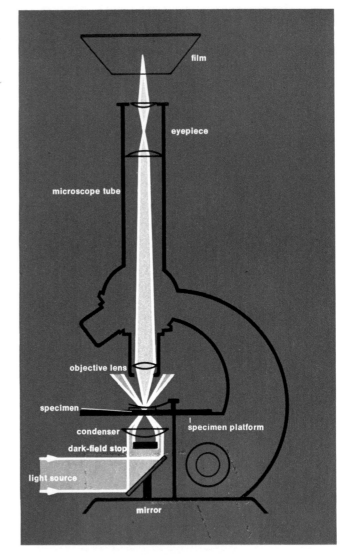

To illuminate a specimen with dark-field transmitted light, an opaque disk called a dark-field stop is placed in the path of the light beam just before it reaches the condenser lens. The stop prevents light from going through the center of the condenser, permitting only a cone of light to pass obliquely through the edges of the condenser lens. This portion of the light continues in an oblique path, missing the microscope's objective lens. Only those rays that bounce off features within the specimen itself and are deflected from their oblique path can be sent upward into the objective lens of the microscope to form the photographic image.

In photographs of many microscopic subjects, certain kinds of details can be emphasized and others defined more clearly if the specimen is not illuminated with a head-on beam of light but instead with oblique, glancing rays. Only the light that is sent back to the objective lens by the specimen itself forms the image. Everything around it looks dark; therefore, this system of lighting is called dark-field illumination.

As with bright-field photomicrography *(pages 60-61)*, the light can come from in front of or behind the specimen, so that both opaque and transparent objects can be photographed. The pictures above, for example, show the insect and piece of metal that were previously photographed in bright-field.

But now they are seen in altogether different aspects. The nearly transparent insect shows up only in outline form, but its shape is more clearly profiled and the minute hairs on its surface are more visible because they catch the glancing rays of light produced by dark-field illumination. In the picture of annealed brass *(opposite)*, regions that have different physical characteristics are seen in bold contrast because each reflects light differently.

Beyond its great scientific usefulness, dark-field illumination—with its dramatic emphasis on the extremes of highlight and shadow—offers excellent opportunities for adding esthetic value to photomicrographs, as these pictures amply demonstrate.

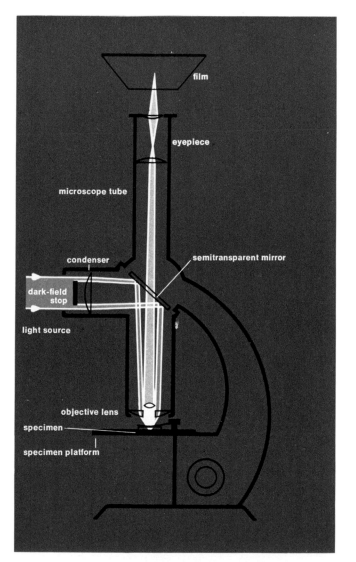

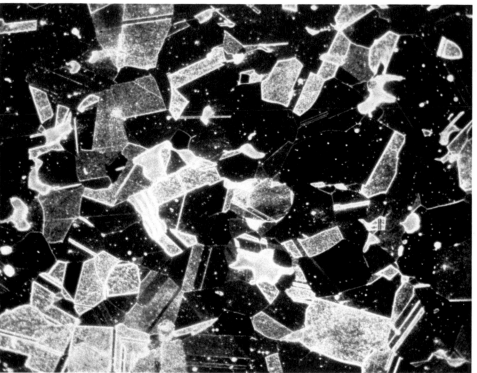

EUGENE S. ROBINSON: *Annealed and Etched Brass,* 1970; magnified 61.5X, here enlarged to 135X

*For dark-field incident light, an angled mirror that
is partially transparent is placed inside the
microscope tube opposite the light source. A
dark-field stop is placed in the path of the beam
before the rays get to the condenser and
mirror; this enables light to be reflected
downward toward the subject only from the edges
of the mirror. This light is angled by the mirror so
that it passes around the objective lens but goes
through the ring-shaped condenser to reach the
specimen. Some of the light rays bounce up
from the specimen, pass through the objective
lens and the center of the semitransparent mirror,
and finally enter the eyepiece to form the image.*

Filters That Create Color

Some of the most spectacular photographs taken through a microscope —and many of the most useful—are obtained by taking color pictures with polarized light. With this kind of illumination a specimen that has little color to start with can be made to exhibit many different shades and hues. This effect is demonstrated in the series of photographs *(opposite)* that LIFE photographer Fritz Goro made of a single moon rock, its colors changing from picture to picture to show structural details clearly. The polarized-light technique is also able to reveal the physical properties and composition of many objects, since these characteristics influence the manner in which the objects react to polarized light.

Polarized light is produced by putting special filters, both of polarizing material but called the polarizer and the analyzer, in the path of the microscope's light beam *(diagram, right)*. When rays of ordinary light, undulating in all directions, hit the polarizer, only those rays that are undulating in one particular plane pass through. These rays alone then go through the specimen, and if the specimen has polarizing properties, the ray is divided into two components, which travel at different speeds. These rays continue up the microscope, each traveling at a different angle, to the analyzer. Because one of the components traveled slightly slower within the specimen, it arrives at the

analyzer behind the other component. As a result, the two components interact, canceling some of the wavelengths —colors—and reinforcing some others to create the hues that are seen.

Entirely new colors may be obtained, as Goro did with the moon rock, by moving the analyzer around until it passes rays that have traveled at a different angle and interacted differently to produce still another combination of wavelengths. (The light could be transmitted through the rock because the specimen had already been sliced to a thickness of about 1/1000 inch for microscopic examination.)

Stronger and more brilliant colors can be obtained if a third optical element, called a retardation plate, is placed in the microscope between the objective lens and the analyzer. Its function is simply to slow the rays down more than the specimen alone would.

Microscopes with built-in polarizing components are expensive, but polarized color photomicrographs can be made by modifying any microscope, such as the ones shown on pages 70-71. All that is needed are two small pieces of polarizing material, which can be obtained at most photographic supply stores. Attach one piece of the material below the condenser, in the position shown in the diagram. Then remove the eyepiece and attach the other piece of polarizer to the bottom of the lower lens of the eyepiece.

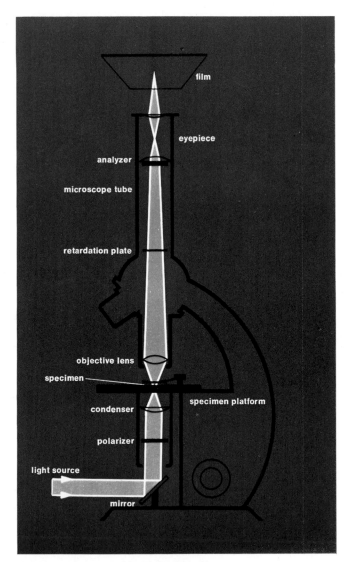

To produce polarized light for brilliant color pictures with a microscope, a polarizer—a polarizing filter—is placed in the light beam below the condenser. The polarizer permits only rays that are undulating in a single plane to pass. These go through the condenser where they are concentrated and sent on through the specimen. The specimen itself alters the polarized beam and sends it up through the objective lens. The beam then passes through a retardation plate, which slows it down and enhances the color-creating process, and then through the analyzer that produces the colors seen in the image and recorded on film.

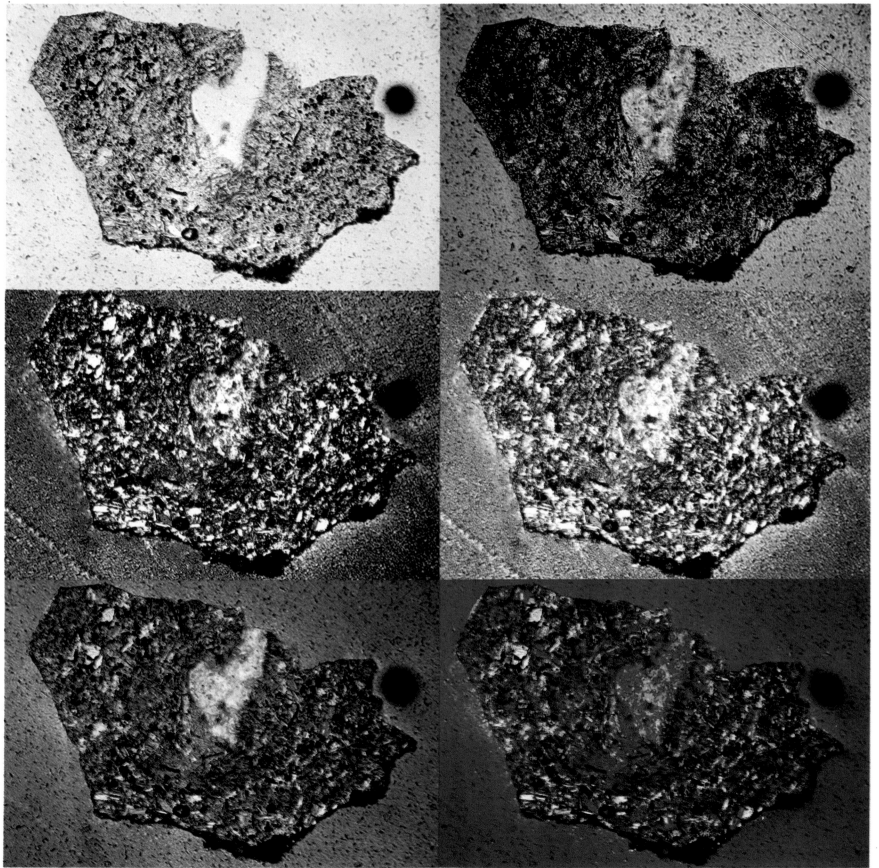

FRITZ GORO: *Polarized Pictures of Moon Rock*, 1969; magnified 16X, here enlarged to 50X

Prisms That Add Contrast

The complex instrument diagramed at right has an equally complex name—the Nomarski differential interference-contrast microscope (it was invented by the French optical expert G. Nomarski)—but it gives detail and form to specimens that would in most cases show up in photographs as vague and hazy. It does this by greatly increasing the contrast of things that have virtually none to begin with, making their features clear and often adding a three-dimensional effect. For example, the two planktonic fossils that are shown in Fritz Goro's pictures opposite are extremely thin and normally almost transparent. With the special lighting this microscope produces, the edges and internal structures of the specimens are transformed into what appear to be bas-reliefs, bringing out characteristics that could not be recorded with conventional instruments.

The Nomarski microscope has an optical system that is as complicated as its name. The way it works is fairly easy to follow, however. A beam of polarized light is sent through a double prism that splits the beam into two beams, altering their polarizations so that each is now polarized differently. These are then sent through the specimen, which makes some rays in each beam travel slower than equivalent rays in the other beam. After entering the objective lens of the microscope, the two beams are drawn together by the second double prism and the rays that had traveled at different speeds interact to give the image of the specimen more shadows and depth. Since the slowing effects depend on wavelength, the interaction of the waves emphasizes some colors, and this is made apparent by the second double prism and a second polarizing filter called the analyzer.

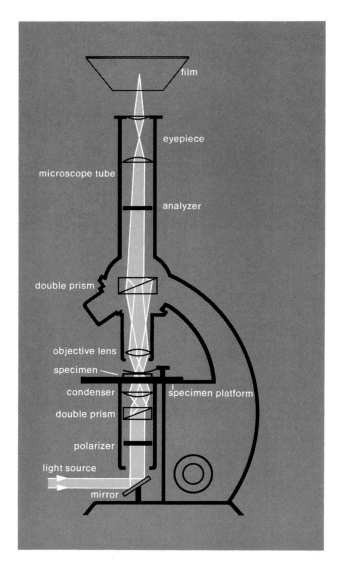

To illuminate a specimen for photography with the Nomarski interference-contrast microscope, light is directed from the side of the microscope to an angled mirror that sends the beam through a polarizer and a double prism. The prism splits the beam in two, each now of different polarization. These beams then pass through the condenser, which alters their paths so that their light rays become parallel and pass through the specimen side by side. The rays in each beam continue upward into the microscope's objective lens and pass through another double prism that draws them together again and, with the aid of the analyzer, reveals the colors.

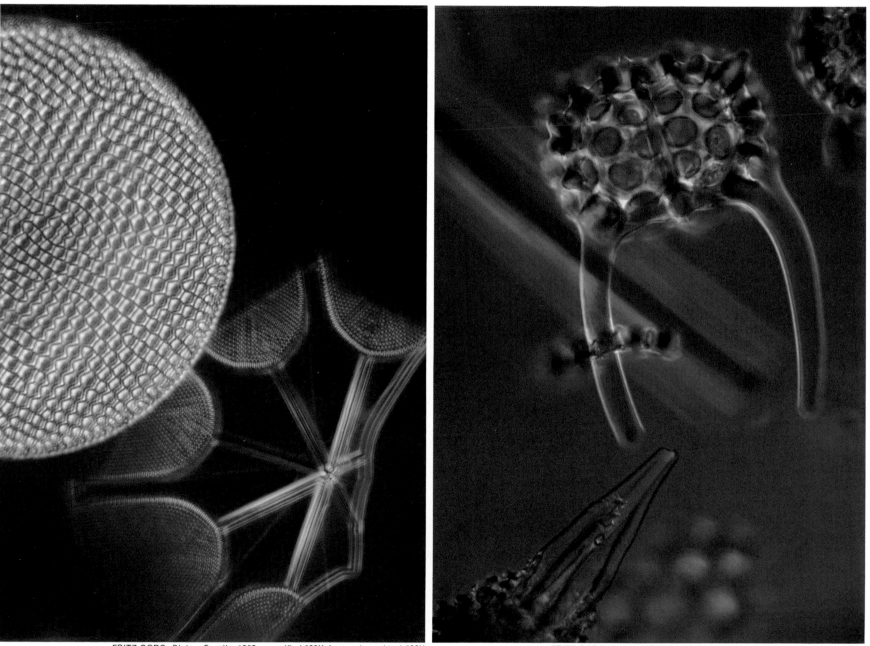

FRITZ GORO: *Diatom Fossils*, 1969; magnified 300X, here enlarged to 1,500X

FRITZ GORO: *Protozoa Fossils*, 1969; magnified 100X, here enlarged to 500X

The Amateur's Photomicrographs

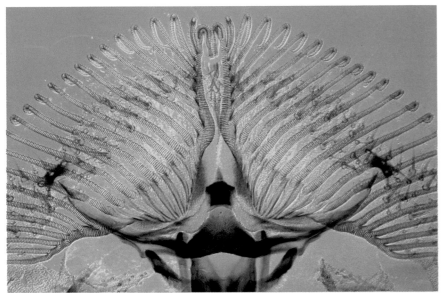

Mouth of Blowfly, 1967; magnified 25X, here enlarged to 80X

Oak Wood, 1969; magnified 50X, here enlarged to 160X

The picture-taking opportunities afforded by photomicrography are not limited to those few photographers having access to complicated instruments. The beautiful pictures on these pages were taken with quite inexpensive equipment *(page 71)* by Mortimer Abramowitz, a Great Neck, New York, school superintendent. Abramowitz got started when he was an elementary school principal; one day after classes, he attached his 35mm camera to a modestly priced microscope given to the school.

Abramowitz suggests starting with ordinary objects picked up around the house. That is how he got all those shown here except for the blowfly specimen at top left, which he bought from a scientific mail-order catalogue for $1.50. Homemade specimens are easily prepared on microscope glass slides. Dry objects like bits of wood *(lower left)* are shaved thin with a razor blade and placed in a drop of water between the slides. Liquid specimens need only to be pressed between glass; a drop can be photographed without covering.

To start with, Abramowitz recommends using black-and-white film and switching to color when the photographer is familiar with focusing the microscope and figuring exposure times. Eventually, to achieve striking colors like those shown here, polarizing filters can be used *(see pages 64-65).*

Abramowitz has found a satisfying reception for his pictures among his pupils (who wrote poems about them), neighbors, fellow photographers—and even in the commercial world. The picture on page 70 was sold to a fabrics manufacturer who wove the design into wool and silk. Mrs. Abramowitz now has a coat made of the material.

Beach Grass, 1969; magnified 50X, here enlarged to 160X

Houseplant Fertilizer, 1969; magnified 50X, here enlarged to 160X

Menthol Crystals, 1966; magnified 50X, here enlarged to 160X

DDT Powder, 1970; magnified 50X, here enlarged to 160X

How to Attach a Camera to a Microscope

Crystals of Salol Compound, 1967; magnified 50X, here enlarged to 320X

With one exception, Mortimer Abramowitz took all of his photomicrographs *(pages 68-69 and opposite)* with the good—though by no means elaborate—camera and microscope setup at far right. The exception is the picture of beach grass at top left on page 69, which was made with the inexpensive camera and microscope at near right. Abramowitz took it to demonstrate that good photomicrographs can be made with even the simplest equipment if the photographer exercises care in focusing and lighting.

The big difference in the two rigs, beyond their optical qualities, is that the inexpensive camera has a nonremovable, fixed-focus lens, while the other camera's lens is removable. Given a choice, it is better to use a camera without its lens, since the lens plays no part in taking a photomicrograph; magnification and focusing are done with the microscope alone. A fixed-lens camera has two inherent drawbacks: its lens may cause reflections or distortions in the image if the camera is not mounted exactly right, and the camera must be taken off the microscope each time a new image is focused.

Focusing is easiest with a single-lens-reflex camera or a view camera that gives the photographer a direct view of the microscope image. Other cameras that do not permit through-the-lens viewing can be used, however, with an accessory called a beam-splitter. This is a device that fits between the camera and the microscope and divides the image-forming beam so that part of it goes through an auxiliary eyepiece to permit viewing and focusing and the other part goes along its regular path to take the picture.

A $17 fixed-lens camera, a $15 microscope of the type used in elementary schools, and a $2 light-tight collar for coupling the two together constitute the improvised but perfectly workable photomicrographic rig shown above. To get a sharp picture, the microscope is focused first, and then the camera is attached, with the collar, at a predetermined distance above the microscope eyepiece. This distance is found by shining light through the microscope—from below in the usual way—onto a piece of paper held above the eyepiece. The paper is moved up and down to locate the precise distance from the eyepiece at which the light beam forms the smallest spot on the paper. If the camera is then attached with the light-tight collar (which is adjustable) so that the front of the camera lens is at this same distance from the eyepiece, the picture will be in focus.

The setup used by Mortimer Abramowitz for most of his photomicrography (above) consists of a Miranda 35mm single-lens-reflex camera, a Zeiss microscope (a 1905 model he bought second-hand) and a $12 light-tight adapter collar. One end of the collar fits into the camera in place of its lens, which is not needed. The other end of the collar fits over the microscope eyepiece and attaches to the microscope tube. Since both the camera and the microscope now share the same lens system, focusing on the microscope specimen is done through the camera viewfinder. When the visual image is in focus, the image on the film will be also.

Pictures Made by Electrons

JOHN SMART: *Paper Fibers*, 1969

PETER J. HYDE: *Nylon Fibers*, 1966

Greatly enlarged pictures that show three-dimensional objects in much the same way that ordinary photographs show them can be made with a microscope that does not use light rays but generates visible images from beams of electrons. Called the scanning electron microscope (SEM), it has an exceedingly wide magnifying range, from 20 times to 140,000 times life size, and is particularly useful for the investigation of such things as insects *(opposite)*, fibers *(above)* and bacteria.

This electronic device works on the same general principles as an optical microscope, except for its use of electrons. A "gun" at the top of the SEM fires a fine stream of electrons down through the microscope. The stream is focused toward the specimen by pow-

erful magnets that act as lenses do in optical microscopes (and they are actually called lenses). A scanning device then causes the electrons to bombard each part of the specimen's surface. This causes other electrons that are already in the specimen to be released. They are then amplified and displayed on a phosphorescent screen to form the magnified image. To record the image a camera is used to photograph the viewing screen, or a special screen provided for photography.

The SEM is a special-purpose version of the older "transmission" electron microscope, which works by sending electrons through a specimen rather than bouncing them off its surface. It gives higher magnifications but not the amazing perspective of the SEM.

Strange shapes and convolutions that are taken by different fibers are revealed by the scanning electron microscope in the pictures above. The photomicrograph at left, above, was taken of an ordinary piece of bond paper, showing the cotton and wood fibers magnified 220 times, then enlarged photographically to 1,200 times life size. In the right-hand picture are smooth fibers of a nylon stocking, magnified 220 times and further enlarged to 900 times life size.

Pictured in the lifelike perspective attainable ▶ only with the scanning electron microscope, the head of an ant is shown magnified 50 times and further enlarged photographically to 160 times actual size. The relatively low original magnification increased the depth of field as well as permitting a larger portion of the insect to be included in the photograph.

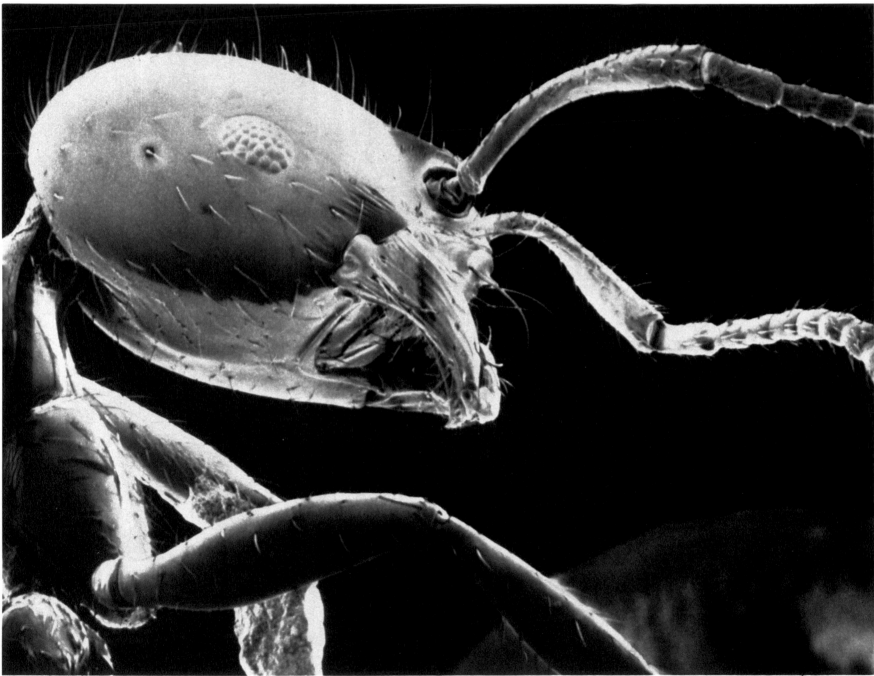

LLOYD M. BEIDLER: *Head of Red House Ant*, 1969

PASQUALE P. GRAZIADEI: *Taste Buds of Guppy,* 1968

Taste buds of a tiny fish, set among its scales,
were magnified 2,000 times by a scanning
electron microscope, then enlarged to 4,000 times.

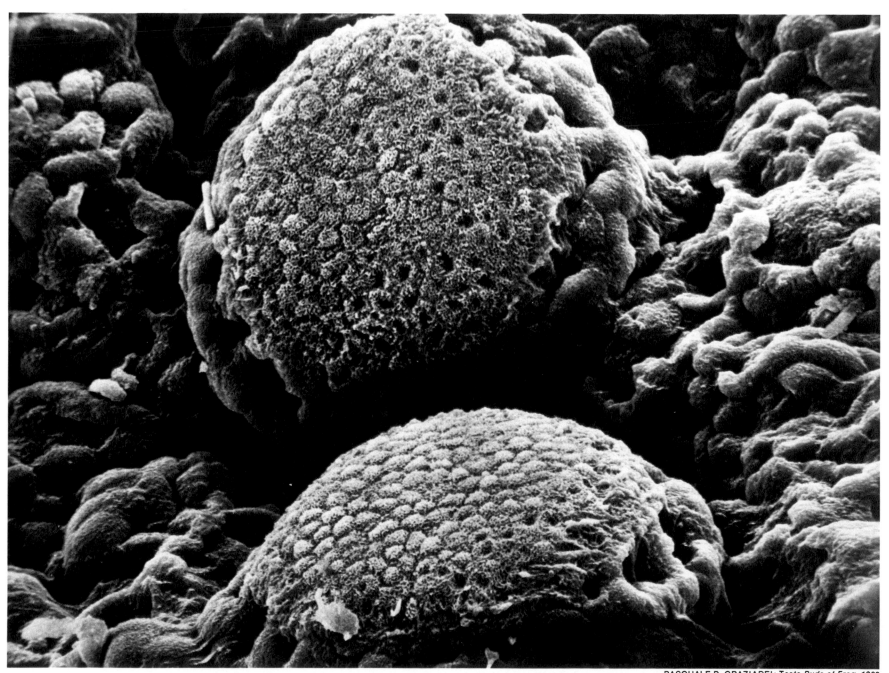

PASQUALE P. GRAZIADEI: *Taste Buds of Frog,* 1968

Taste buds of a frog, two bumps on its tongue,
were magnified 500 times by an SEM and further
enlarged photographically to 1,300 times life size.

Pictures Made by Ions and X-rays

Nobody has ever seen an atom and no one ever can—light waves, unimaginably fine as they are, are too crude to pick one out for vision. But photographs can reveal images made by atoms, with the help of special instruments that do not use light, but X-rays and beams of the electrically charged atoms called ions.

The picture at right was made with a field ion microscope, which first provided a direct view of atoms. The specimen being studied, the tip of a platinum needle in this instance, is placed in an evacuated chamber and the chamber is filled with gas. When a high voltage is applied to the platinum tip, atoms of the platinum push ions of the gas against a fluorescent screen. The screen lights up when struck by the ions, revealing images of the platinum atoms that pushed the ions. These images are caught with a camera built by the microscope's inventor, Professor Erwin Müller of The Pennsylvania State University. Starting with a 35mm camera body that cost $16, Müller modified it to take a special $1,600, f/.87 lens.

Photographs that reveal the atomic structure of crystals, like the picture opposite, are made by directing X-ray beams through the crystals onto film —no lens is needed. The X-rays' paths are affected by the latticelike arrangement of the crystal's atoms, creating a pattern on film from which the design of the structure can be figured. ☐

A field ion microscope picture records the actual locations of individual platinum atoms (right), arranged in clusters within the ringlike facets of one crystal of the metal. The atoms —the tiny white dots—were magnified 120,000 times on the negative and here are further enlarged to 500,000 times life size.

ERWIN MÜLLER: *Platinum Single Crystal Hemisphere*, 1965

An X-ray diffraction photograph of a crystal of
beryl (right) reveals the symmetry of the crystal.
The black spots in such a picture are not
atoms, but a pattern created by the atoms in the
crystal. Since the pattern depends on the
arrangement of the atoms in the crystal, analysis
of various X-ray diffraction pictures
indicates the atomic structure of the crystals.

MAURICE VAN HORN: *Beryl Crystal,* 1957

77

The Small World of Manfred Kage

Manfred Kage *(right)* is Europe's most prolific photographer of the Lilliputian world. He never, by his own account, photographs anything bigger than a hen's egg and most of his subjects, as the following portfolio shows, are a good deal smaller, requiring a microscope (photomicrography) as well as extended lenses (photomacrography).

Though many of Kage's pictures look like the by-products of scientific projects, they are taken with esthetics, not technical recording, in mind. Most are commissioned by industrial firms engaged in basic research, which accounts for the scientific subject matter; but the firms use the pictures to advertise their products rather than to illustrate technical reports, and they give Kage a free hand to "interpret" the subjects as he sees fit. All this work was done in two houses in the small German town of Winnenden, not far from Stuttgart, which Kage converted into home, workshop and lab—plus his own small discothèque for trying out, on the neighbors, gadgets of his own design that "show" music as well as play it.

A skilled optical craftsman, Kage builds much of the special equipment he needs for magnification, photography and for optical effects like the kaleidoscopic pictures on pages 204-207. Because he is forever modifying commercially made lenses for his special needs, his visits to the optical workrooms of Leitz and Zeiss are greeted with mock dismay: "Here comes *Der Kage,* the man who takes our lenses apart." But the staid firms pay Kage the ultimate compliment of using his pictures themselves to show the miracles that fine lenses can perform—whether theirs or his, it does not matter. □

Taking a photomicrograph, Manfred Kage uses a 5 x 7-inch camera of his own design that is attached by a bellows to a laboratory microscope. Because the bellows is extended so far to produce a larger image on the film, Kage fine-focuses the microscope with his big toe while observing the image in the ground glass. At bottom center is a voltage regulator that prevents variations in the electric current from causing changes in the microscope illumination. At the left are lenses and extension bellows for making photomacrographs.

MANFRED KAGE: *Watch*, 1969; magnified 3.2X, here enlarged to 7.2X

Orchid, 1968; magnified 3X, here enlarged to 3.6X

"Lady's Slipper" Wild Orchid, 1968; magnified 8X, here enlarged to 9.7X

Cross Section of Prostate Gland, 1967; magnified 250X, here enlarged to 321X

Head of Dragonfly, 1969; magnified 40X, here enlarged to 51X

Ketone Crystal, 1968; magnified 21X, here enlarged to 40X

*Vitamin B*₁₂ 1968; magnified 120X, here enlarged to 154X

Vitamin B₆ 1968; magnified 120X, here enlarged to 154X

Vitamin B₁ 1968; magnified 120X, here enlarged to 154X

The Distant Made Near 3

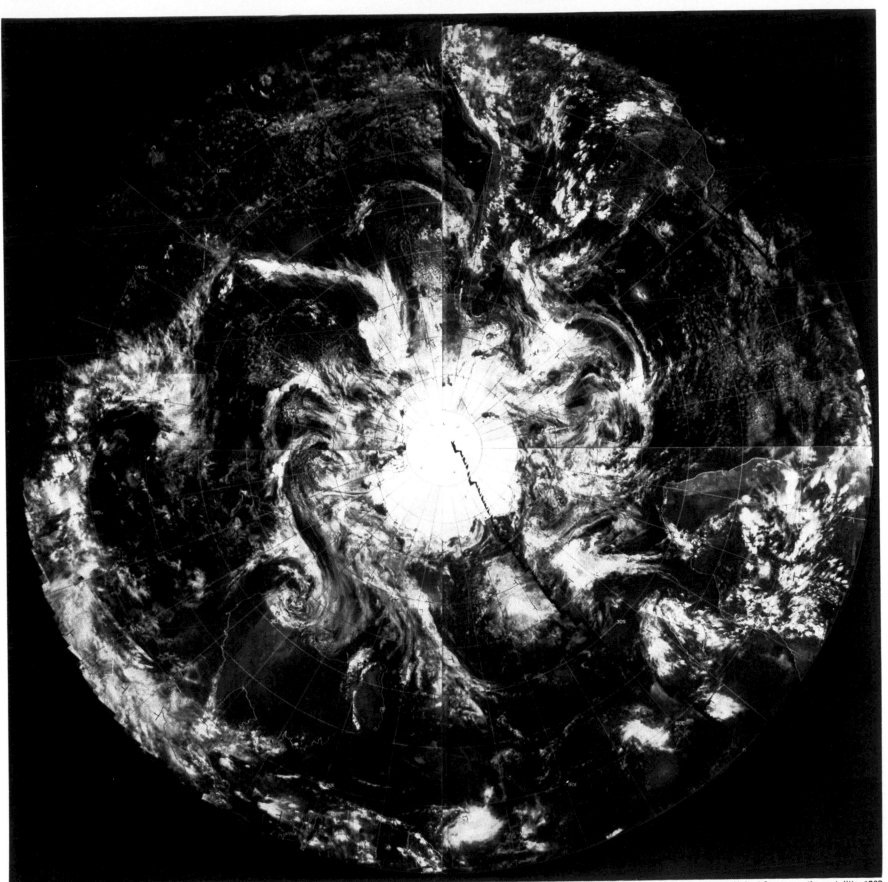

Southern Hemisphere of the earth photographed from a United States weather satellite, 1969

A View of Other Worlds

In outer space, from high inside the earth's envelope of air and under water, photography has given man fresh facts, insights and scenes. Cameras have enabled him to see in outer space celestial bodies he was completely unaware of. They have brought views of the earth from the air that are both helpful in a thousand practical ways and pleasing esthetically. They have allayed the fears and superstitions that traditionally lurked in tales of the sea by showing that mysterious world to be an animated, curiously appealing kingdom of weird creatures and colorful forms. Wherever earth-bound, air-breathing man cannot naturally go, photography has given him a better appreciation of the complexities not only of his own planet, but the entire universe. It is a fresh view that is open to amateurs as well as professionals. Even with relatively simple equipment, good aerial, undersea and astronomical photographs can be made.

Astronomers had with uncanny accuracy charted most of the planets and many stars using their own eyes aided by telescopes. But the introduction of the camera revealed entirely new categories of celestial bodies. Combined with the telescope, it recorded objects and details much dimmer than could be seen with the eye. This not only extended astronomers' grasp farther into the universe, making possible the study of stars at incomprehensible distances, but revealed new information about relatively close objects. Cameras were the cartographers of the moon's surface. Pictures from rocket probes gave such detailed views of the moon that scientists sitting in laboratories on earth could decide just exactly where the first space craft should land. Conversely, pictures of the earth taken by the astronauts showed with clarity that it is a refreshingly beautiful oasis in the black void of space.

The earth takes on added grandeur from on high, but the pictures serve as more than scenic views. Aerial photographs have scores of practical applications. Ranchers use them to count their livestock without bothering with a roundup. Geographers map unexplored territory from them, and city planners plot redevelopment by studying overhead views of urban areas. Geologists study aerial photographs to spot the hidden faults in earth structure that often provide clues to oil deposits. Sand bars unseen from the ground can be picked up from the air, a river's course can be studied, the behavior of wild animals analyzed and real estate taxes apportioned.

Sources of water pollution can be easily pinpointed by aerial photography, while water resources can be estimated through pictures of snow fields. Archeologists are so dependent on information furnished by aerial views that one famous scientist, the Englishman J. P. Williams-Freeman said, "one ought to be a bird in order to be a field archeologist." Lost cities have been rediscovered and mysterious artifacts from vanished cultures have been spotted by archeologists using aerial photography.

The fate of nations can even rest on it. Aerial photographs taken over Cuba by an American U-2 reconnaissance plane in October 1962 revealed the presence of Russian-made missiles and precipitated the "Cuban missile crisis." War was averted when the Russians acceded to the American demands and withdrew the missiles. But aerial photographs of the Russian freighters that carried the missiles away were taken almost continuously just to be sure that the ships did not turn around in mid-ocean and return their lethal cargo to Cuba.

While much of aerial photography is the province of professionals—specialized ones at that—this is not true of photography in the strange and alluring world beneath the seas. The rapid development of underwater cameras and equipment since World War II has made the seas a new adventureland for thousands of fascinated photographers. Scenes once reserved for intrepid deep-sea divers are now the highlights of many a home slide show. Diving today is simple enough to be enjoyed by entire families, many of them carrying their own cameras.

Pictures have helped lure people into diving in much the same way that elaborate drawings of the New World's bounty were sent back by explorers to titillate settlers into following them. But photography has shown the tragedies of undersea life too. It was through deep-sea photography that the wreckage of the United States nuclear submarine *Thresher* was discovered 8,000 feet down on the floor of the North Atlantic 220 miles east of Boston. The *Thresher* had disappeared April 10, 1963, with 129 persons aboard. No deep-sea diving equipment could go to the depths where the Navy feared the sunken sub lay. But cameras could go that deep. A Navy ship was dispatched to patrol the area while trailing a mile-and-a-half-long cable that held a six-foot-long sled called "the fish." The equipment on the fish included three pressurized cameras fitted with stroboscopic flash lamps. It was film from these cameras that eventually indicated the burial ground of the *Thresher*. In such detail did they show the wreckage that even a milk carton from the downed sub could be picked out lying on the ocean floor. But even in tragedy, the camera provided helpful information. The pictures also established that the sub's nuclear reactor had not blown up, thus precluding the possibility that atomic radiation had contaminated the living sea. □

The Heavens in Close-up

In photography, astronomers discovered their most useful tool since the invention of the telescope. Photographs taken through telescopes provide permanent records of the stars, placing and tracking them with indisputable accuracy. Further, photographs made visible portions of the universe man never even knew existed *(following pages).* In all, so dependent have astronomers become on photography that most professional telescopes are designed almost exclusively for cameras, making the popular idea of an astronomer bending toward an eyepiece an anachronism.

From the day in 1839 when the invention of Louis Jacques Mandé Daguerre was first described to the French Academy, astronomers realized they had an invaluable ally in the camera. That very year the French astronomer François Arago encouraged Daguerre to make a picture of the moon, an experiment that proved a failure. Arago remained optimistic, and under his prodding the scientists who set out to improve the daguerreotype often used the moon and sun as models for their pictures. The first recognizable daguerreotype of the moon was made by the American physiologist Dr. J. W. Draper in 1840. The picture could hardly be termed a smashing success. In it the moon was only about an inch in diameter, but the familiar shadows of its mountains and craters that form its "face" were distinguishable. As photography evolved from daguerreotype through wet, then dry plates, astronomical photography grew in sophistication and range.

But even with sensitive lenses and films the astronomer still faced a barrier to perfectly clear pictures of the heavens—the earth's atmosphere. Its density varies from point to point, in effect forming lenses of air that bend light rays the way glass lenses do. The atmosphere's clouds, smoke and haze also interfere with clear views of the heavens. Even in the relative seclusion of mountaintop observatories, camera-equipped telescopes still suffered from distortions caused by the atmosphere. So astronomers bent their efforts toward lifting cameras above the atmosphere. In the late 1950s, the Princeton University Observatory launched a balloon carrying a 12-inch telescopic camera to an altitude of some 80,000 feet where it took pictures of the heavens clearer in definition and detail than any previously seen.

But the most dramatic advances in astronomical photography came with the dawning of the space age. With the development of powerful rockets, electronic cameras and television, computers and magnetic tape, astronomers could send their observation stations far beyond the atmosphere into the still clarity of outer space. Probes like the Mariner series in the late 1960s to photograph the planet Mars *(right)* opened entirely new vistas. Capsules bearing not the usual photographic cameras and films but television cameras and magnetic recording tape were powered by rockets to within 2,000 miles of the face of Mars. On command from scientists on earth, the pictures were transmitted as coded pulses of radio waves. On earth, the pulses were decoded and converted into electrical impulses that established a pattern of light and dark dots to compose photographs of Mars —the closest, clearest views of earth's neighbor planet ever obtained.

Two views of Mars taken during the flight of ▶ Mariner VI, which provide pictures of unprecedented clarity, were taken by a television camera and reconstructed on earth from computer analysis of the electronic signals. The picture at right shows the planet in its entirety, including the light coverings on the poles (top and bottom) that led many astronomers to think they were ice caps. These and other earthlike features such as the famous long "canals" suggested that Mars supported life. But the picture at far right, taken from approximately 2,000 miles away and showing an area about 560 by 430 miles, makes Mars seem as barren and lifeless as the moon.

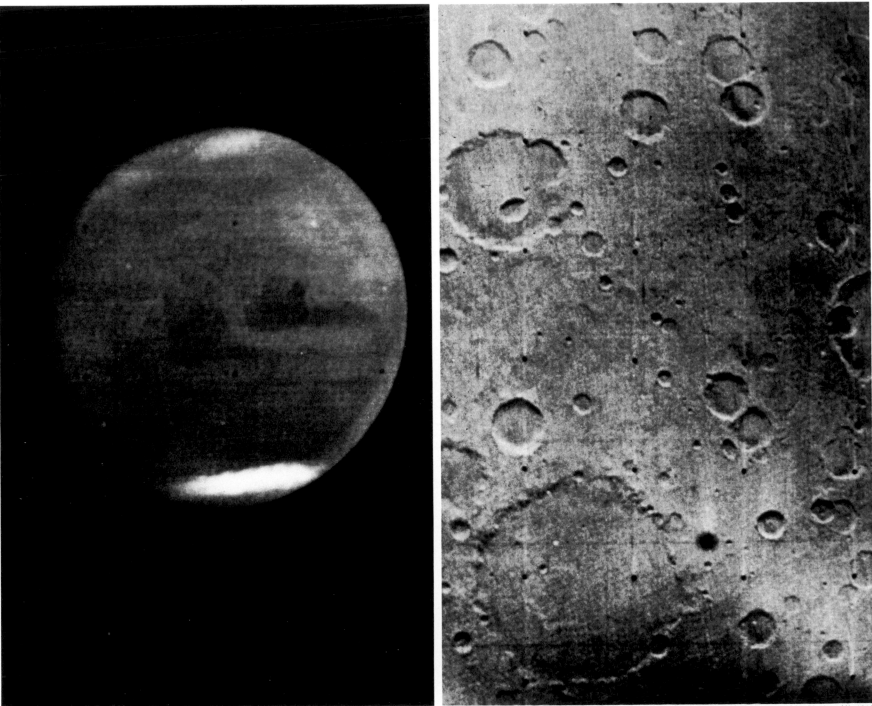

NASA: *Two pictures of Mars relayed by Mariner VI*, 1969

Without photography, the astronomer would never have known of the true nature of the two celestial bodies seen here. On the opposite page is a galaxy, a mass of stars and dust so huge that it would rival our own Milky Way; at right a nebula, a swirling cloud of gas on its way to becoming stars. Yet both are so far away that very little of their light reaches the earth and a man looking through the most powerful telescope made could not clearly perceive them.

Film can see what the human eye cannot because film, unlike the retina of the eye, can store up light. Each incoming particle of light leaves a permanent impression on the film and an image gradually builds up. With long exposures—each of the pictures here required several hours' exposure—the once-fuzzy celestial bodies slowly take shape on the film.

Photography has also enabled astronomers to distinguish among different types of objects that seem very similar. For example, astronomers had long called all dimly perceived swirls of light far out in space nebulae. They were considered clouds of gas without form or substance. Then in 1925 some new photographs taken with powerful telescopes revealed that many of the so-called nebulae actually were large groups of stars. They turned out to be galaxies, like our Milky Way.

By exposing film at the focus of the Hale Observatories' 200-inch telescope, astronomers captured this evanescent image of the giant Trifid nebula—a monster mass of gas and dust that may eventually give birth to giant stars dwarfing the sun. The large cross-shaped object at top is a bright star, its image distorted into this strange shape by the long exposure.

HALE OBSERVATORIES: *The Trifid Nebula.* 1950

*Through pictures such as this one, also made
with the Hale 200-inch telescope, of a massive
spiral galaxy millions of light-years away,
astronomers first began to realize the nature of
the universe. Our own galaxy, the Milky Way,
was always considered the center of the
universe, but photographs have proved that the
Milky Way is but one of countless galaxies.*

HALE OBSERVATORIES: *Spiral Galaxy in Ursa Major,* 1950

Patterns in Star Trails

JOHN C. DUNCAN: *Orion Rising*

In this time-exposure photograph, the constellation Orion rises behind the observatory at Wellesley College in Massachusetts. Because of its brightness, Orion is among the most photographed of celestial bodies.

Taking pictures of the nighttime sky requires only a camera equipped for time exposures, a tripod and fast film. Two of the best subjects are seen here: the stars that hover near the earth's poles (the Southern Hemisphere pole stars are shown opposite), and such constellations as Orion *(above)*.

Because of the daily rotation of the earth, every star in the sky seems to turn around a point directly above the earth's axis—marked by Polaris in the Northern Hemisphere, and approximat-

ed by the Southern Cross in the south. To photograph this phenomenon, aim the camera at the pole star, set the lens aperture at its widest opening and make a 30-minute exposure. If that lengthy exposure causes a gray veil of fog over the whole negative, shorten the time to 15 or 20 minutes. The picture will show each star with a trail made by its light as the star "moved." The length of the trail depends on the duration of the exposure.

The same methods can be used for

photographing the trails left by the stars forming constellations as they rise in the heavens. The times when the most interesting constellations appear above the horizon are listed in astronomy and natural history magazines.

The pictures of stars require special treatment in processing. Use a slow, contrasty developer for home development. If the film is sent to a commercial lab, mark on a label that the pictures are of the sky at night and should be handled accordingly.

Stars seemingly rotating around the South
Pole leave their marks on the night sky in this
45-minute exposure taken with a 4 x 5 Linhof
view camera outside Sydney, Australia. In
the foreground is a radar antenna used to study
stars' emissions of very short radio waves.

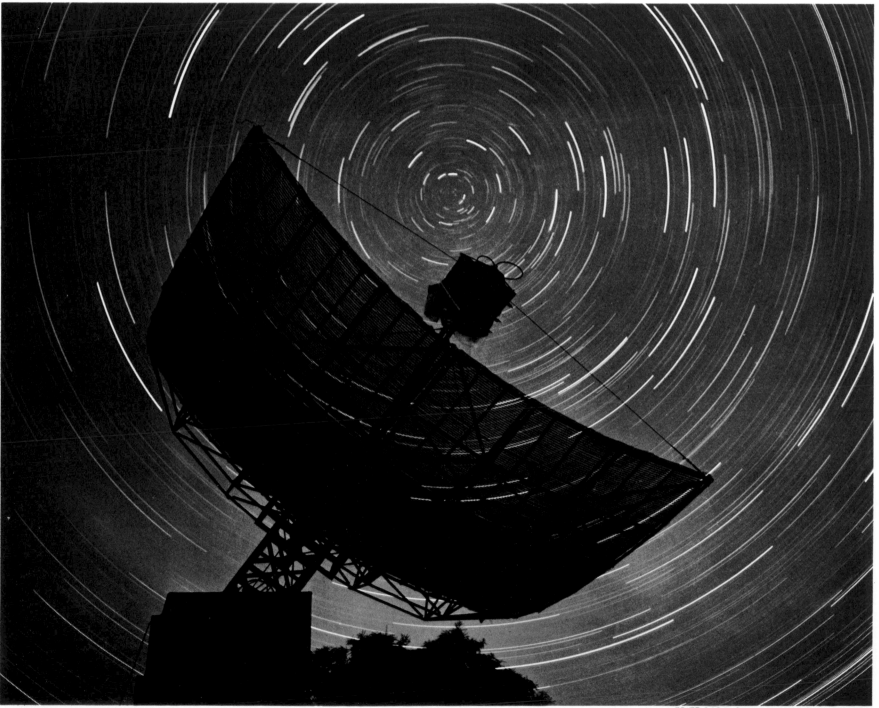

FRITZ GORO: *Stars around the South Pole*, 1951

How to Use a Camera with a Telescope

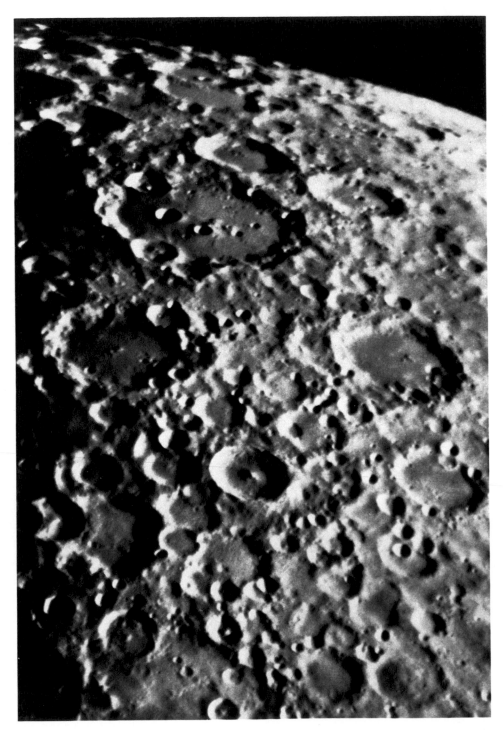

Cameras are easily attached to the compact, portable 3.5-inch Questar telescope—a high-precision (and fairly expensive) portable instrument—by a simple mechanism that is standard equipment. The picture at left, shot through the Questar with an exposure time of 10 to 15 seconds, shows the region around the largest crater of the moon, Clavius (near top).

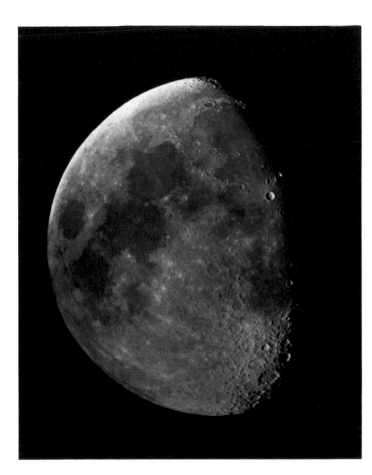

Relatively inexpensive telescopes of the kind used by many amateur astronomers, such as the 4-inch Dynascope reflector shown here, can be fitted to take a camera by an adapter that is slipped into the vertical eyepiece (arrow). Thus equipped the telescope is capable of producing clearly detailed pictures of the moon (left).

Many amateur photographers are also enthusiastic amateur astronomers (or vice versa) because excellent photographs of the heavens can be made with little special equipment. Most cameras are easily attached to the popular types of telescopes by inexpensive adapters (about $10 to $30). They may usually be purchased wherever telescopes and cameras are sold, including the large mail-order houses. Although almost any camera—including the simplest types—will serve, the 35mm single-lens reflex is often preferred because it lets the photographer see what the telescope sees, and it is adaptable to many kinds of telescopes.

Set the camera lens for infinity and focus the telescope—the image will also be in focus in the camera. Exposures depend on atmospheric conditions, the subject and its position in the heavens. But when photographing the moon—a favorite subject because it is close enough to show its details —lengthy time exposures should be avoided to prevent blurring caused by its apparent motion across the sky. Short exposures are usually practical because the moon is fairly bright. Here are a few suggested times and settings, but remember that good pictures of the moon can be achieved only through trial and error: for the full moon, shoot at f/11 and 1/100 second with ASA 32; for a quarter moon, use f/11 at about 5 seconds; and for a crescent moon use f/11 at 10 seconds. The planets Venus, Saturn and Jupiter are also frequent subjects because they, too, are bright. For photographing them through a telescope try a film of about ASA 125. Start experimenting at f/3.5 with an exposure time between ½ and 15 seconds, depending on atmospheric conditions. ☐

Payoff from a Bird's-Eye View

To see the earth from on high, men scaled mountains, ascended in leaky, gas-filled balloons and took off in the first rickety airplanes. Today the modern airplane enables millions of people to see the bird's-eye view—with their own eyes, or better, with a camera's. For it is the aerial photograph that has provided such revealing—and haunting —glimpses of earth as the one at right. In the hands of professionals, the airborne camera serves naturalists and archeologists, city planners and map makers, and many amateurs seize the opportunity of an airline trip to make their own aerial photographs—a relatively simple procedure *(pages 110-111)*. Good pictures can also be taken from a small private plane. It can fly to specific locations at fairly low altitude, providing clear detailed shots of points of interest more readily than a high-flying jet. The photographer in a small plane also experiences some unexpected sensations. To take an unencumbered picture, the door of the plane should be open. When the pilot banks to circle the area to be photographed, the photographer will suddenly be facing downward through the open door. For a moment, it will seem as though the plane is level while the ground tilts upward at a 45° angle. There is no danger of falling out, for centrifugal force will keep the photographer in place, but a tight seat belt may be reassuring.

A simple camera can make good snapshots from the air, but the high shutter speeds of more advanced types are an advantage; they prevent blurring that could be caused not only by the motion of the camera in relation to its subject, but also by the vibration of the airplane. A fast lens helps make up for high shutter speeds. Focusing is no problem; the subject is always at infinity. Many amateurs who do more than occasional aerial photography look for old World War II Army Air Forces aerial cameras, particularly the K-20. It has an 8½-inch-focal-length lens that produces very sharp negatives in a 4 x 5-inch size; it also permits many shots to be made without reloading—each roll of film takes 50 pictures.

The aerial cameras used for large-scale professional work are quite different from the hand-held K-20. For extensive surveying and map making, the United States Coast and Geodetic Survey had designed and built a hulking, nine-lens, 600-pound camera that is mounted in the belly of a special plane. The camera, which rests on rubber mounts to protect against vibration, takes 100 pictures on a roll of film 24 inches wide. The nine lenses give it extraordinary coverage. A single photo made at 13,750 feet will show an area that measures 120 square miles. With this kind of coverage, map making can be done in a fraction of the time previously required by land surveys.

But perhaps the most remarkable aerial cameras are those fitted into "spy planes" like the American U-2. From altitudes of 60,000 feet—nearly 12 miles above the ground—these instruments produce clear reconnaissance pictures of such fine detail that the experts who study the prints can pick out the crossties in a railroad bed.

"The Burning Tree"—a view of the Colorado River Delta at the Gulf of California taken from 14,000 feet—reveals the unexpected visual treasures inherent in aerial photographs. The river is at bottom, its water fanning out into a spreading network of limbs and branches. Through the years the silt deposits have filled the channels causing the river to branch again and again. The light areas are sand bars; the dark dots bushes and trees that have rooted on them. From the aerial perspective, the delta looks like a giant tree that is being consumed by billows of flame.

GEORGE W. SUTPHIN: *"The Burning Tree,"* 1944

WILLIAM A. GARNETT: *Los Angeles Sprawl*, 1969

Portrait of Megalopolis

The spread of urban sprawl that makes up much of Los Angeles can be seen—house by house —stretching out to the mountains in the background. In the foreground is the Hawthorne district; the old core city with its high-rise buildings is at the center rear. Planners use comprehensive pictures like these to see where a city is going—and where it has been.

The extent of the urban sprawl that surrounds most American cities is told with numbing force through aerial photography. On the ground each house and plot of land is an entity with a separate existence of its own. Yet, when they are seen from the air, the individual houses merge with one another like oversized grains of sand, their numbers forming a virtual beach of habitations.

Such views do more than startle, they also serve city planners. Experts use aerial photographs of urban areas to help them decide how to lay out the right-of-way for a new highway or how to improve or extend an existing one. Aerial photographs also tell planners about the topography of uncharted land in areas where new cities are going to be built. When Brazil decided to locate its new capital city, Brasilia, in the wild jungle interior of that gigantic country, aerial photographs were the basis for planning. Some 20,000 square miles were photographed and from this huge area 80 square miles were chosen as the site of the city. The entire job, from photographing through analysis and selection of the site took less than a year—a fraction of the time a land survey would have required.

Sighting Traces of the Past

From the air the camera recaptures messages and memories of the past that are often invisible on the ground. The California Indian pictographs, or ancient drawings, at right, were unknown until seen from the air, while the picture of the site of Fort Union, New Mexico, not only shows the plan of its old fortress but even the impressions wagons left on the Santa Fe Trail.

The pictographs are located on the bluffs above the Colorado River in remote but not inaccessible areas. Yet these giant figures—the human form measures 170 feet from head to foot and 158 feet from hand to hand—were never noticed until 1932, when they were spotted by George Palmer, a local aviator, while he was cruising at 5,000 feet. Suspecting his eyes might have been deceiving him, Palmer returned to the scene with a box camera to take some aerial snapshots. Archeologists have since speculated that the human form is probably an Indian goddess; both pictographs are now believed to have been made some time after 1540 —the figure of the horse must have been drawn after the introduction of the animal to the New World by the Spanish explorers in that year. The exact reason for the huge pictographs may never be known. There are no nearby hills or promontories from which the artisans could admire their work.

The airborne camera gave the world its first look at these gigantic Indian figures—a human form and a horse—scratched into the gravel in Southern California. The figures were made by Indians scraping away the top gravel to expose the lighter soil beneath. The larger form is believed a goddess; quartzite stones indicate her eyes, nose, mouth and breasts.

UNITED STATES AIR FORCE: *Indian Pictographs*, 1932

The crisscross tracks left a century ago by pioneers' wagons can still be picked out in this aerial picture of the old star-shaped fortress at Fort Union, New Mexico, once a haven for settlers heading west along the Santa Fe Trail. The trail itself, its ruts so blurred by erosion that it is barely noticeable on the ground, is clearly visible winding out of the east (top left corner). The adobe brick buildings of the fort are still in use but hardly more prominent from the air than the remains of the old fortress.

WILLIAM A. GARNETT: *Fort Union*, 1969

A Watch on Wildlife

By studying aerial photographs, naturalists gain valuable information on such animal habits as the state of feeding grounds, the size of the herds and even on the work of poachers. The pictures are so detailed that scientists can often add up individual creatures —even small ones—for a census that is impossible to carry out on the ground. It is not even necessary to tally each one separately—the number showing in one square of picture area is counted and then multiplied by the area covered to get a total. By knowing how many wild animals exist in a certain territory and where they are, the authorities can establish hunting seasons and set bag limits, which are regularly adjusted to fit the size of the herds.

Mountain elk follow the leader, displaying their inherent herd instinct for single-file walking, as a helicopter drives them over the snowy slopes of the Rocky Mountains in Yellowstone National Park to a corral. They were rounded up for tagging in a study of the extent of their range.

U.S. NATIONAL PARK SERVICE: *Elk Herd*, 1968

Each black dot is the shadow of a penguin—or a pair of penguins—at the rookery at Cape Crozier in Antarctica. This picture shows but a small section of the area, but by analyzing many of these pictures zoologists have estimated that some 300,000 Adelie penguins occupy the Cape rookery each summer.

J. J. PARKER, U.S. NAVY FOR THE U.S. GEOLOGICAL SURVEY: *Cape Crozier, Antarctica,* 1964

How to Take Pictures from a Jet Liner

The lack of specialized equipment and an airplane maneuvering to the photographer's order does not stop many amateurs—and professionals too—from getting good pictures from the air. They shoot aboard commercial airliners with their regular cameras. A fast shutter —1/125 second or better—is a help to avoid blurring the landscape sweeping by. That calls for a fast lens—f/2.8—or better—and fast film. If the lens also has a short focal length, it will give the picture the breadth and scope that enhances a panorama.

The favored vantage point for photography is forward of the wings. From other seats the view may be obstructed by the wings and blurred by the turbulence caused by vapor from the jet engines. In any location, hold the camera fairly level. If it is aimed downward through the window at a sharp angle pictures may be blurred by the plastic windows. They are several layers thick and at a steep angle they distort the view in the same way as cheap glass.

This means that the best times to photograph the ground from a plane are when it is banking after take-off or before landing. Since such occasions come over cities, the pictures are also fairly interesting. At other times, good photographs can be made of cloud banks or of a sunset or sunrise. To cut down on the brightness then, the lens should be stopped down about four stops from normal exposure.

For any aerial views, a few cardinal rules should be remembered:
Keep the horizon level; if it tilts, the picture will seem disoriented.
Never brace the camera by pressing the arms against the plane's fuselage —engine vibrations will be transmitted by the body and cause blurring.
Keep the lens from touching the window, and check to see if the window frame is jutting into any part of the picture; this serves to distract from the sweep of the panoramic view.
Clean the window of smudge marks. They may blur the picture or cause flaring highlights. Be careful when using a polarizing filter to darken the sky—it often produces a rainbow effect *(right and opposite).* ☐

A rainbow may appear if a polarizing filter is held in front of the plastic window of an airplane. This effect results from the reaction between polarized light and stresses in the plastic (pages 168-171); it is only noticeable in color shots and can be a distracting element in the picture. But some photographers have deliberately created the rainbow to introduce a surprising note of color into the picture.

The rainbow effect of a polarizing filter adds a bright touch to this photograph of Arizona mountains taken from a jet liner. Such rainbows are seen only when the camera is at certain angles, and slight shifts of the camera position can usually make them disappear.

TOM McCARTHY: *Arizona*, 1970

Bizarre Scenes from Underwater

The camera has transformed human knowledge of the underwater world, once a realm of dark secrets and imagined monsters, showing it to be a bizarre place, yet beautiful as well. This ability to record the unusual features and creatures of the sea has come from two diving inventions—scuba gear for deep seas and the snorkel for shallow water, plus the development of watertight housings for cameras.

The scuba (self-contained underwater breathing apparatus) quite literally set the diver free to take pictures. It is actually just a tank of compressed air strapped on the diver's back with a regulator and an air hose leading to his mouth, a transparent face mask, rubber fins for the feet and perhaps a rubber suit for protection against the cold, or cuts and scratches. The scuba was developed by two Frenchmen, an engineer, Emil Gagnan, and the now-famous undersea explorer and photographer Jacques-Yves Cousteau, who accelerated interest in scuba diving—and photography—with the book and subsequent movie, *The Silent World,* published in 1953.

The snorkel is only an inexpensive breathing tube with a mouthpiece. It is usually worn with a face mask, so that a swimmer can move along the surface, his face submerged to observe underwater sights while breathing through the short snorkel tube. To explore, he holds his breath and dives down.

When snorkeling first became popular, its principal attraction was not photography, but spear fishing. Almost every diver carried a spear gun with him, his trigger finger itchy to fire at passing fish. The resulting slaughter revolted many divers. As had many African big game hunters, they put aside their weapons and took up cameras.

A wide range of equipment for undersea photography is now readily available *(pages 228-229),* and some types are quite simple and inexpensive. This was hardly the case when underwater photography was begun in 1892 by Louis Boutan, a burly, bearded professor at a marine laboratory located in the south of France, who took a picture of a Mediterranean spider crab crawling across the rocky floor of the sea. To contain his camera, which used 5 x 7-inch plates, he constructed a huge, watertight metal box with glass portholes for the lens and viewfinder. The box with camera was so heavy, a block and tackle was needed to move it around on land. In order to manipulate the box underwater, Boutan suspended it from an empty wine cask that acted as a float. Wearing one of the awkward diving suits common in his day, Boutan descended to depths of 155 feet, hauling his ungainly camera with him. Because of the weak natural light at that depth, he even invented an underwater flash gun. Its components were a lighted lamp placed under a watertight glass dome attached to a barrel. To use it, he pumped magnesium powder onto the lamp through a hose. The powder hitting the flame gave a bursting flash.

Today, nearly a century later, the scuba, snorkel and simple photo equipment bring to reality Boutan's vision of a pictorial record of life beneath the sea. Some of the most remarkable pictures are being shot by Douglas Faulkner *(following pages),* whose lifelong love of the sea has made him one of America's outstanding young underwater photographers.

This cowfish, so called because of the hornlike ▶ projections over each eye, was shot by Douglas Faulkner at a depth of 40 feet in the Inland Sea of Japan. The camera was a twin-lens Rolleiflex protected by a Rolleimarin 4 waterproof housing. A flashbulb was used and the exposure was 1/250 second at f/22. Faulkner was diving with scuba gear when he caught this fish head-on. It is so heavily shielded by its rectangular, bony armor that only the mouth, eyes, gills and tail and fins can move.

DOUGLAS FAULKNER: *Cowfish*, 1966

DOUGLAS FAULKNER: *Scorpion Fish*, 1966

DOUGLAS FAULKNER: *"Deathmask" Scorpion Fish,* 1965

DOUGLAS FAULKNER: *Lion Fish,* 1966

These members of the scorpion fish family—so called because of the venom they discharge when molested—were all shot with a Rolleiflex at f/22 and 1/250 second. The one opposite, photographed at a depth of 30 feet, dwells on the sea floor where its protective coloring makes it difficult to be spotted by potential enemies. The "deathmask" scorpion fish (above, left) gets its name from its ghastly visage. The lion fish, shown above, right, has dangerously sharp spines and lives in the coral reefs where its color is a warning to would-be predators.

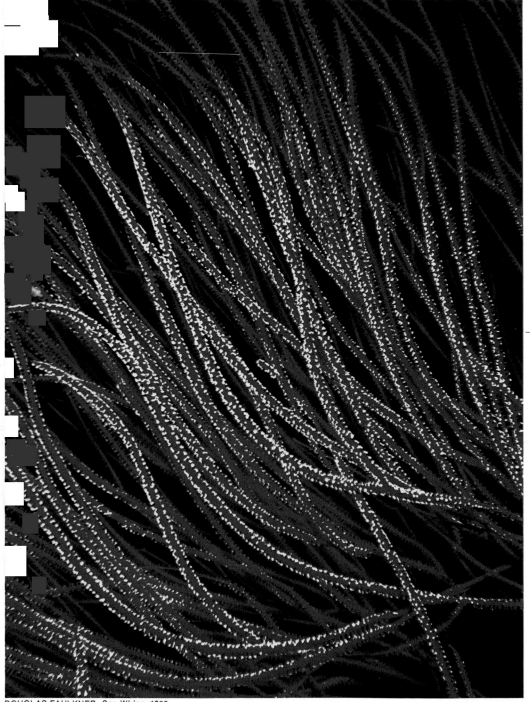

The supple branches of sea whips were photographed in fairly shallow waters—30 feet deep—off the Southwestern Pacific with a Rolleiflex set at f/22 and 1/250 second; a flash provided illumination. The whips are soft coral that gather in colonies on the firm bottom of the ocean. Surrounding its mouth cavity, each whip has poisonous tentacles, with which they can sting and daze the microscopic zoöplankton the whip engulfs. To get the picture opposite of a graceful sea anemone, Faulkner had to dive to a depth of 120 feet in Pacific waters off New Caledonia. He again used his Rolleiflex with a flash, with the shutter set for 1/250 second and the lens aperature between f/16 and f/22.

DOUGLAS FAULKNER: *Sea Whips*, 1965

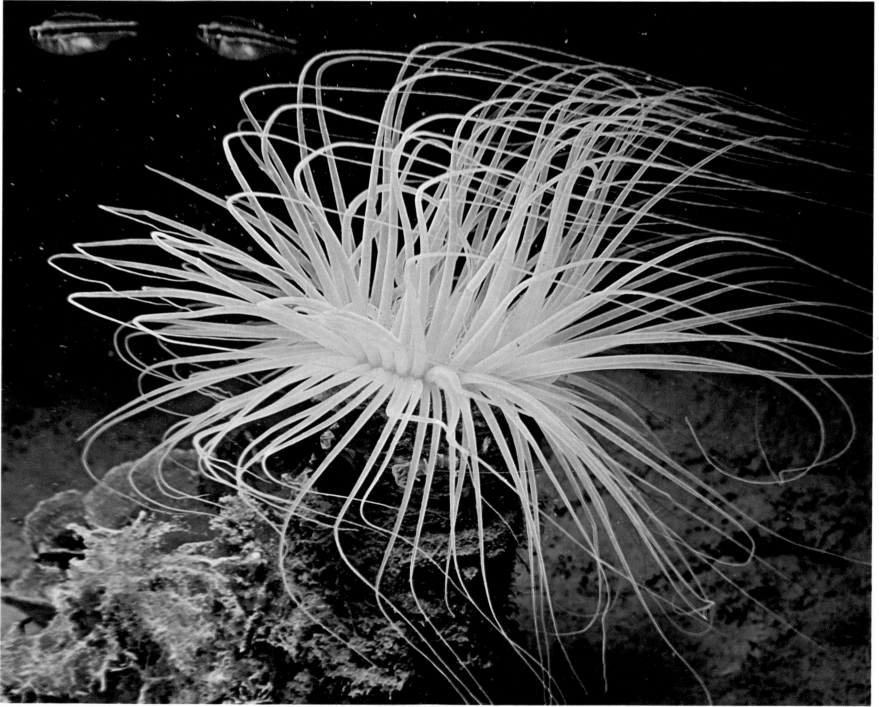

DOUGLAS FAULKNER: *Cerianthus Anemone*, 1965

Taking Pictures in the Deep

The deep-sea realm of the scuba diver is one of motion and dimness—and these characteristics introduce more difficulties for the photographer than the obvious problem of protecting his equipment against water. One camera on the market does not require a watertight housing *(right)*. For most other popular types, housings are available in plastic or metal. The housing is simply a box with a window for the camera lens and another for the viewfinder. Most have controls on the outside to enable the diver to operate the camera inside, tripping the shutter, focusing and winding the film as necessary. Flash units are also available in waterproof designs; others can be protected with watertight housings. (A selected list of useful undersea equipment is provided on pages 228-229.)

A flash unit is generally used by scuba photographers because there is little natural light at depths beyond 30 feet or so. At that level in clear water, a sunny day may permit exposures of 1/250 second at f/8 with fairly fast film. But conditions vary so much that considerable experimentation is necessary to be sure of getting good photographs.

The water itself introduces other optical effects. Because of the way it refracts light, everything seems at least 25 per cent closer than it really is to both the human eye and the camera. This restricts the area covered by a picture, a limitation that cannot be entirely overcome by moving back from the subject. Pictures taken from more than 10 feet away are generally murky because of tiny particles in the water. The best solution is a lens of short focal length, and some diver-photographers prefer the fisheye lens that covers a 180° view of the scene.

One underwater problem for which there is no mechanical solution is film-changing. To do this the diver must surface, change the rolls, then dive again. To lessen this chore, many photographers prefer to use 35mm cameras, which take rolls providing 36 exposures. And there is little that can be done about the water itself, which is in constant motion, swinging the diver and his camera back and forth and blurring his pictures unless he takes pains to hold himself still.

The Nikonos 35mm is an amphibious camera that is completely waterproof and can withstand the pressures generated by depths as great as 150 feet. On land its watertight construction protects it against damage in rain, snow, sand and dust storms. The camera, sold either with a 35mm, f/2.5 lens, or 28mm, f/3.5 lens, is shown here with a 7.5mm Nikkor fisheye lens that covers a 180° view. In order to fit this lens on the Nikonos, a special adapter is required.

Protected by a wet suit and heavy gloves, this scuba diver sights his Nikon F camera, which is encased in a watertight Niko-Mar II cast-aluminum housing. The viewfinder is enlarged so that sighting will be easier underwater.

Exploring the Shallows with a Camera

A snorkeler steadies himself in the currents by
holding onto the stag coral he is photographing.
His camera is a simple fixed-focus type, which
is kept dry by a transparent plastic housing.

Shallow water with its wealth of life forms—and more important for easy picture taking, plenty of light—is easily explored and photographed by snorkel divers. Even a simple camera encased in a watertight housing can produce memorable photographs. The housings can be purchased relatively inexpensively and at almost all popular seaside resorts they can even be rented—complete with cameras inside them.

The snorkel photographer, because he is generally swimming on the surface, should resist the temptation to shoot straight down. This puts the light source behind him and makes the picture seem flat. The solution is to dive deeper and photograph from an angle. A good time for shooting is between 11 a.m. and 2 p.m., when the sun is directly overhead and the illumination is heightened, but sometimes more interesting lighting effects and shadows may be utilized both earlier and later.

A snorkel photographer can sometimes find history mixed in with nature underwater. Here a colony of brain coral has rooted on the wreck of a German freighter scuttled off the island of Aruba during World War II. In the relatively shallow depths shown here, natural light is ample for picture taking, although a flash may be needed to light shadowy areas.

FLIP SCHULKE: *Brain Coral*, 1970

FLIP SCHULKE: *Sea Fans*, 1970

*Sea fans and coral in the shallow waters off the
Bahama Islands are caught in a picture
taken by a snorkeler using a Nikonos 35mm fitted
with a 7.5mm Nikkor fisheye lens (page 118).*

Photographing the Invisible

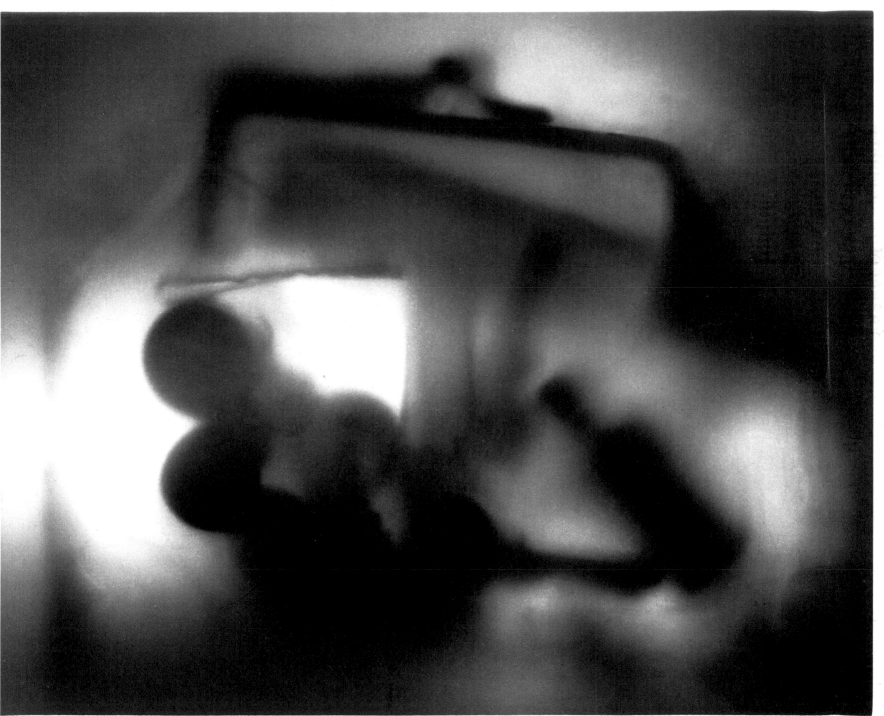

JONATHAN NORTON LEONARD AND THE TIME-LIFE PHOTO LAB: *Contents of a Woman's Purse Photographed with Radioactive Material*, 1945

Beyond the Rainbow's Spectrum

Visible light is what men see by—but not necessarily what they take pictures with. Its waves, evoking the familiar colors from violet to red, make up only a tiny section of the great spectrum of electromagnetic energy. All other parts of the spectrum are invisible, but some of them can be used in photography. Beyond the violet, short-wave end of the visible spectrum are ultraviolet and X-rays. Beyond the long-wave end, red, is infrared. All these waves have properties different from those of ordinary light and serve as invaluable tools for exploring the physical universe. The bulk of them are restricted to scientific, industrial and medical uses—no amateur, of course, should attempt to make X-ray or gamma-ray pictures even if he had access to the equipment or to radioactive elements. But one section of the invisible spectrum, infrared, can be used by amateur photographers with little special apparatus to take interesting and sometimes eerily beautiful pictures—of landscapes, seascapes, objects in the household, pretty girls—in tones startlingly different from those perceived by the human eye and frequently revelatory of features hidden in natural light.

Infrared rays, which include those sensed as heat, were the first of the invisible waves to be discovered. Anyone who has held his hand up to the sun knows that heat radiation is associated with visible light, but there was no clear thinking on this point until the spectrum of visible colors was studied carefully. In 1800 the British Astronomer Royal, Sir William Herschel, set up thermometers in sunlight that had been spread out into a rainbow of colors by a prism. He found that the thermometers registered a higher temperature near the red end of the spectrum. Even beyond the red the thermometers remained hot—hotter than those in the visible spectrum. Herschel correctly concluded that sunlight contains something like light that is invisible to the eye but still carries a large amount of energy. He named it infrared, which means "below red."

The infrared begins with waves longer than deep red, 700 millimicrons (millionths of a millimeter). When its waves are not much longer than those of red light it is called near infrared and though invisible to the eye behaves much like visible light. Infrared was not used photographically for more than a century because ordinary film was not sensitive to it, but about 1931 it was discovered that certain dyes added to the emulsion would make it record an image in some but not all kinds of infrared. Today infrared pictures can be taken in an ordinary camera with special infrared film. The longer the waves get, the harder they are to handle. About 1,350 millimicrons is roughly the limit for practical photographic use. Far infrared—heat waves—longer than this can be detected only with special apparatus and used to form vague "heat" pictures of warm objects such as the human body or a car whose engine has been running.

Photography with near infrared does not record the world in the same way as with visible light. Near infrared is reflected strongly by many common materials that absorb most visible wavelengths. Moreover, it passes through other things that absorb or reflect visible light. In some cases visible light makes objects give off infrared wavelengths, the infrared radiating outward as part payment for the incoming visible light.

Taking black-and-white pictures with near-infrared waves is not at all difficult. The only essential special equipment needed is infrared film, several kinds of which are available, and a filter to keep out most visible light, which would otherwise dominate the scene. It must also be remembered that the glass of a lens does not refract infrared as strongly as it does the shorter waves of visible light. Therefore the lens focuses an infrared image slightly behind the visible light image. This must be allowed for by focusing in visible light and then moving the lens a small additional distance away from the film, thus bringing the infrared image into focus on the film. The correction varies with different lenses and is usually marked on the lens. In any case it is good policy to use the smallest practicable lens opening, because infrared behaves somewhat differently in passing through a lens, and aberrations are not as completely allowed for. When a small lens opening is used, say f/11, such failings of the lens do little damage to the quality of the picture. Depth of field is also increased, reducing the effects of focusing errors.

The sun provides plenty of near infrared for landscapes and other scenes taken outdoors, but ordinary light meters are not reliable guides for exposure, for they are designed to measure only visible light. The easiest and most startling black-and-white infrared photographs that amateurs can take are of landscapes with mountains in the far distance. In visible light mountains are usually obscured by haze and show little contrast against the pale sky near the horizon. Infrared sees through the haze; the mountains stand out sharply against a dark, almost black sky, and many distant details appear that are invisible to ordinary photography or to the human eye.

The improvement is due to a combination of several different effects. The ratio of brightness between many objects is usually greater in infrared than in visible light, making them easier to distinguish from one another. Also, the longer waves of infrared are not scattered as much by the atmosphere, and this reduces two scattering-caused interferences with long-range clarity: the brightness of the sky and the bluish haze that often intervenes between the camera and the horizon. Probably most important is the fact that most objects on the ground reflect more infrared than they do visible light rays; therefore they stand out against the sky.

Besides delineating distant landscapes, infrared provides some strange —and useful—effects. Green foliage absorbs a large part of the visible light

that strikes it and therefore shows up fairly dark in ordinary black-and-white photographs. By contrast, foliage strongly reflects infrared, so trees and green fields appear almost white in pictures taken by its light. Clouds show brilliant white against the dark sky because the comparatively large water particles of which they are composed reflect infrared much as they do visible light. Lakes and other bodies of water that take their color from the blue sky appear dark also. This often makes small streams that would normally be hidden by foliage show as prominent features.

Infrared pictures taken across water often achieve startling effects. The water comes out ominously dark except where ripples reflect the full rays of the sun, including its infrared, as if they were small mirrors. In these places the water sparkles like diamonds strewn on black velvet. Leaves in the foreground look like white paper cutouts. Trees on the far shore, which would be dark in visible light, are flecked with lacy brightness. Above them float hills and distant mountains wonderfully clear and sharp.

Architects often use infrared to enhance the drama of a building and its surroundings. Tourist agencies sometimes use it to show to best effect spectacular mountains that are hard to photograph because of haze. Their cameras often see far more than trusting tourists do.

Close-up infrared pictures are not apt to be beautiful. Portraits look unhealthy because lips and skin appear unnaturally pale; other subjects show unusual contrasts and details that the eye interprets as ugly blemishes. But for just such reasons infrared photography has a long list of important uses, most of them based on the fact that it sees what the eye does not. In medicine it is used to judge the condition of the network of veins just under the skin —unhealthy veins may be filled with oxygen-poor blood that shows dark in infrared and therefore stands out clearly.

Infrared is extremely valuable for studying illegible or suspect documents. If writing or printing has been erased, either mechanically or chemically, the fact is often revealed by infrared, which is strongly absorbed by traces of ink that remain invisible in normal light. Forgers sometimes erase everything but the signature on a hand-written letter, and then type a will or other important document above it. No handwriting expert would question the genuine signature. Infrared, however, reveals the erased writing and so proves the document false.

Many old objects, maps and documents have writing on them that is illegible because the ink has faded or is covered by dirt or darkened varnish. Infrared often shows the writing as clearly as if it were new and fresh. This technique was spectacularly used in deciphering the Dead Sea Scrolls, the 2,000-year-old Hebrew manuscripts that were found in caves near the Dead Sea in the 1950s. Some of the parchments had turned so dark with age that

the writing on them could not be read. When photographed, however, the ink absorbed infrared, which was strongly reflected by the darkened parchment. The photographs consequently showed the writing clear and black against a light background.

Police and private detectives make extensive use of infrared. It shows up powder marks on the clothing of persons killed by short-range gunfire. It helps in the study of fingerprints, permits letters to be read inside sealed envelopes, detects some kinds of writing in invisible ink. Best of all, it permits pictures to be taken in the dark. Burglars can be photographed at work without their knowledge, by focusing a camera on a cash drawer or safe and arranging for its shutter and an infrared flashbulb to be tripped when an intruder approaches. Infrared is also used by blackmailers and by lawyers looking for evidence to use in divorce cases. Pictures taken by hidden infrared cameras may not be artistic, but they are sufficiently explicit to be extremely useful for such purposes.

Infrared can also be used to take pictures in color—but the color is what is known as false color. Colors, of course, are merely sensations produced in the brain by certain wavelengths of visible light that have entered the eye. Infrared produces no sensation because the retina is not sensitive to it. But since it affects certain photographic emulsions, it can be considered a color and used to take pictures that show it as a color when they are developed. This is generally done by making invisible infrared reveal itself as red in the final photograph.

Like standard color film that takes pictures in true colors, infrared film has three superimposed emulsions, each sensitive to a different set of wavelengths—in this case infrared, green and red. These wavelengths form images on their respective layers, but when the film is developed, positive images in other colors appear. Green light produces an image on the middle emulsion in the negative stage. That is, objects that send a lot of green light through the camera lens appear as light-toned areas in the yellow positive. Red light produces a positive in magenta (a reddish purple), and infrared produces a positive in cyan (a bluish green).

Yellow, magenta and cyan are subtractive colors. When superimposed and viewed in white light passing through them, they yield the three primary colors familiar to the eye. Yellow and magenta combine to form red. Yellow and cyan form green. Cyan and magenta form blue. When they are present in unequal strengths, they yield an unlimited number of intermediate colors. Infrared, normally invisible, is rendered as red, and the visible colors are deliberately mixed. As a result most of the colors in the final picture are false. That is, they are different from what the eye sees in ordinary visible light.

Since foliage reflects a lot of infrared, it makes light-toned areas on the cyan positive. This permits magenta and yellow in the other layers to predominate; they combine to form false red, making green leaves look like flaming autumn foliage *(page 155)*. Any object that reflects a lot of red but only a little of other wavelengths permits cyan and yellow to predominate, forming green. Where the yellow positive image is light-toned, magenta and cyan form blue. Since little red or infrared, which would wash out magenta and cyan, comes from the clear, cloudless sky, an infrared false-color picture usually shows the sky in a color close to the blue the eye would see. Human bodies show an unsightly network of deep blue veins.

False-color pictures are useful militarily because they make it even more difficult for an enemy to hide behind camouflage. False-color has its civilian uses too. When an orange grove is photographed in false color the healthy trees are a uniform reddish brown while trees attacked by pests or fungi are purplish or blue. Often an aerial color picture of a landscape made in visible light shows little but slightly varying shades of green. Infrared enlivens the entire scene, making its individual components stand out in a full gamut of false but meaningful colors.

Amateurs have no great difficulty with false-color film, and sometimes they get surprising results that experts cannot fully explain. One reason why the colors are not fully predictable is that not all the infrared that affects the film comes from reflected sunlight. Some of it is infrared that is generated when ultraviolet waves from the sun hit certain materials. It is difficult to predict without trial what effects this will produce in the final picture. Filters may also yield unexpected colors *(pages 152-153)*, and an interesting recreation is to take a series of false-color pictures of a beautiful girl, using different lipsticks on the girl and different filters on the camera. Endless color variations of complexion, hair, eyes and make-up will appear on the film, some of them pleasing to the sitter, others not.

In the electromagnetic spectrum, the opposite number of infrared is ultraviolet. The long rays of infrared are just longer than the visible spectrum of colors perceived by the human eye; similarly, the short waves of ultraviolet occupy the area just shorter than the eye's range. Ultraviolet occupies the wavelengths between 10 millimicrons and 400 millimicrons, where blue visible light begins. For photographic purposes the most important of these waves is near ultraviolet, which is longer than 200 millimicrons. Only this part of the ultraviolet range can be used in a camera without extremely expensive special equipment.

Ultraviolet is reflected, as visible light is, when it hits most materials, but it also has another interesting effect. Its energetic waves make many materials

fluoresce—that is, give off visible light, usually blue or greenish yellow. So there are two distinct ways to make ultraviolet pictures. In the first method, both the source and the camera lens are covered with filters that allow no visible light to pass; thus, the only radiation that affects the film is the ultraviolet being reflected from the subject, just as visible light is the basic radiation affecting film in an ordinary photograph. In the second method, the camera lens is covered with a filter that excludes ultraviolet, and the resulting picture shows only the visible light that comes from the subject's fluorescing materials.

The two kinds of picture can be quite different because of the varying ability of different materials to reflect ultraviolet or fluoresce when struck by it. Both are widely employed in the study of suspicious documents, the principal use of ultraviolet photography. Often, erased printing or signatures on a document can be revealed because invisible remnants of them reflect ultraviolet differently from the paper or fluoresce brilliantly. Many a seemingly clever forgery has been detected in this way.

Ultraviolet is sometimes called "black light" because the lamps that generate it produce no radiation visible to the eye, but unlike infrared it is not much use for taking secret "surveillance pictures" (as detectives call them) of unsuspecting people in the dark. Projected in the dark, it makes human skin and teeth fluoresce with ghastly brilliance, so that persons under surveillance are apt to perceive that they have been photographed and can take appropriate action against the photographer or his hidden camera.

Long before the development of infrared and ultraviolet photography, X-rays, short waves that occupy a position just beyond ultraviolet in the invisible spectrum, were discovered and put to practical use. In 1895 Wilhelm Konrad Röntgen, a professor at the University of Würzburg in Germany, was experimenting with a Crookes tube, a then-mysterious device that produced a visible glow by passing electricity between two electrodes in a glass tube from which most of the air had been removed.

One of the experiments that Professor Röntgen performed with his tube was to enclose it in thick black cardboard and turn it on in total darkness. When he closed the switch that sent electricity through the tube, a dim glow appeared across the room far from the covered tube. The light had come from a cardboard screen that had been coated with barium platinocyanide, a material that fluoresces when struck by ultraviolet light. But ultraviolet could not have passed through the cardboard encasing the Crookes tube. Some unknown ray was apparently issuing from the tube and activating the screen.

Professor Röntgen realized that he was in the presence of an important mystery. Working systematically, he explored the properties of the new ra-

diation, which he named X-rays, X being the mathematical symbol for an unknown. It must have been an enormous thrill when he put his hand between the tube and the fluorescent screen and saw a shadow picture of his own bones, and he got another thrill when he found that the rays had fogged photographic plates that he kept carefully wrapped inside a drawer, apparently penetrating the solid wood of the drawer. This told him that he might take X-ray shadow photographs. He tried it at once, and one of the first was a picture of his wife's hand, clearly showing her bones as well as a ring on one of her fingers.

Not until 1912 was it proved that Röntgen's mysterious X-rays are electromagnetic waves analogous to light but much shorter in wavelength, between .005 and 10 millimicrons. The shorter the waves of X-rays, the more energetic they are and the more material they can penetrate.

Seldom has the practical value of a discovery been exploited so promptly. Long before X-rays were understood they were put to use in medicine. Even primitive X-ray apparatus could locate bullets embedded in human flesh, help surgeons set broken bones and find out whether Baby had really swallowed Mother's wedding ring. They also caused an enormous amount of popular excitement and misunderstanding. When it became known that most clothing is transparent to X-rays, scandalized persons jumped to the conclusion that Röntgen's discovery was a threat to feminine modesty.

Any Peeping Tom who tried to use X-rays in this way was surely disappointed; a clothed girl who is X-rayed of course looks like a skeleton surrounded by shadowy outlines of flesh, a most unappealing sight. Far more serious than this misunderstanding was the long-continuing ignorance —even on the part of scientists—of the danger of X-rays. Since the rays cannot be seen, felt or otherwise sensed, they appeared harmless, but they are not. When they penetrate human tissue, they can kill living cells or, which is worse, cause them to multiply unnaturally as deadly cancers. Many early X-ray workers suffered burns on their hands that refused to heal and got so bad that fingers, hands or arms had to be amputated. Many died slowly of radiation-induced cancer. Modern apparatus and precautions make X-rays virtually harmless to the patients, but physicians who use them frequently tend to get careless. A disproportionate number of them still die of leukemia, which is a form of cancer often caused by the cumulative effects of radiation.

X-ray photography has many uses aside from medicine. Perhaps the most common is taking pictures of welds and metal castings in search of imperfections such as cracks, gas bubbles or slag inclusions. Before X-rays were available, many metal parts failed disastrously because of defects that were not revealed by normal inspection methods. It is now common practice in industry to X-ray all metal parts whose failure might cause a catastrophe.

A subtle use of X-ray photography is in studying paintings, for it reveals even more than infrared examination. When a painting is X-rayed, strange things often appear on the film. The surface paint vanishes while the thick layers of white lead with which many artists blocked in their main figures become prominent. Often figures appear that were wholly invisible to the eye, showing how the painter changed his concept as the work progressed. Sometimes these ghostly shapes prove that the artist used a second-hand canvas with a picture, by himself or another painter, already on it. When the films are examined in detail the artist's brushwork—the way he applied his paint—is often easy to see in the underlying layers. Many forgeries have been exposed in this way. If the forger worked before the day of X-rays, he thought only of making the surface layers of paint conform to the brush-style of the old master he was imitating. Having used his own style of brushwork on the underpainting, he is betrayed by the X-ray.

Some X-ray tests of paintings have unexpectedly happy endings, however. Many excellent paintings by old masters have been altered to fit changes of taste or even covered completely by a later work of low value. In such cases, X-rays show interesting ghosts invisible to the eye. When the surface paint is removed, the original painting is revealed in all its glory.

Gamma rays constitute still another part of the electromagnetic spectrum that can be used to make photographs. First noticed by Henri Becquerel of France in 1896, only one year after Röntgen discovered X-rays, they are essentially the same kind of waves as X-rays, but are produced naturally by radioactive substances. It was quickly found that they could be used to take pictures, but the only available sources of them, radium and its derivatives, were much too rare and expensive to enable them to be widely employed. It was not until the development of nuclear energy during World War II that man-made radioactive materials became plentiful enough for this purpose.

Probably the first published picture taken with gamma rays from radioactive materials produced by a man-made nuclear reaction was taken, or at least instigated, by the author of this chapter. I was then science editor of TIME magazine and was invited in September 1945 to see the crater of the first atomic test bomb near Alamogordo, New Mexico. The Army Air Forces flew about 20 reporters to a base where we were joined by a party of physicists. We got into cars and drove toward the test site, which was in the center of a great, dry plain covered with low brush. In the distance we could see what looked like a smallish pond of green, scummy water. A dirt road led toward it, and beside the road ran a row of telephone poles, their crosspieces loaded with wires and cables. As we approached the test site, which still looked like a green pond, the wires disappeared, blown away by the

bomb blast. A little farther on, the crosspieces disappeared. Then the poles themselves were snapped off at the ground.

The "pond" proved to be a shallow crater lined with fused soil that looked like green glass and crackled underfoot like ice. Because of radiation danger, we were allowed to stay only about 20 minutes, but in that time I collected a handkerchief full of the green fused soil. If I had known what I was to learn later, I would not have touched the stuff, but at least I had sense enough to ask a friendly looking physicist (he turned out to be Dr. J. Robert Oppenheimer, head of the Los Alamos laboratory that built the first atomic bombs) to test my souvenirs with a radiation counter that he was carrying. He rejected some of the pieces as too radioactive, told me the rest were not too hot and advised me to wrap them in my coat and keep them well away from my body. At the first opportunity I wrapped them in sheet lead. Back in New York I took them to the TIME-LIFE darkroom where the technicians, some of whom were a bit skeptical, provided a wrapped sheet of photographic film. On it we put a woman's purse bought in the five-and-ten and filled with such things as coins and bobbypins. On top we laid a sheet of stiff cardboard with lumps of the fused soil from New Mexico arranged on it. The result was the picture on page 125 showing the contents of the purse.

Certain United States government officials had been claiming that the two bombs exploded over Japan at the end of World War II had no radioactive aftereffects. When TIME ran that picture, the article described the test site in New Mexico. It did not call anyone a liar, but it pointed out that "X-ray" pictures could be taken with the soil melted by the test bomb.

Radioactive isotopes, produced not by nuclear explosions but by controlled nuclear reactors, are now used widely for gamma-ray photography much more sophisticated than the picture of the purse. The most popular of these isotopes is cobalt 60, but others can be used. They are all extremely dangerous and must be handled with elaborate safeguards, but they have the advantage over X-ray machines of portability, independence of power supply and small size. A potent pellet of cobalt 60 can be placed, by remote control of course, inside a narrow-bored, thick-walled pipe or casting, where an X-ray tube would not fit. From this vantage point, it will take a picture of an entire welded joint, throwing telltale shadows of imperfections on a strip of film wound all around the pipe. Such a source can take many pictures at the same time. Since it radiates equally in all directions, it can be placed in the center of a shielded room while objects to be gamma-rayed are set all around it with filmholders behind them. Each gets a picture taken of its inner secrets, the time of exposure varying with the material and thickness of the object. When large numbers of pictures are needed, this method may be convenient and economical.

Modern nuclear physics has created another kind of radiation that can be used for photography: the neutron beam. Neutrons are not, however, electromagnetic waves; they are nuclear particles with zero electric charge. They can be made to emerge from a nuclear reactor in a beam that passes through many massive materials and registers on a film. Pictures taken in this way—Neutrographs—resemble X-ray pictures superficially, showing shadows of varying density, but in neutron pictures the shadows are cast by light materials rather than heavy ones.

Neutrons are not handy tools for photographers or even for most scientific laboratories because nuclear reactors are few and expensive. Neutrons are used nevertheless for many critical kinds of inspection. They look for flaws in the uranium fuel for nuclear reactors. They pass through thick metal walls and detect the hydrogen in unwanted moisture. They find cracks in plastic or aluminum parts that might elude X-ray inspection. Neutrons are dangerous, but their use has probably prevented disasters and saved many lives in the nuclear-energy and aerospace industries. ☐

Jonathan Norton Leonard

The Rays That See through Anything

Almost as soon as a little-known professor of physics at the University of Würzburg in Germany, Wilhelm Röntgen, discovered in 1895 the strange emanations he named X-rays, he found out the two facts that would make them so useful to mankind: they affect photographic emulsions just like visible light; but unlike light waves they are not reflected by most objects—they pass through them, penetrating some substances more easily than others. Thus "shadow pictures," or "radiographs," made by placing a piece of film on one side of an object and an X-ray generating tube on the other, can show what is inside the object.

It was many decades after Röntgen's discovery before other scientists figured out what X-rays are—electromagnetic waves like visible light but of shorter wavelength—and why it is they "see" through solidly opaque objects. In general it is the electrons contained in atoms that absorb X-rays; elements of high atomic weight have many electrons in a given amount of space, so they block X-rays more than do elements of low atomic weight, which have few electrons per unit volume. That is why iron and lead, which are heavy, block X-rays while such lighter elements as carbon, oxygen and hydrogen allow the rays to pass without as much obstruction. Human bones, which contain calcium and phosphorous, both fairly heavy, show as light markings on X-ray pictures. They have blocked the rays and kept them from darkening the film. Soft tissues, made mostly of carbon, oxygen and hydrogen, show darker on the film because they have permitted more X-rays to pass. The amount, as well as the composition, of absorbing material is also important. Hidden cavities in a metal casting or the air passages in a human lung appear darkest in the picture because they have not absorbed as many X-rays as the solid material around them.

How easily X-rays penetrate parts of an object depends also on the X-rays themselves, for the shorter the length of their waves the more energetic they are. The shorter X-rays, called "hard," show more of the finer details inside large, heavy objects such as ancient gold sculptures. But the longer ones, called "soft," are particularly useful for recording delicate nuances within easily penetrable materials—slight variations in thickness or composition then have a large effect on the amount of X-rays reaching the film, producing beautifully shaded pictures of things like plants, as in the photograph opposite.

Other kinds of radiation are more energetic—and penetrating—than X-rays. Gamma rays are essentially the same as X-rays but can be of shorter wavelength, and are used to make detailed shadow pictures of less easily penetrable objects such as machinery. (The basic difference between X-rays and gamma rays is in their sources: X-rays are produced by electronic tubes and gamma rays are given off naturally by some radioactive materials.) Quite different are neutrons, which are not electromagnetic rays but particles from the interior of atoms. They penetrate substances that X-rays and gamma rays cannot, giving the most detailed radiographs of all.

Dr. Paul Fries, a German physicist, uses X-rays ▶ to create such haunting shadow images of plants as those in the picture at right. Here he radiographed bouvardia and foxglove against a background of ferns, using long-wavelength, or soft, X-rays to reveal subtle differences in the inner structures of the plants.

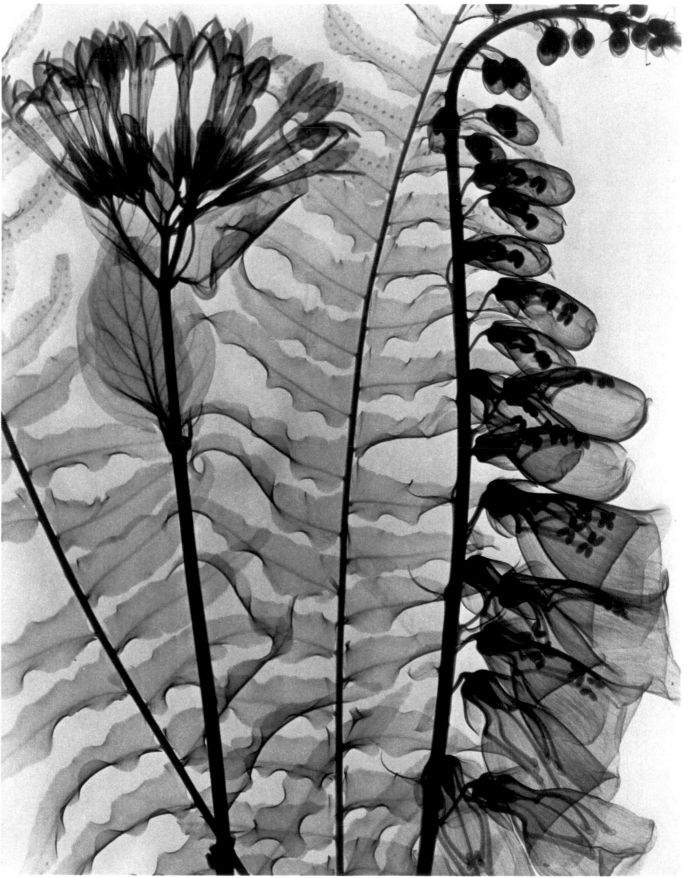

PAUL FRIES: *Among the Flowers*, 1956

Revealing Secrets within a Work of Art

Archeologists and art historians use the penetrating power of X-rays and gamma rays to probe opaque surfaces to study what is underneath the surface of the work without destroying it. Mummies are radiographed to investigate the medical histories and the physical characteristics of peoples who lived thousands of years ago. The craftsmanship of past civilizations is also revealed by radiography and often shown to be surprisingly sophisticated. Egyptologists, for example, long believed that the mask of Tutankhamen, Pharaoh of Egypt in the 14th Century B.C., had been constructed of two separate pieces of gold, although it appears to the eye to have been molded as a single piece. But since gold is extremely dense, impervious to even the hardest X-rays, the theory was not confirmed until 1967, when very hard gamma rays from iridium 192, a radioactive isotope that is produced by a nuclear reactor, were employed to make the clear radiographs at right.

Unmasking fraudulent works of art is another task for radiography. It immediately puts the finger on the forger who creates cracks on the surface of his painting to make it look old. Since he cannot make the cracks extend to the base of the canvas, the X-ray pictures show that they are superficial, revealing the fraud.

But art historians value X-ray pictures even more for the opportunity they give to study the artist's technique. X-rays, like infrared rays, frequently reveal that the artist made several different versions of a painting before he was satisfied with the version we see. These esthetic changes of mind are clearly visible in such photographs.

The mask of Tutankhamen (above) reveals its construction details in gamma-ray radiographs (right), confirming archeologists' suspicion that the mask was made from two pieces joined by a strip of gold, which appears as the light band running down behind the ear. The full-face view revealed an additional surprise: the pharaoh's beard was cleverly attached by a tapered cylinder pushed into the chin—visible in the bottom half of the picture at far right, opposite—and the beard was then fitted over it.

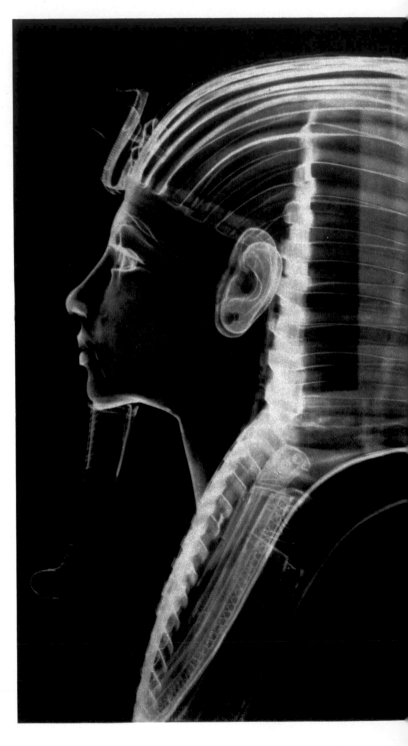

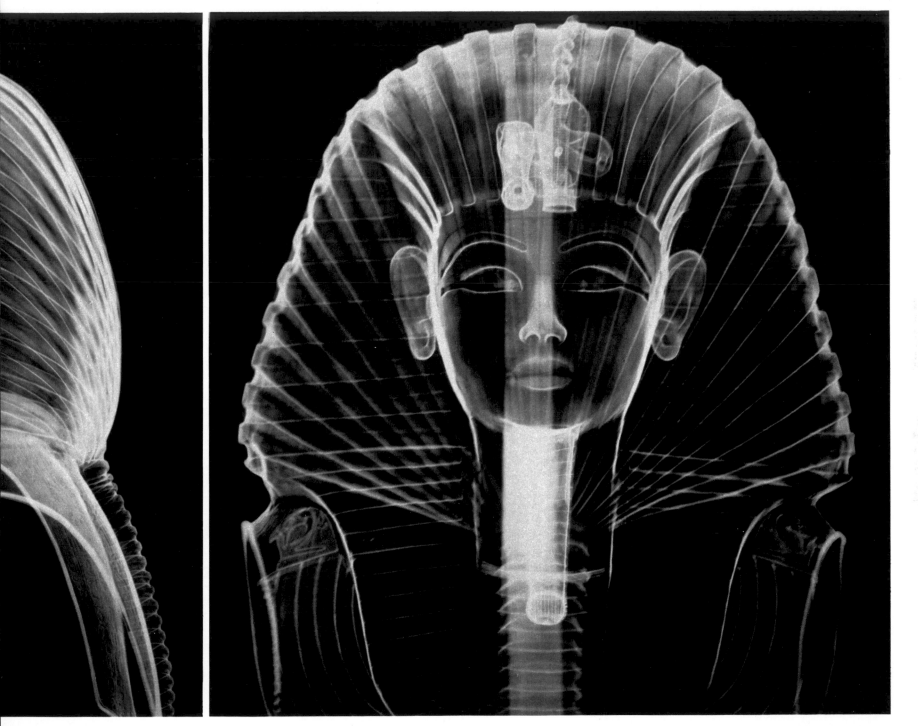

Details from a Radioactive Beam

Just as a dentist takes X-ray pictures of his patients' teeth to check for cavities, industries use the penetrating power of the rays to examine their products for weak spots or structural flaws. Dark spots on the film after exposure indicate cavities and flaws that have allowed the rays to pass through.

Radiographs are valuable for checking the consistency of raw materials as well as the quality and safety of finished products. If one part of a metal is thinner than another, it will show up darker on the radiograph. If the inconsistency is so great that it fails to meet specifications, the section is rejected.

Since their primary purpose is to check individual parts or samples of raw materials, industrial radiographs are usually quite small. The radiograph of the Mercedes Benz 230SL sports car at right is an obvious exception. To make the picture, hard gamma rays from radioactive cobalt 60 were used. The cobalt was then suspended from a crane that was secured to eliminate vibrations, five large photographic plates were placed under the car, and after 50 hours' exposure a detailed record of the works of a car had been made.

Made to demonstrate how radiographs can reveal fine detail, this gamma-ray picture—at 17 feet overall the largest ever made—shows the smallest part of an automobile's structure with incredible accuracy. Even the filaments in the headlights, at left, can be seen clearly.

What X-rays Miss, Atomic Particles Catch

As X-rays penetrate material that is opaque to visible light, neutrons, particles that constitute part of the basic make-up of nearly all atomic nuclei, pass through material that is opaque to X-rays—and also produce their own distinctively different kind of shadow pictures. Because neutrons, unlike X-rays, gamma rays and visible light, are not electromagnetic waves, they are not affected by the electrons that orbit around the core of an atom. Only the nucleus itself influences their passage, some nuclei affecting them more than others. Neutrons go easily through the atoms of heavy elements like lead, which stop X-rays, but are stopped by atoms like hydrogen and carbon, which pass X-rays.

The contrast between X-ray and neutron pictures can be seen in the two shadow photographs of a toy train. X-rays *(opposite, top)* outline the train's metal structures and little else. The ghostly image in the lower picture, made by scientists at General Electric, who used a stream of neutrons from a nuclear reactor, reveals the engine's plastic structure and even the rubber traction rings on the wheels because the nuclei of the rubber and the plastic stopped the neutrons.

Neutron pictures, or Neutrographs, are expensive to make, largely because they require costly nuclear reactors. But they are used in a few critical areas where X-rays are inadequate, such as checking the quality of explosives and inspecting parts used by aerospace and other industries. □

Made with a beam of neutrons from a reactor, this neutron picture of a stopwatch looks like an X-ray but is more detailed. The jewels can be counted easily, and the plastic fob, which is invisible to an X-ray, is clearly recorded.

Since neutrons penetrate objects that stop X-rays, this Neutrograph of a toy train (above) does not show its metal rails, visible in the X-ray at top. The neutron beam is absorbed by the wood crossties, and shows them clearly.

Infrared's Unnatural View of the World

Originally developed for the military to search for camouflaged enemy installations, films sensitive to the invisible waves of radiation called infrared help biologists take pictures in the dark, artists study paintings, ecologists detect water pollution—and ordinary photographers make extraordinary views of the world. Infrared films fit many standard cameras, and pictures are taken with them in the usual way (unlike X-ray photographs, which require special equipment). Infrared produces black and white or color—yet the pictures are anything but usual, for the tones are rendered in unnatural ways *(pages 150-156)*. This deliberate modification of nature is one of the attributes that makes infrared photographs so useful. The film records not simply the light the eye sees, but some of the invisible infrared waves provided by sunlight and artificial light. These are reflected by many things in ways different from the way visible light is reflected. Polluted water, for example, reflects visible light waves much like pure water. But it reflects infrared waves in a considerably different fashion; the pollution in a stream thus stands out noticeably in an infrared photograph.

The invisibility of infrared waves is their second great merit. Since good photographs—like the one at far right —can be taken in total darkness, many animal studies, for instance, are greatly simplified. The pictures of a gecko lizard shown here are part of a sequence made to investigate the action of the pupil of the eye as it opens and closes in response to changes in illumination. Catching the gecko with its pupil in various stages of contraction was simple with ordinary film and standard lights. But they would not do for a picture showing the pupil open to its largest aperture—it would begin closing as soon as the photographer started to take its picture. The solution was infrared illumination, to which the gecko is as insensitive as humans. The camera was loaded with infrared film and the light source was covered with filters that permitted the transmission of infrared waves—and the gecko's pupil was caught wide open in the dark.

Pictures can be indirectly made in the dark even without supplying the infrared illumination from filtered lamps, but only with very special equipment, for such pictures require electronic detection of very long infrared waves that do not affect films. But with this apparatus, man has been provided with an extra sense that reveals the appearance of the world even without light.

As a standard flashbulb fires, the pupil of a gecko lizard, a reptile native to Southeast Asia, contracts (above). But the picture at right shows the pupil fully dilated—a shot that could be made only because it was taken in total darkness with infrared film and a filtered flash that released only infrared waves. The flash of infrared, invisible to both lizard and photographer—but not to the infrared-sensitive film—is reflected in the cornea of the animal's eye.

Seeing through a Painting

Infrared photography is the next best thing to a short-range time machine for art historians. The history of a painting often lies just beneath the surface, unseen by even the most discerning eye. A restoration that covers part of the artist's original work, a painted-over signature, a change in the position of a subject, even a complete painting—all of these features may be hidden below the varnish of a finished painting. But infrared pictures can see through these uppermost layers to reveal what lies underneath. The pictures often reveal subtle artistic changes, as can be seen in the details at right from a painting by the Flemish master Jan van Eyck.

Infrared photography is particularly helpful for studying old paintings that are extremely fragile and must be handled with great care to prevent the paint from cracking. Infrared pictures can be made with the painting hanging in its position on the wall. There is thus little danger of damaging the work.

Infrared and X-ray photographs are usually made to study paintings before they are cleaned. Infrared is first used, and if further investigation is required X-ray pictures are taken.

As its title suggests, Jan van Eyck's 15th Century painting, "The Marriage of Giovanni Arnolfini and Giovanna Cenami," represents the wedding of a well-to-do Italian merchant. Because of its apparent symbolism—the candle signifies the presence of God—some imaginative art critics have suggested that the work is an allegorical marriage license. The impression that the bride is pregnant is simpler to explain—it is an illusion created by her costume, which was fashionable in that period.

This infrared photograph, taken at the London National Gallery before a cleaning, reveals that the artist reinforced the story he was telling just before he completed the painting. At the last moment Van Eyck changed the angle of the bridegroom's hand to indicate more clearly that he was taking his marriage vows, and also proceeded to place a wedding ring on his finger.

Pictures Made by Heat

Dark patches on a thermogram, or heat picture,
show cool skin on the right side of a patient's
head; normally warm skin appears lighter. The
unnatural coolness indicates impaired
blood circulation and suggests that an artery
carrying blood to the brain is partially blocked.

Only infrared radiation of a relatively short wavelength—called near infrared because the lengths are so close to those of visible red light—can be recorded on infrared film. Longer infrared waves, the far infrared rays of radiant energy that are generated in varying degrees by every physical object on earth, do not affect photographic emulsions. But they can be detected with electronic instruments—the descendants of the World War II snooperscope, which spotted enemy soldiers at night—that show heat images, known as thermograms, in televisionlike patterns. These images can be photographed to provide permanent records.

Thermograms are literally heat maps that record differences in temperature in the subject. When made in color, they reproduce hot areas as red, cooler areas as yellow, and the coolest parts as green. (If a black-and-white picture is made, cooler areas are dark while warmer areas appear light.)

Deviations of a fraction of a degree in the operating temperature of parts of machinery can be recorded on a thermogram to give advance warning that the part is functioning improperly. And cancer specialists have found that malignant tumors are slightly warmer than healthy tissue, permitting early, lifesaving detection of malignancy.

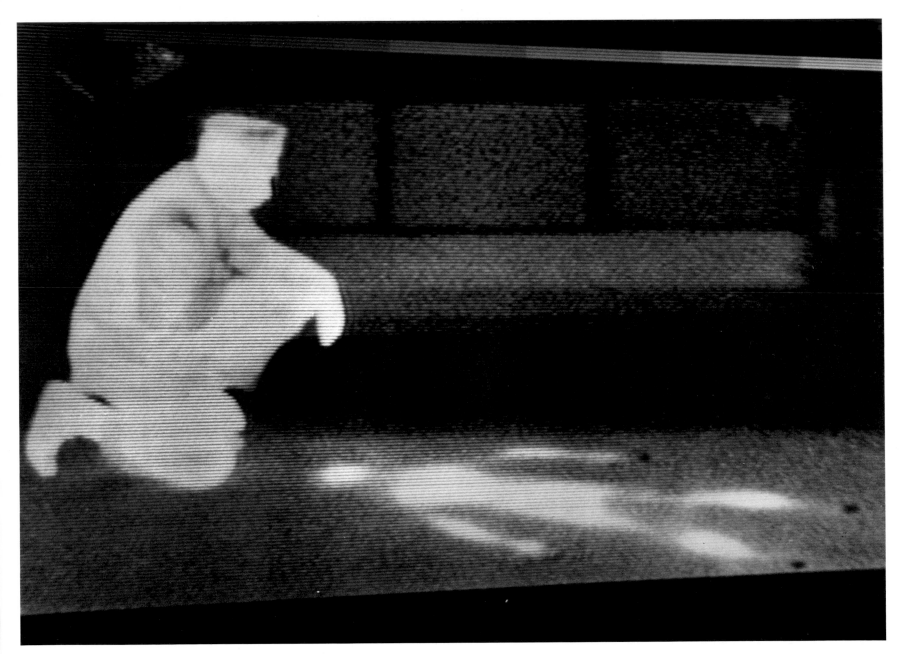

The body is gone, but the image of a "murder victim" remains in this thermogram made to show the power of infrared to peer into the immediate past. The policeman sees only a rug; the thermogram reconstructs a "corpse" from the heat the body left on the rug.

False Colors' Hidden Truths

Color infrared film is an invaluable tool for many disciplines because the colors it produces are so unlike the real colors of the world, making many natural features, invisible in standard pictures, stand out in "false" color. This transformation of the real world's hues was first used by the military. Trees and bushes cut down to camouflage equipment give themselves away because their foliage, still a fresh-looking green to the eye, shows brown in infrared's false colors, while healthy foliage registers as brilliant red. This is in part a result of the fact that objects reflect infrared waves to varying degrees. Healthy foliage contains a greater amount of chlorophyll, which reflects the infrared waves more strongly than dying foliage; these stronger reflections show up as red instead of brown in an infrared color picture taken with an orange

filter. Polluted water shows in a color different from that of clear water because decomposing organisms or other foreign matter interfere with the normal reflections of infrared.

The advantages of being able to distinguish between healthy and dead or dying plants and to note the presence of pollution in water by studying infrared color shots was quickly realized by ecologists, foresters and agricultural experts. Plant diseases, for example, can be sought and detected with aerial cameras before a widespread area is affected. Infrared photographs can be used to survey the entire plant resources of an area, for it is possible for experts to distinguish among varieties of trees and bushes in a forest by studying an infrared picture made from the air—the foliage shows obvious variations in infrared color.

The standard-color photograph above, taken from Gemini V, clearly shows the Imperial Valley, which extends from the Salton Sea (left) in California south across the border into Mexico. The entire valley appears fertile. But in the false-color infrared photograph at right, taken during the flight of Apollo IX, the well-irrigated California section of the valley stands out in brilliant red, a sign of healthy vegetation. The Mexican part of the valley appears bluish, an indication of poor drainage and excessive salinity in the soil. The thin line between the two sections marks the American-Mexican border.

JAMES A. McDIVITT, RUSSELL L. SCHWEICKART, DAVID L. SCOTT FOR NASA: *Imperial Valley*, 1969

151

A Practical Guide to Using False Colors

no filter　　　　　　　　　　　　**yellow filter, # Y-8**　　　　　　　　　**orange filter, # O-22**

Kodachrome II ➤

Kodak Ektachrome infrared *Aero* film 8443 ➤

When photographers first started using false-color infrared film, they quickly discarded the data sheet's recommendation of the No. 12 filter (frequently called "dark yellow," but actually closer to orange) and began experimenting with different filters, producing pictures that were often beautiful—but puzzling. The color of the filter seemed to bear no relation to the colors that appeared in their photographs.

To provide a guide to the color transformations obtained with different filters, the LIFE Library of Photography asked Tom McCarthy, a photographer noted for his infrared studies *(pages 154-156),* to take this series at Grand Canyon. As expected, the natural-color pictures *(top row)* assumed the colors of the filters used; the colors in the infrared photographs are quite different.

When no filter is used with infrared film *(far left, bottom),* the entire scene assumes a purplish hue, but features on the horizon that appear grayish brown in normal color *(top, far left)* shift to fuchsia. With a yellow filter *(second*

red filter, # R-25 **green filter, # G-11**

from left) the dominant color of the infrared scene becomes blue.

With the orange filter *(third from left, bottom),* the color shifts are dramatic. Green foliage, barely discernible in natural color and in the first two infrared shots, takes on a reddish cast. The red filter *(fourth from left)* produces less striking color shifts, and the green filter

at far right simply gives everything a bluish cast, but does create a striking, other-worldly landscape.

Using these pictures as a guide, photographers can obtain at least a general idea of what to expect with different filters. But there are certain cautions to observe. Normal filter factors do not apply to infrared film. All of these pic-

tures were shot at 1/250. For the natural color, recommended filter factors were employed and f-stops adjusted accordingly. For the infrared, McCarthy used f/11 for the filterless shot, f/8 for the yellow, orange and red filters, and f/4 for the green filter. But bracket widely, at least two full stops above and below the estimated setting. ☐

TOM McCARTHY: *Fishing Pier,* 1969

Using infrared color film and a red filter on the lens of his camera at 1/100 second and f/16, Tom McCarthy transformed a Florida fishing pier at sunset into this eerie scene in which the water appears yellow and the sky green.

In this subtle double exposure, McCarthy ▶ photographed the same scene twice at 1/250 second and f/11, using a red filter for the first exposure, then switching to a yellow one. Infrared reflected by the leaves registered as red. The filters created additional color shifts to produce the faint yellow shades.

TOM McCARTHY: *The Tree,* 1969

Combining the two dominant images of Venice, McCarthy took this false-color infrared double exposure—of a canal and St. Mark's Cathedral—at sunset with green and blue filters, and using a speed of 1/125 second at f/4.

TOM McCARTHY: *Venice Submerged*, 1969

An Aid to Technology and Medicine

5

HENRY GROSKINSKY: *Photographically Produced Computer Circuit*, 1969; magnified 40 times

New Eyes for Factory and Laboratory

The more man builds complex machines to extend his muscles and mind, and the more he attempts to repair that most sophisticated of machines—the human body—the less adequate seems his eyesight. No eye can see what happens in the howling flame of a rocket, perceive the strains and stresses within a building, or watch a baby growing inside its mother's womb. But photography can. To keep pace with the ambitions of a modern technological society, photography has had to develop all sorts of complex and specialized powers. Its basic image-making ingredients of light and film have proved amazingly adaptable and versatile.

Images are formed by an uneven distribution of light that creates brighter and darker regions in a picture. In ordinary photography, inequities of distribution are caused when objects in the world reflect and absorb light in varying amounts; the pattern is faithfully conveyed to film by a lens. The phenomena of refraction, diffraction and polarization also alter the motion and distribution of light, and they play an important role in technological photography as well. All of these aspects of light have long been known. The ancient Greeks understood that light is bent—refracted—as it passes through media of differing densities. In the 13th Century, the English scientist Roger Bacon explored the behavior of convex lenses (he was, in fact, imprisoned for inventing spectacles, held to be an instrument of the devil). Religious conservatism notwithstanding, monks were soon wearing eyeglasses, and in the middle of the 17th Century an Italian Jesuit named Grimaldi went on to discover diffraction—the bending of light waves as they pass a sharp edge or through a slit. Only a few years later, the great Dutch scientist Christiaan Huygens investigated polarized light waves, whose vibrations are restricted to a single narrow plane—unlike ordinary light, which vibrates in all directions perpendicular to its line of travel.

The men who unveiled the complex behavior of light would undoubtedly marvel at today's technological applications of their discoveries. Refraction, for example, is exploited by techniques called schlieren photography and shadowgraphy, which are used to capture and investigate such elusive subjects as a shock wave from an explosion, the turbulence in a flame or the air currents generated by a speeding aircraft. Compressed or heated gas refracts light, and the bent rays can be recorded by photographic emulsions if the illumination is sufficiently brief and intense.

Lenses also employ refraction, but in a rigorously predictable manner. They preserve the pattern of light from a subject, and at the same time bend the rays so that the image will fit on the film. This bending can also produce drastic magnifications or reductions of size, and modern technology and medicine utilize both effects. Sweden's famed medical photographer Lennart Nilsson, for instance, uses tiny, high-magnification lenses to reveal such

arcane scenes as the inside of an artery or the gossamer tissues of a fallopian tube. The electronics industry, on the other hand, often proceeds from the large to the small. Through the intercession of distortion-free lenses, the patterns of electronic circuits of up to 40 square feet can be reduced in size to fit on chips of silicon smaller than the head of a pin. These miniaturized circuits are very reliable and function with great rapidity, making possible hearing aids that fit inside an ear and computers that perform many millions of calculations per second.

Polarized light has also become a technological boon. Most photographers regard it as something to be gotten rid of, and they employ filters to cut off the polarized reflections from windows or water. But a technique called photoelastic stress analysis uses a pair of polarizing filters to see the stresses inside plastic materials. By making small plastic models of buildings and photographing them in polarized light, structural engineers are able to instantly identify complicated inner forces that would defy mathematical analysis. Automotive engineers spray adhering plastic on car parts, put the parts under stress, and then photograph them in polarized light to see if they will hold up under hard driving.

Ingenious as all these methods may be, they nonetheless pale beside a technique called holography. As its name implies (*holos* means entire), holography captures all the visual information about a subject, yielding three-dimensional images that can be viewed from many angles. Holographic instruments can scan the distribution of dust and pollution particles in the air, detect imperfections in machine parts or store enormous amounts of data for computers. Among the medical applications of holography are microscopes that will enable biologists to photograph specimens in the round. And someday there may be holographic television sets whose three-dimensional pictures will seem to float in mid-air.

In one sense, holography is a radical departure in photography. It makes use of the laser—the technological wonderchild of the 1960s that produces a brilliant beam of light with its waves all perfectly in step. However, it is also based on the long-known principle of diffraction. Holography is thus a melding of a new discovery and an old one—and the combination promises to change the world of photography.

Eerie Visions of Heated Gas

Light rays are bent when they pass from one transparent medium to another of different density—from air to water, from one gas to another, or among currents of the same gas at different temperatures. An ingenious technique called schlieren photography *(schlieren* means streaks in German) exploits very slight amounts of bending—or refraction—to make visible the most ephemeral motions of gas and to tell scientists what happens in such unapproachable regions as the fiery exhaust of a jet engine. For the remarkable pictures on these pages, William T. Reid, a fuels specialist of the Battelle Memorial Institute in Columbus, Ohio, employed the schlieren method to show heated air rising from his own fingers *(right),* and to reveal the turbulence in a Bunsen burner flame *(opposite).*

A high-speed flash of light is needed to stop the motion, but the heart of the technique is the use of two sharp knife-edges that partially intercept the light beam before and after it strikes the gaseous subject *(diagram below, right).* The second knife-edge causes the various degrees of refraction, resulting from temperature differences in the gas, to be recorded on film. As shown in the diagram opposite, it cuts off some bent rays of light and allows other bent rays to pass on to the camera. The result is a glimpse of gas currents that would normally be invisible.

WILLIAM T. REID: *Warm Air Currents Rising from Fingers,* 1950

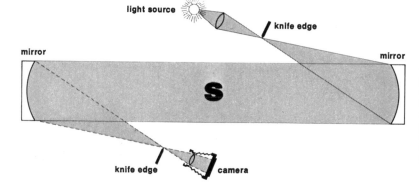

Warm air currents—around 98° F.—rising from William Reid's fingers (left), are distinguished from the 75° laboratory air by the adding and subtracting of refracted light by the schlieren knife-edge. The picture was made with a 5 x 7 Corona view camera. The light source was an electric pulse in a high-pressure mercury lamp, which produced a flash of 3/1,000,000 second.

As shown in the diagram at left, schlieren photography uses a focused light beam passing over two knife-edges—before and after it illuminates the gas currents being recorded. After the first knife-edge has given the beam a sharp edge, the light is directed to the subject by a concave mirror. A second mirror simultaneously refocuses the light at the other knife-edge and directs it into the camera.

A turbulent Bunsen burner flame (right) is frozen into a flowing sculpture in this schlieren shot made by Reid at 3/1,000,000 second. This extraordinarily fast speed was needed to freeze the extremely rapid turbulence in the primary burning zone at the base of the flame.

The diagram below schematically shows how the second knife-edge affects light refracted by the Bunsen burner flame. The edge normally cuts off half of the focused beam. However, temperature differences within the gas bend some rays in the beam—which would otherwise pass over the blade—downward, where they are intercepted. This leaves some dark sections in the part of the beam passing over the blade edge. Other rays, which would have been intercepted by the edge, are bent upward and add their brightness to the bright sections already in the part of the beam passing over the edge. A coruscating image of light and dark areas is thus recorded on the film, revealing the rolling currents that are present in the gas.

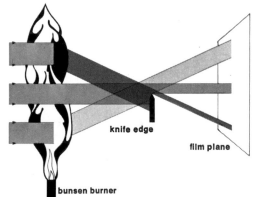

knife edge

film plane

bunsen burner

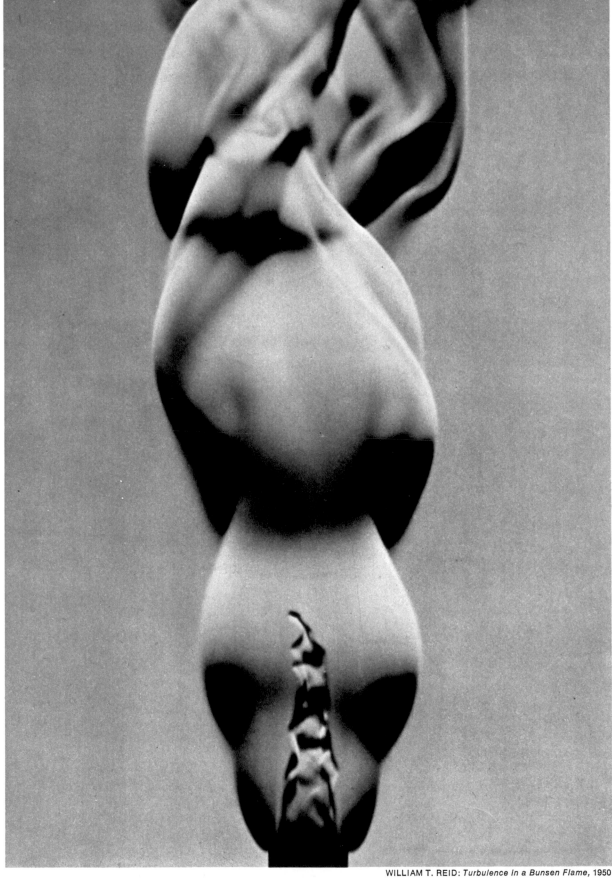

WILLIAM T. REID: *Turbulence in a Bunsen Flame*, 1950

Shock Waves: Shadows of a Bang

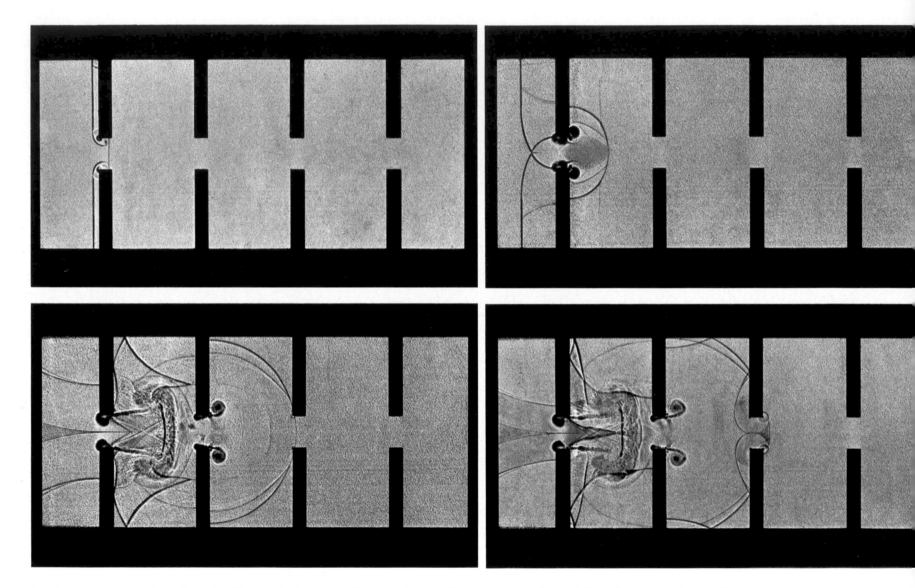

In designing an internal-combustion engine or a gun, engineers must find a means of reducing the impact of the shock wave that is produced by the explosion and causes its noise. One way is to direct the shock wave—a region of compression in air moving at the speed of sound—through baffles. A car muffler works on this principle. Through a technique called shadowgraphy, engineers can actually photograph the effect of the baffles on the wave. Compressed air bends light to a greater degree than air at normal pressure because it is denser—and the bent waves of light can draw shadowlike lines directly on film without the intercession of a camera lens.

To get the shadowgraphs on these pages, a team of scientists at the Ernst-Mach-Institut in Germany used a spark device that emits bursts of light at the rate of 50,000 per second—fast enough to catch a shock wave, emitted by a laboratory device called a "shock tube," making its way through four baffles at 1,100 miles an hour.

In a sequence of eight shadowgraphs, a shock wave can be seen (left to right across these pages) passing through apertures in four baffles (dark areas) in a pipe. Part of the wave is deflected by each baffle in turn, and the rest surges into the next chamber with its pressure lessened. A series of bright electrical sparks cast the shadows directly on the film.

Small Electronics Printed from Large Negatives

Microphotography performs a function just the opposite of photomicrography: instead of producing a magnified picture of a small object, it makes an extremely small image of a large one. Microfilms are well-known examples. In industry its most spectacular application is the integrated circuit. By microphotography, scores of tiny electronic components can be made to operate appliances, pocket computers and, if anyone needed it, a finger-ring radio to make Dick Tracy's seem cumbersome.

To mass produce these building-blocks of the space age, a master circuit pattern *(above, left)* is reduced photographically to a 1/500-sized image and repeated hundreds of times side by side on a single negative. In a process very similar to photoengraving, light is then beamed through the negative to print the hundreds of circuit images on half-dollar-sized slices of silicon that have been made light-sensitive. After this exposure, the unexposed areas are etched away. The etched-out areas are then exposed to chemical "dopants" that alter the electrical nature of the silicon. Repeating the process builds up a series of deposits that create the circuit components; these can perform all the functions of transistors, diodes, resistors and capacitors. The integrated circuits are then cut apart, each a chip so small that many thousands of them will fit into a thimble.

A technician at a New Jersey plant of RCA examines a master pattern (left) for an integrated circuit to be photographically reduced in size. Each circuit, which combines many diverse electronic elements in one tiny chip of silicon, contains several such patterns. Above, an employee of Texas Instruments in Dallas, her head covered to keep dust from upsetting the process, projects multiple-image circuit patterns onto the sensitized silicon wafers visible in the foreground of the picture. Mass-production techniques have reduced the price of some integrated circuits to less than 50 cents each—one tenth the cost of equivalent circuits made the old-fashioned way by laboriously wiring individual elements together.

In the group of simple integrated circuits at right (enlarged about 18 times), each 1/20-inch block contains three transistors and several resistors. These circuits were made for use in early transistorized television sets. One of the circuits did not develop correctly; the blank space in the photograph indicates that it was excised. Microphotography can yield circuits miniaturized even further—with as many as 500,000 components per square inch.

MANFRED KAGE: *Integrated Circuits*, 1966

Analyzing Stresses with Polarized Light

Engineers have often wondered whether the beautiful spires and arches of Europe's Gothic cathedrals served a structural purpose—or whether they sometimes were used as mere decoration. To find out, Professor Robert Mark of Princeton University photographed Amiens Cathedral in France, using a technique known as photoelastic stress analysis. He built a cross-sectional plastic model of the cathedral and hung it with steel weights *(above)* to simulate a 60-mile-per-hour wind from the right.

When the model was photographed between two crossed polarizing filters, psychedelic swirls of color appeared —produced by the effect that stressed regions of plastic have on polarized light. After studying the stress pattern, Professor Mark concluded that most structural features of Amiens Cathedral were fully functional. A similar study of a church in Rouen indicated stresses high enough to have caused cracks —and when he checked, the cracks were indeed there.

A number of steel nuts, pulling from one side against a plastic model of a cross section of Amiens Cathedral, duplicate the pressures of a 60-mile-per-hour gale on the original. The model has been heated and made less rigid so that the stresses will actually reshape the plastic. Next, it will be cooled down again in order to "fix" the effect of the stresses permanently.

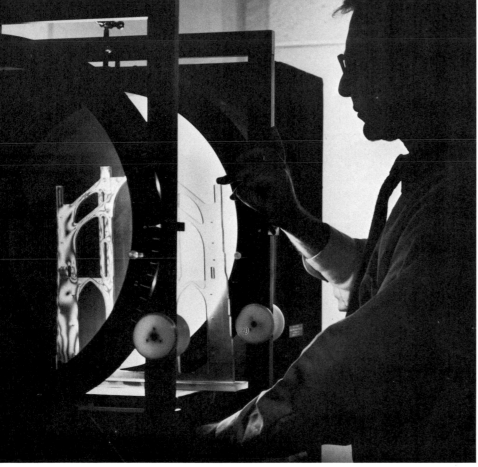

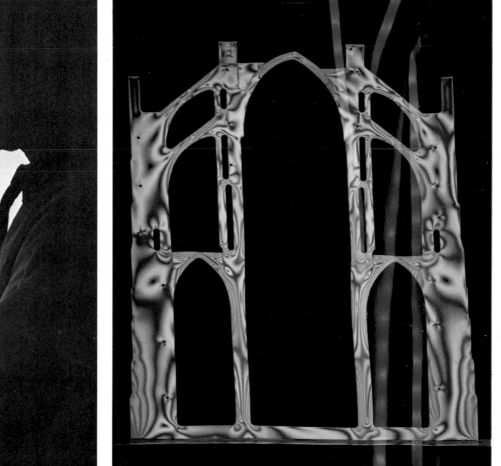

Professor Mark puts the cathedral model, its stress patterns fixed in place, between two sets of filters. The rear filter polarizes the light falling on the model, so that only light waves vibrating in restricted directions reach it. Normally, this light would not pass through the foreground filter, which is oriented to block waves vibrating in the direction given by the first filter (and, in fact, the left side of the light source is dark in the picture above). But the stressed areas in the plastic alter the direction of polarization of some light waves passing through the model and they can get through the second filter.

In addition to altering the polarization of light, the stressed areas of the plastic slow down light waves of some wavelengths—or colors. Some of the slowed light waves will be out of step with the others, and they tend to cancel each other. However, other wavelengths will remain in step. When viewed through the second polarizing filter, the noncancelling wavelengths show up as swirls of color. Stress is greatest in the plastic model where the color-pattern is most crowded.

169

Creating Polarized Colors at Home

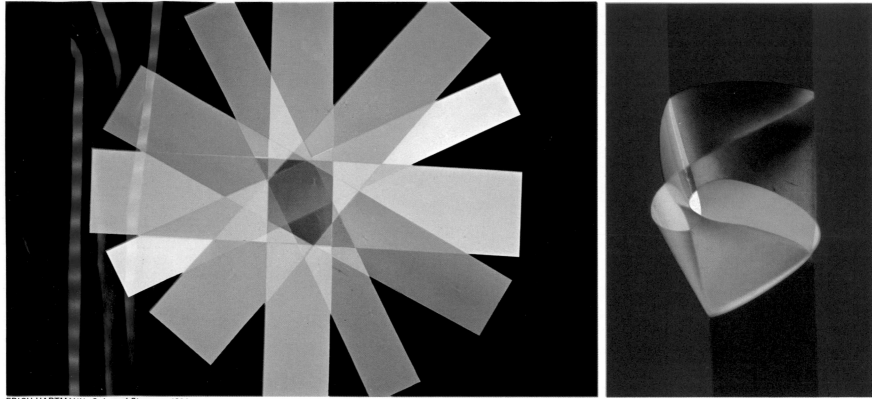

ERICH HARTMANN: *Colors of Stresses*, 1964

The same technique that engineers and scientists use to study structural stresses in buildings has been exploited by some photographers for esthetic reasons alone. Even ordinary transparent plastic materials—things like hangers, wrappings, and so on—can put on a peacock display of colors, because they contain stresses built into them when they were manufactured, and the stress areas selectively reinforce certain wavelengths, or hues, of polarized light that are passing through them. The only special equipment needed is two filters to produce cross-polarization. One, in front of the light source, polarizes the illumination falling on the plastic subject; the other polarizing filter, in front of the camera, makes the colors apparent.

For the pictures above, Erich Hartmann used clear sheet acetate as his subject. The pastel colors reveal the stresses formed when the acetate was extruded during its manufacture. Nina Leen chose household items for her composition *(opposite)*. Both photographers turned their filters to cross the angle of polarization of the light waves. Although scientific studies usually require large polarizing screens, pictures such as these can be made with small filters. One can be a polarizer used as a sky-darkening or reflection-reducing filter on a camera; the other can even be a lens from Polaroid sunglasses.

Erich Hartmann arranged strips of sheet acetate in a one-inch-wide rosette design for the picture at left and tied another strip into a knot for the picture above. To get close to the subjects, he used extension tubes (page 52) on his Pentax.

Plastic hangers, a small plastic box and ▶ cigarette-package wrappings glow with intricate colors in Nina Leen's picture at right. The light came from small spotlamps and passed through polarizing filters that were placed under and on the table on which the objects were arranged.

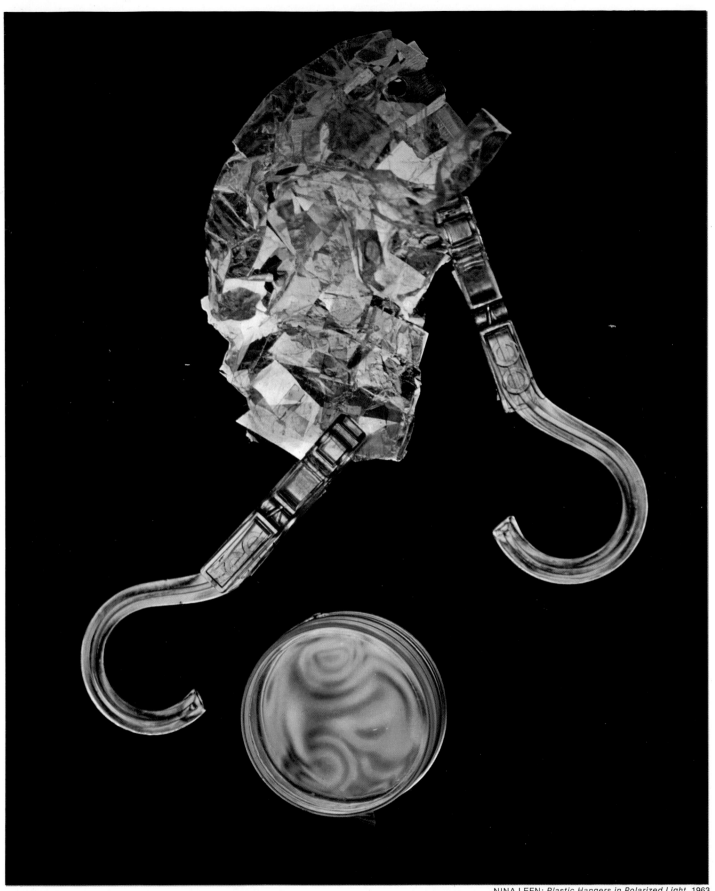

The Laser's 3-D Pictures

Holography—the technique of making three-dimensional pictures with laser light—is such a radical departure from conventional photography that it seems to have sprung full blown from science fiction. A hologram *(right, below)* is a photographic transparency—in this instance, a glass plate rather than film —exhibiting misty, swirling lines that were registered without the aid of a lens. And yet this apparently inchoate picture contains not just one but thousands of different views of the scene that it recorded. When laser light is shone through the front of the transparency, a startling three-dimensional vision of the scene can be perceived by the naked eye, floating in mid-air behind the transparency, as though seen through a window. Laser beams can also project the scene onto a screen *(opposite),* and different perspectives will appear each time if the spot where the projecting beam goes through the transparency is changed.

The theory of holography has been known since 1947, but it could not be put to work until lasers began to supply the world with an entirely new kind of light in the 1960s. The crucial characteristic of a laser beam is its orderliness: all the wavelengths are in step, like a flawless marching band. To make a hologram, a single laser beam is split into two (or sometimes more). One part of the beam is bounced off mirrors and then spread to illuminate the subject. The other—the reference beam—is reflected by mirrors onto a photographic plate without being directed to the subject. When the light reflected from the subject reaches the film, it interferes with the reference beam. That is, some of the perfectly regular waves from the

two beams reinforce each other, and some cancel each other out. The result is a seemingly garbled photographic recording of tiny lines. These lines, however, can help re-create the shapes of the light waves that made them. If laser light is shone through the lines at the same angle as the reference beam was, the lines will bend the light waves so that they cancel and reinforce in a manner exactly matching the relationship between the original beams. An absolutely lifelike, three-dimensional image is the result.

Such a three-dimensional view cannot, of course, be duplicated on a two-dimensional printed page. So for the demonstration shown here, photographer Fritz Goro designed an arrangement of solid shapes and letters that would reveal the variety of viewing angles packed into the one hologram. The hologram was made with laser equipment at the laboratory *(right, top)* of research engineer Juris Upatnieks and Professor Emmett Leith, who have pioneered in the technique at the University of Michigan. Because recording requires extremely fine separations between the lines on a hologram, almost no vibration was permissible. All of the equipment—the mirrors, lenses, beamsplitters and photographic plate—rested on a seven-ton granite slab set on inflated inner tubes. The subject figures were cemented to a wooden plate, since the slightest movement would have made them not merely fuzzy but totally invisible. Even the most minute sound vibrations—such as those made by voices—would have spoiled the experiment, so Goro and the scientists sat silent in the dark for the five-minute exposure that made the hologram. □

The main laser beam—made visible by smoke that Fritz Goro had blown into the laboratory —passes Upatnieks' right elbow and, controlled by a series of lenses and pinholes, illuminates the subject. Its companion reference beam has been temporarily switched off.

Professor Leith scans the final hologram—an 11 x 14-inch photographic transparency crammed with microscopic lines produced by a meeting of the reference beam and light waves that reflected off the subject. The pattern bears no visible resemblance to the subject.

Two different perspectives of Goro's specially designed subject are projected on the screens that are shown above when laser beams pass through the hologram at different places. Every part of the hologram contains a complete view of the entire scene holographed.

Witness to the Mysteries of the Body

No one has done more to reveal the innermost secrets of the body than the Swedish photographer Lennart Nilsson. He has devised special equipment and techniques that enable him to take the unusually beautiful and informative photographs that show what happens inside the body. In one of his most ingenious probes, shown at right, Nilsson was able to use the lens of a human eye in photographing the image it cast on the retina. Shimmering on the back of a young man's eye is an upside-down vision of a girl holding a telephone.

Nilsson took this most extraordinary picture with a special type of camera that ophthalmologists use to check on the health of the eye. The instrument is an intricate collection of mirrors and lenses that reflect a beam of light through a series of zigs and zags into the eye and back out to the camera. Nilsson adapted the device so that he could insert a color transparency of the girl into the beam of light, supplied by an electronic flash. When the flash was triggered, the young man actually saw the girl—and the camera was able to share in the marvel of human eyesight.

Inverted by the lens of the eye, the image ▶ of a girl on a color transparency floods the retina— a layer of light-sensitive cells that sense visual images. The picture discloses the network of blood vessels that occur in and around the cells and the optic nerve—the bright spot to the left of the girl—which transmits the image to the brain, where it is turned right side up again.

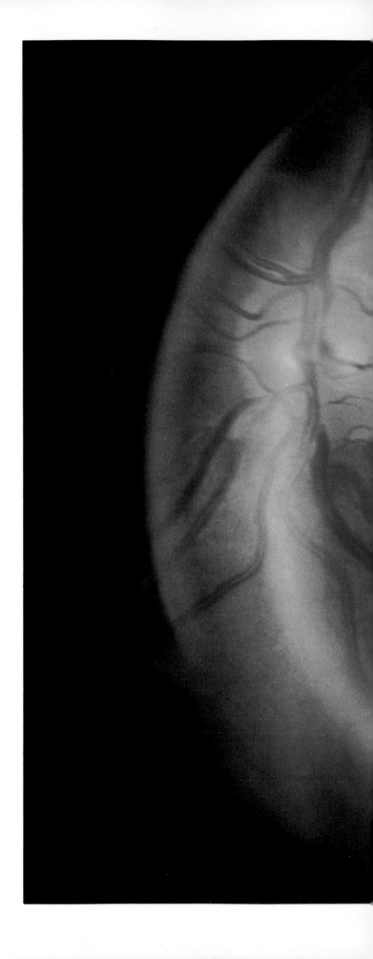

Anatomy Seen from the Inside

LENNART NILSSON: *Heart Surgery*, 1968

*For the eerie shot above, Nilsson placed a
super-wide-angle lens about five inches behind
the crest of the bared, beating heart of a man
whose chest had been opened for surgery. The
tiny lens, only 1.5 millimeters in diameter, was
attached to a Leica. Two electronic flash units
provided the illumination in the operating room.*

Besides sending light into the body
from the outside, Lennart Nilsson has
taken his lenses and light sources into
the most restricted recesses of the hu-
man anatomy. By using such achieve-
ments of miniaturization as a wide-
angle lens no larger than a rice grain,
Nilsson was able to make a heart's-eye
view of doctors about to commence
cardiac surgery *(left)*.

The picture at right reveals the inside
of a fat-choked aorta, surgically re-
moved after death, with an enormous
blood clot hanging like a stalactite.
Even the pathologists in the Stockholm
hospital where Nilsson was working,
veterans of daily study of the anatomy
of life and death, had never seen such a
sight until they looked through the
viewfinder of Nilsson's camera.

*To enter the previously unseen interior of a fat-
constricted aorta (right), Nilsson employed the
same tiny lens he had used for the heart picture,
plus a cable of twisted glass fibers to carry
light inside. Two holes can be seen where the
aorta, the body's main blood vessel, divides
into smaller arteries carrying blood to the legs.
In the foreground dangles a huge blood clot—a
coagulated mass of blood cells and protein
that measures a quarter of an inch in width.*

LENNART NILSSON: *Blood Clot*, 1968

The Story of Life's Beginnings

Of all the secrets of life, none is more moving than the creation of a new human being. Lennart Nilsson devoted seven years to capturing an entire record of the beginnings of life, from conception to natal squall. Working with doctors at several hospitals in Stockholm, he photographed embryos and tissues that had been removed for medical reasons—such as the gossamer folds of the fallopian tubes *(right),* where sperm and egg join up to share their hereditary material. He also took the first portrait of a living embryo in its mother's womb *(opposite).*

Only 15 weeks old, this tiny being measures about five and a half inches from crown to hips. Yet the features are already recognizably human, and the embryo has a heart that beats, nerves that send signals and muscles that can deliver a surprisingly strong kick to the mother. A leading Swedish gynecologist said of the historic photograph: "This is like the first look at the back side of the moon."

LENNART NILSSON: *Fallopian Tissues,* 1970

Nilsson photographed the tissues lining the fallopian tubes with a Hasselblad equipped with a Zeiss Luminar, a lens designed especially for extreme close-ups, which magnified the subject 25 times. Amid these cloud-soft tissues, sperm and egg come together in the moment that is the actual initiation of life. Some 200 million sperm may be present, but only one fertilizes the egg, which is about 90,000 times its size.

Using a super-wide-angle lens that covers 110° ▶ of view and a tiny light bulb at the end of a surgical viewing scope, Nilsson shot his picture of a living 15-week-old embryo (right) from only one inch away. The skin of the embryo is so thin the blood vessels seem to be right on the surface. In 25 more weeks, the baby will be born, having developed from two cells into an incredibly complex creature of 200 million cells.

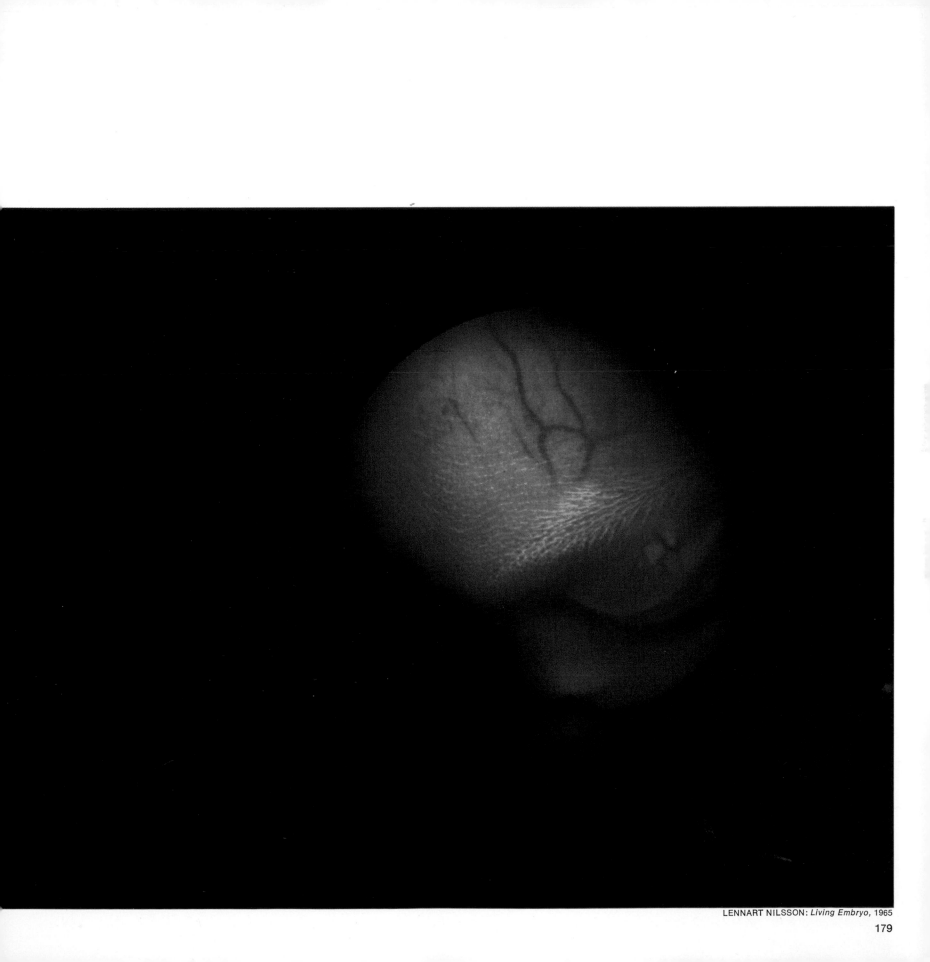

LENNART NILSSON: *Living Embryo,* 1965

The Magic Moment of Birth

While few photographers can hope to duplicate Lennart Nilsson's intricately managed medical picture taking, some amateurs can now move into the once-restricted precincts of the hospital to record the birth of their own children. In some hospitals, fathers are encouraged to accompany their wives through labor and delivery—with cameras, if they choose. John Graham, an NBC art director, availed himself of this opportunity. Both he and Mrs. Graham had taken a course in a natural-childbirth method in which the mother controls her breathing to eliminate the pain of labor. In hospital garb, Graham stood in a Hunterdon, New Jersey, labor room and posed for the shot above—calmly taken by his wife, early in her labor. The rest of the pictures document the drama thereafter from a father's view. □

◄ 3:55 p.m. (opposite, top right): As she has done since labor began at 8:00 a.m., Mrs. Graham works at breathing exercises to counter the tendency of pelvic and abdominal muscles to tense up painfully during contractions. Her husband, free to move about shooting pictures with his Nikon F, timed the procedure with a stopwatch to help in the exercises.

4:00 p.m. (opposite, bottom): At delivery's start, Mrs. Graham sits up to watch the baby starting to emerge as her husband continues his photographic record. The delivery room's bright illumination and shadows lightened by reflections from white surfaces eliminated the need for special lighting equipment. Exposures of 1/50 second at f/11 on ASA 400 film gave good negatives. The photographer's only problem was the excitement that comes with involvement. In Graham's case this was heightened by the fact that he and his wife had tried for four years to have a child and had pretty much given up on their chances.

4:00 p.m. (above): The baby reluctantly leaves its nine-month sanctuary. A few minutes later (right, top), the healthy infant—a boy—has liquid removed from his mouth by a suction tube. The mother, fully alert thanks to natural-childbirth methods, had watched the whole delivery in an overhead mirror. When she sat up and took her first direct look at her baby (right, bottom), she exclaimed, "Oh, he's so beautiful." The father later observed, "He wasn't. But it was a beautiful experience. We were both tearful."

*Only 10 minutes old, Benjamin Samuel Graham
—a robust infant weighing eight pounds
and 14 ounces—sleepily poses for his father's
camera in the hospital delivery room.*

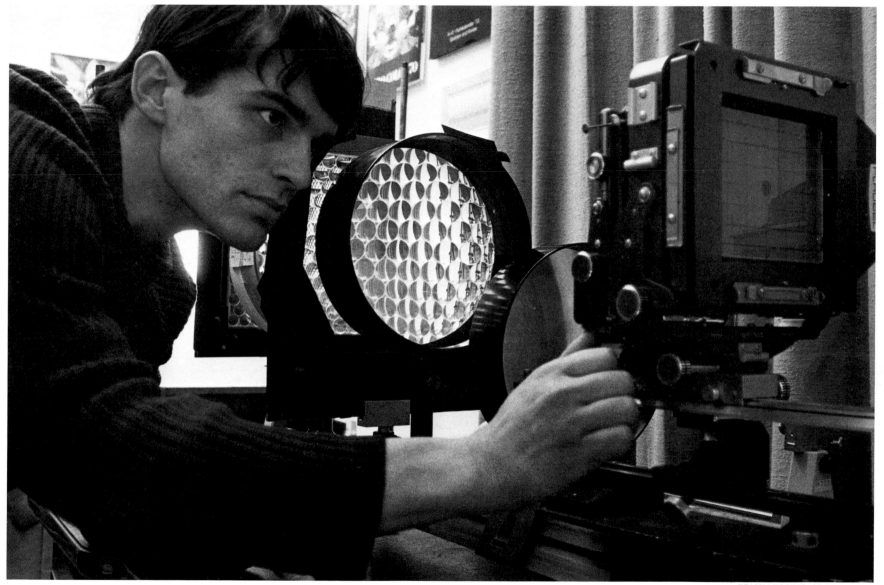

ERICH LESSING: *Multilens*, 1970

Special Equipment, Special Effects

The camera brings into being some of the most striking and useful views of the world when it deliberately lies, altering what the eye would normally see into what the eye would like to see. It can make subtle shifts of perspective, radical distortions of form or wholly new images. The agents of visual change can be mirrors, moving lights, even devices that cause the subject to vibrate rhythmically. Most often, however, photographers adjust the appearance of reality by using lenses of various types.

Both short- and long-focal-length lenses distort the apparent perspective in a picture, yet they may work in the cause of normality. For example, a wide-angle lens will produce an illusion of immense distances, which may be desirable in a picture of some expansive subject, such as a mountain range that seems to go on forever. A long lens, on the other hand, will diminish the effects of distance. Parallel lines, such as those of receding railroad tracks or (if the camera is looking upwards) the outlines of a skyscraper, will not appear to converge markedly; also, distant objects will retain more of the size that the brain knows they possess. Actually, neither short nor long lenses alter perspective in the true sense of the word—that is, they do not change the placement of objects in relation to one another, as would be the case if the camera had been moved closer or farther away from the subject. Their suggestions of distance—or lack of distance—are entirely due to the angle of view that they scoop in. A short lens captures a wide angle of view, and anything very far away will constitute only a small part of the picture—hence will look small. A long lens takes a narrow angle of view, and an object that is 200 yards away may fill up almost as much of this angle as an object of the same size that is only 100 yards away—hence there will seem to be far less loss of size with distance than the eye would ordinarily perceive.

Illusions of distance are not the only means of enabling lenses to preserve the appearance of normality. A special type of lens—called anamorphic —can make an image appear impressively tall by squeezing the horizontal dimension of the picture while leaving the vertical dimension alone. If the subject is tall to begin with, this effect may seem natural, for the human brain is more struck by height than by horizontal expanse.

Sometimes photographers want to break free of reality altogether, seeking stunning and mysterious effects that are obviously unnatural. With the naked eye, no one has ever seen a 360° panorama, a mosaic of images such as an insect perceives or a threefold multiplication of a scene. Yet lenses can produce all of these effects. Even more bizarre versions of reality are possible with the aid of such simple reflecting devices as kaleidoscopes or distorting mirrors. A kaleidoscope creates visions of orderliness by repeating an image over and over again within the compass of a circle. Distorting mirrors, on the other hand, may violate form and orderliness by inducing an

image to bend, bulge or contract in the most unexpected ways. The results may have the appeal of the funhouse, but sometimes they can stir deep questions about the make-up of the world.

Light itself—the very basis of photography—can also be manipulated to transform the eye's view of the world. Not only can it change color, cast strange shadows or range in intensity from dazzle to dungeon darkness, but it also may be given movement of its own. A beam of light, trapped by a time exposure as it plays across a wall, deftly sketches compositions. If a light is attached to a free-swinging pendulum and photographed by time exposure, it traces curving figures more accurately than any human hand, and replicates the eerie beauty of galaxies spiraling in the blackness of space.

Photographers are also learning how to exploit the laser's light, which is generated in a special way that gives it unusual characteristics. Ordinary light is emitted by the motions of the tiny electrons inside atoms when they are randomly excited by heat or electricity, and the random nature of the motions makes the light waves always out of step with one another. But a laser produces waves that are in perfect step, because its electrons are excited in a very regular fashion. Due to its regularity—or "coherence," as scientists say—laser light is pure in color, intensely bright and susceptible to extremely fine focusing. A laser beam can light up tiny areas of hard-to-reach spots, reach unerringly across miles of darkness and trace light pictures that are far more detailed and vibrant than anything ordinary light could produce. The laser is a recent invention, but it has already revolutionized many fields of technology—and promises to do the same for photography.

Experiments with new and startling sorts of photographic vision are particularly tempting because they are so easy. Lenses to perform a great variety of optical tricks are on the market. Lasers can be purchased for home use. Distorting mirrors can be made with polished sheet metal. Kaleidoscopes are simple to construct (directions are given on pages 208 and 209). With such special equipment so readily available, the only bounds to the effects that can be created are those set by the photographer's imagination.

Controlling Perspective with a Long Lens

HORST SCHÄFER: *Window Cleaner*, 1966

Even though the camera was aimed upwards at the United Nations Secretariat building, the outlines of the windows hardly converge at all. A 300mm lens distorted the apparent distance from top to bottom to retain the grid pattern.

Photographed from a distance of one mile with a ▶ 135mm lens, tenement buildings on a bluff of upper Manhattan (right) all seem to be of about the same size and appear squeezed together into a dense architectural mass.

What the eyes see and the brain knows are often quite different. The human eye possesses a lens whose rendering of perspective is about the same as that of a 50mm lens on a 35mm camera. When a skyscraper is viewed from below, the lines of the building appear to converge—and the "normal" 50mm lens will produce the same effect. Yet the brain knows that the lines of a skyscraper are in fact parallel, and it tends to interpret them that way.

Long lenses can build such an interpretation into a photograph. For example, the lines in the building above are parallel because Horst Schäfer used a 300mm lens on his camera. The long focal length keeps lines from converging (or objects from diminishing in size) as

much with distance as they would when photographed with a normal lens. The lens also enabled him to stand so far away that he did not have to aim his camera upwards. This picture looks right because it matches the brain's interpretation of the subject.

The effect of long lenses is demonstrated in another way in the picture of a cityscape at right. A 135mm lens has rendered the buildings in the background almost as large as those in the foreground, even though they are farther away. Yet this flattened effect jibes with the brain's interpretation. Facing such a scene in person, an observer would be more impressed by the massing of the buildings than by differences in their sizes.

HORST SCHÄFER: *Upper Manhattan*, 1964

Adjustable Cameras to Correct Perspective

Using a long lens is not the only way to adjust the appearance of perspective to prevent parallel lines from converging. In fact, it is often impossible or inadvisable to use one: the photographer may not be able to get sufficient distance between himself and the subject; or the distance may result in a loss of detail. The alternative is to employ special devices that keep the film plane parallel to the plane of the lines in a subject and thus maintain parallelism of lines in the photograph.

Such controls are an integral part of a view camera, making it the preferred choice for architectural and landscape photography. The lens and camera-back, connected by a flexible bellows, are independently mounted so that they can be raised, tilted and turned. By properly positioning the lens and film plane, even a very tall building can be photographed straight-on, and the entire façade will be the same distance from the plane of the film.

Some 35mm cameras can be modified to function like view cameras by replacing the standard lens with a "perspective-correction" lens *(opposite).* Since it is lacking a bellows, the P-C lens is not quite so flexible as the view camera—but it can move up, down or sideways so that the camera-back remains parallel to a subject, thus retaining parallelism of lines. Distortions also can be introduced for artistic effect.

Photographed by tilting the whole camera upward, New York City's Municipal Building tapers toward the top (right). The top is farther from the camera than the bottom, and the normal convergence of lines is recorded.

With a view camera, the lens can be raised to take in the whole building while the film plane remains parallel to the building. When the image is photographed in this way, convergence of parallel vertical lines does not appear.

The IBM office building in Harrison, New York, appears to be falling over backward in the picture at left because the 35mm camera was tilted upward and the film plane was thus not parallel to the building's glass façade.

The converging effects of normal perspective are nullified (left) when the P-C lens on the 35mm camera is cranked upward. This permits the image of the entire façade to be cast on a film plane parallel to the plane of the subject.

A Lens That Restores a Sense of Height

Many photographers have felt dismay upon seeing their pictures of the Matterhorn, the peaks of Yosemite Park, or some other towering subject. Even though the scene has been faithfully recorded, it somehow lacks the height that seemed so awesome. There is a simple explanation for this lack; the human mind is exceedingly impressed by height, but a camera, of course, has no such mental attitude.

However, one special lens system—known as anamorphic—can emphasize the vertical dimension just the way the brain does. Originally used to squeeze a broad view into the standard frames of motion picture film for wide-screen movies, it is shaped to compress one dimension of an image but leave the other dimension unaltered. The three views of a Spanish castle at right show what this treatment can do. The picture at near right is an undistorted view of the castle, shot with a standard lens, and it looks disappointingly squat. But the center picture, shot with an anamorphic lens that squeezes 50 per cent more subject-matter into the horizontal dimension, conveys an exhilarating and natural-looking sense of height. In the picture at far right, an anamorphic lens squeezed the horizontal dimension by 100 per cent; although the castle is now clearly distorted, it has a fascinating, fairyland appearance. (This picture is darker because it was taken later in the day; the lens did not affect the color.)

All such distortions must be introduced with forethought. If a wheel is in the picture, it will be transformed into an ellipse; a well-proportioned person may become a beanstalk. But prudently used, the anamorphic lens is a powerful tool for photographic drama.

normal lens

anamorphic lens, 50 per cent more horizontal subject-matter

anamorphic lens, 100 per cent more horizontal subject-matter

The View from the Top of Switzerland

The great Swiss photographer Emil Schulthess brings a rare combination of assets to his work: he is a highly creative technician and also something of a daredevil. Specializing in unusual views of nature, he has traveled to the South Pole and, on another occasion, north of the Arctic Circle to photograph the midnight sun *(pages 44-45);* once he ventured into the heart of an African desert to get the best possible view of a solar eclipse. Recently, Schulthess set out to photograph a 360° panorama of the Alps *(foldout, pages 197-200).* Although the subject was close to home, this turned out to be perhaps the most grueling assignment of all.

He designed a rig of three cameras *(right)* that would shoot simultaneously. Each was equipped with a 26mm lens, which swings through an arc of slightly more than 120°, making the three parts of the 360° picture that would be joined together later. He first planned to dangle this rig from a helicopter flying above the highest mountains—but he soon discovered that his shots became hopelessly blurred as a result of the vibration of the helicopter. The only alternative was to land on the highest mountain in Switzerland, the Dufourspitze, 15,204 feet above sea level.

Since Schulthess wanted to take the picture early in the morning to catch the most dramatic play of light and shade, he had to spend the night on the windswept pinnacle. The adventure began when he and two guides were deposited on the mountain by a helicopter *(opposite).* That night Schulthess tied himself to an iron cross near the top to keep from slipping off as he waited for dawn and the critical picture-taking moment *(overleaf).*

Schulthess' three Wide Lux cameras fastened in triangular formation; each covered one third of the all-around scene. Their views overlapped slightly, enabling prints of the three negatives to be exactly aligned for the 360° panorama.

Two pieces of white cardboard were placed above and below the cameras as targets for the helicopter pilot. By watching them he could make sure the shadow of the helicopter was cast over the camera rig, thus keeping the sun's direct rays out of the eastward-pointing lens.

Three separate photographs, shot simultaneously and later pasted together, make up this 360° view of the Swiss Alps from their highest point. Because the panorama was photographed at 7:50 in the morning, pools of mist still lie in the valleys, and sharply alternating patches of sunlight and shadow lend emphasis to the jaggedness of the mountains. (Schulthess had originally considered taking the picture before sunrise or at noon when the direct rays of the sun would not hit the film; however, he was able to shoot at this much more photogenic hour by using the helicopter to hide the sun.) The serene, crystal-clear view gives no hint of the daring and effort that went into the making of the photograph. Even the fearsome Matterhorn—spiking upward at the center—is just one more beautiful detail in a snowy realm.

Since the sharp, craggy-topped Dufourspitze is too narrow for a helicopter to land there, Schulthess and his equipment had to be lowered by cable. The cross just below the peak is similar to many planted on Swiss mountains.

Lenses That Repeat a Scene

NORMAN ROTHSCHILD: *Tower of Pisa, 1967*

Nature's optical systems for viewing the world are astonishingly diverse: a man looks mostly straight ahead, but a fish looks in two directions at once, a hawk perceives extreme detail and a fly sees a mosaic of images. More and more, photography is exploring the less familiar modes of vision—and inventing new ones as well. The triple image of the leaning tower of Pisa, at left, is unlike anything ever perceived by a living creature. The lens that caught the triplicate view actually contained three lenses. Positioned and shaped like slices of a single pie, they produced parallel, overlapping images.

Far greater repetition of an image can be produced by a multilens, which resembles the compound eye of an insect. The multilens that created the picture at right is shown on page 185. In this case, it was peering at a kaleidoscopic photograph of a face—hence the degree of repetition is even more complex and intriguing than a fly's-eye view of the world.

Photographed through a triple lens, the leaning tower of Pisa (left) becomes three towers, each overlapping and parallel. Similar lenses that give five parallel repetitions are also available.

The subject of the picture at right was a ▶ kaleidoscopic photograph of a face, radially repeated six times. The multilens repeats the sextupled view of the face many more times, and each of the small component lenses shows it from a slightly different angle.

EMIL SCHULTHESS: *Top of Switzerland*, 1969

Emil Schulthess' quest for a panoramic shot of the Swiss Alps suffered a setback at the very outset. After spending the night on the windswept, snowy peak, he awoke to find the mountains shrouded in fog. It was so thick that the helicopter could not pick him up again, and he and the two guides had to climb slowly down the icy precipice to a safer camp several thousand feet below.

Several days later the bad weather broke, and Schulthess had the helicopter take him up again. This time dawn brought a cloudless, brilliant day. As the helicopter hovered nearby, he and his guides climbed the last few feet to the summit *(left)* and began to set up the triple-camera rig. Then another crisis occurred: Schulthess discovered that the mechanism that would release all three shutters simultaneously was not functioning. Working with his bare hands in the freezing air, he disassembled it, only to drop a screw. Finally, after anxious searching, he spotted the screw in a crevice, put the shutter-release system back together, replaced the cameras on their tripod *(right)* and was ready to shoot the vista that can be seen by unfolding these pages.

MANFRED KAGE: *Multilens Kaleidoscope Face,* 1969

Multiplying an Image with a Kaleidoscope

In literal translation from its Greek origins, kaleidoscope means "viewer of beautiful forms." This optical instrument repeats an image line for line and color for color around a circle, generating an orderliness as scientifically symmetrical—and as bewitching—as that of a spider web. Appropriately enough, the leading creator of kaleidoscopic pictures is a photographer who works mainly in technical fields and is best known for his work in photomicrography *(pages 78-88)*—Manfred Kage. At right and on the following pages are shown some of the kaleidoscopic compositions that he produced at his Institute for Scientific Photography and Cinematography in Germany.

The radial repetition of images is a result of the construction of a kaleidoscope, which consists of two mirrors that form a V-shaped trough. The subject is at one end of the trough and the camera at the other, recording multiple reflections in the mirrors. The number of reflections depends on the angle between the mirrors. The angle can be determined in advance by dividing the number of images that you want into 360. Three images, for example, will require a 120° V. The third picture at right has eight images; in this case the mirrors formed a 45° angle.

In a toy kaleidoscope, the subject is bits of colored glass in a drum at the end of the mirror trough. For photography the mirror trough can be aimed at any subject. Manfred Kage, in creating startling evocations of order, uses several mirror arrangements to shoot different multiples of everything from fabrics to faces.

MANFRED KAGE: *Object,* 1969

MANFRED KAGE: *Material*, 1969

MANFRED KAGE: *Girl with Striped Design*, 1969

MANFRED KAGE: *Insect*, 1969

MANFRED KAGE: *Smiling Mouth*, 1969

How to Make a Kaleidoscope

Considering the intricacy of its images, the kaleidoscope is a remarkably simple instrument. One capable of striking photographic effects can easily be constructed in the home by following the directions at right. The essential ingredients are adhesive tape, a cardboard frame that will hold the mirrors firmly at the correct angle, and two mirrors of the front-silvered type. These mirrors have their reflecting surfaces on their faces rather than on their backs, and inexpensive ones can be purchased from scientific supply houses such as Edmund Scientific Co. (Barrington, New Jersey 08007). Ordinary mirrors, silvered on the back, will produce ghost reflections in a kaleidoscope.

The front-silvered mirrors must be handled with care, since they scratch easily. To determine which is the reflecting side, gently place a pencil point against the surface: if the silvered side is facing the pencil, the point and its mirror image will touch.

The kaleidoscope shown was designed to produce six images, hence the angle of the V is precisely 60°. When the kaleidoscope was completed, the photographer used a single-lens-reflex camera to shoot the picture on the opposite page, showing a toy monkey's face repeated six times. An SLR camera is best for kaleidoscopic work, because the image in the viewfinder shows exactly how the multiple reflections will be recorded on the film.

Two front-surface mirrors, each about an inch and a half wide and five inches long, are the heart of this kaleidoscope. (Polished metal will also do, but the reflections will be dimmer.)

Place the mirrors silver side down, separate them by a distance of about double their thickness and join them together with a strip of tape. The mirrors must be exactly parallel.

Stand the mirrors on a protractor, their sides forming a 60° angle, and make sure that they are touching all along the apex of the angle. If there is a gap, the tape should be reapplied.

Now use the protractor to outline two 60° notches on pieces of cardboard that will form the frame to support the mirrors. This requires a sharp pencil, for the angle must be precise.

With a razor knife cut the 60° notches in the two pieces of cardboard. To ensure that the notch angles are correctly cut, guide the knife with the straight edge of the protractor.

After bending the cardboard pieces and forming a rectangular frame with staples or tape, place the mirror trough in the notches. Bits of tape on the ends of the mirrors hold them in place.

When shooting a kaleidoscopic picture, the camera should be held very close to the mirrors (above) and aimed exactly at the point where the mirrors meet at the far end of the trough. Usually it will be necessary to try out various camera angles to get the reflections perfectly symmetrical. This kaleidoscope produced the picture at right. Five faces of the toy monkey are reflections; the sixth is a direct photograph of the subject at the other end of the trough.

AL FRENI: *Toy Monkey*, 1970

Altering and Destroying Form

Even multilenses or kaleidoscopes merely repeat an image but do not deform it. Yet violent distortions can be lovely, particularly if the subject of the photograph is abstract to begin with. The pictures at right and opposite are two highly distorted versions of abstract compositions made of pieces of colored paper *(right, below)*. Both were made by very simple techniques.

For the distortion at right, Japanese photographer Nob Fukuda placed one composition above a sheet of polished aluminum. He then twisted the metal until the reflected colors flowed and spread out like liquid paint.

For the version opposite, Fukuda photographed another abstract composition through a pane of diffracting glass. This time, instead of obtaining sinuous curves, he got a fractured, formless picture that seems totally alien to the original image, which was a concentric design. And yet there is a strange enchantment in the way the colors shimmer and play in the numerous geometric facets of the glass pane.

NOB FUKUDA: *Butterfly*, 1969

The sheet of aluminum reflecting the colors above was flexible but thick enough to hold its shape when twisted. The composition (left) that served as the subject was pieces of glossy, colored paper pasted on white cardboard.

A concentrically shaped, cut-out composition becomes entirely formless (opposite) when photographed through a sheet of diffracting glass, whose surface has many facets.

NOB FUKUDA: *Fractured Globe*, 1969

Celestial Patterns of a Swinging Light

The large-scale movements in nature —planets orbiting a sun, comets following elliptical tracks measured in billions of miles, galaxies pinwheeling in the void—are controlled by the force of gravity. Because gravity is universal, its enormous celestial effects can be replicated with a device as simple as a pendulum—and this is exactly what Jerome Kresch did to create these lovely pictures of spiraling, whirling, weaving patterns the eye never sees.

The head of Kresch's pendulum contained six miniature bulbs of different colors. He simply set his camera for a time exposure and photographed the reflections of the swinging bulbs in a mirror positioned below the pendulum. To yield diverse color effects in the pictures each bulb could be turned on or off by its own switch. Automatic switches flashed the bulbs on and off during an orbit to produce the streaks on various photographs. Kresch also created dots of color by placing a slotted disk, spun by an electric motor, between the lights and the mirror. For the picture at far right in the top row, he employed a multiple exposure—first swinging the pendulum one way, then swinging it in other directions for the second and third exposures—thus compiling motions that suggest a star system.

JEROME KRESCH: *Light Patterns*, 1970

JEROME KRESCH: *Light Patterns*, 1970

A Musical Dance of Laser Light

A laser wields light in ways that can create entirely new kinds of photographic images. Like a very fine paint brush, it can draw ultra-thin lines with light or position a dot of light-energy with pinpoint accuracy. In the pictures on these pages, lasers have been used to meld two kinds of perception—light and sound. The narrow beam of the laser responds to the faint vibrations that make up sound, just as a fine paint brush reveals the faintest trembling of an artist's hand. Both of these pictures were sketched by laser light that jiggled when music caused the air to vibrate. The musical vibrations, affecting mirrors that were reflecting the laser beams, induced the light to dart wildly across a wall.

The man at right is watching a musically induced pattern of light emitted from a single laser. The more complex composition on the opposite page was produced by two musically controlled lasers—one generating a continuous red beam and the other emitting pulses of blue-green light. Jumping about in response to blasts of rock-and-roll music, the dots and lines of laser light never repeat the same pattern—but a time-exposure photograph has forever fixed the fleeting image.

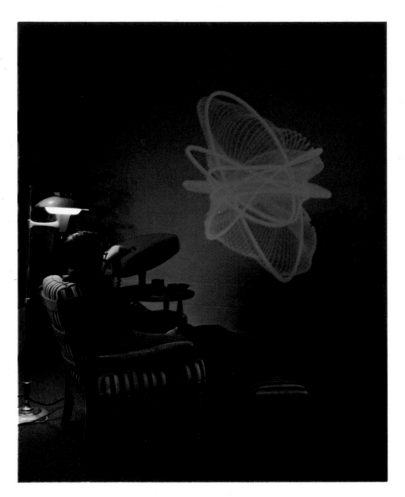

On a living-room wall a laser beam sketches the "look" of music from a phonograph in the background. The laser that projects these evocative oscillations is an inexpensive device especially designed for use at home.

Dots and lines of laser light dance on a wall, responding to vibrations of rock-and-roll. Mirrors mounted on a membrane that was jiggled by sound waves were reflecting the beams of helium-neon and argon lasers.

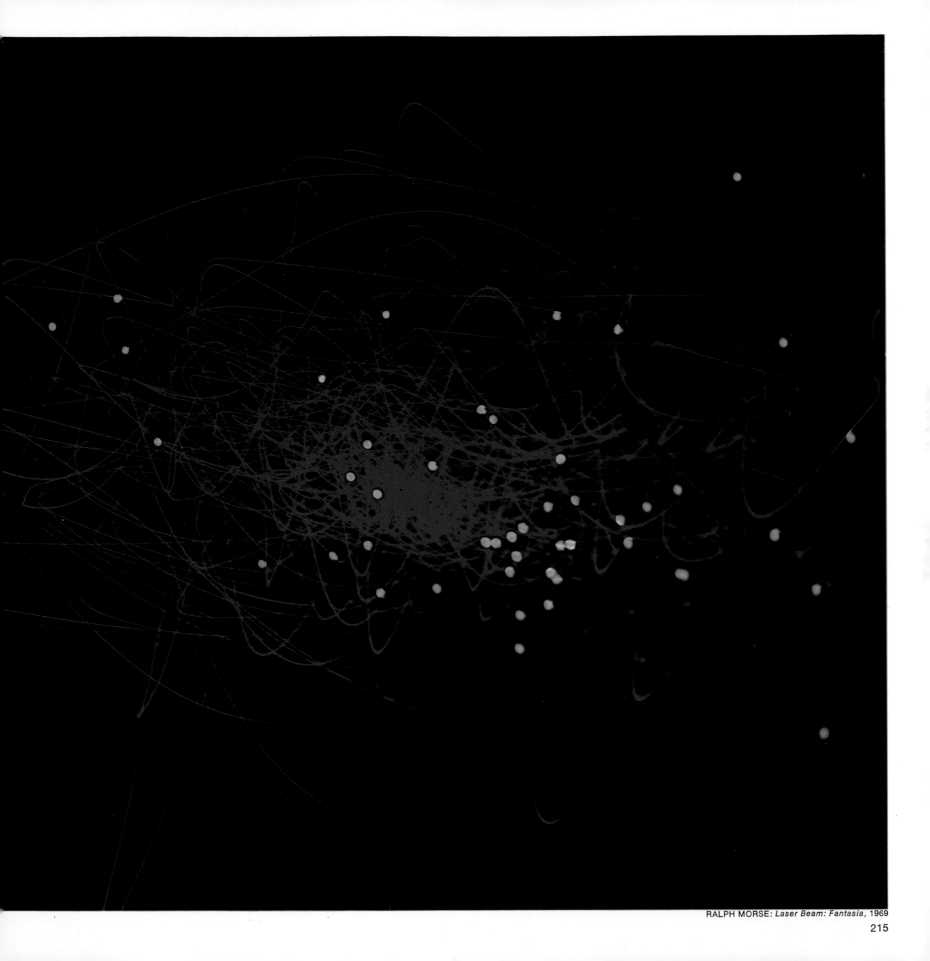

RALPH MORSE: *Laser Beam: Fantasia,* 1969

A Strange World of Vibrations

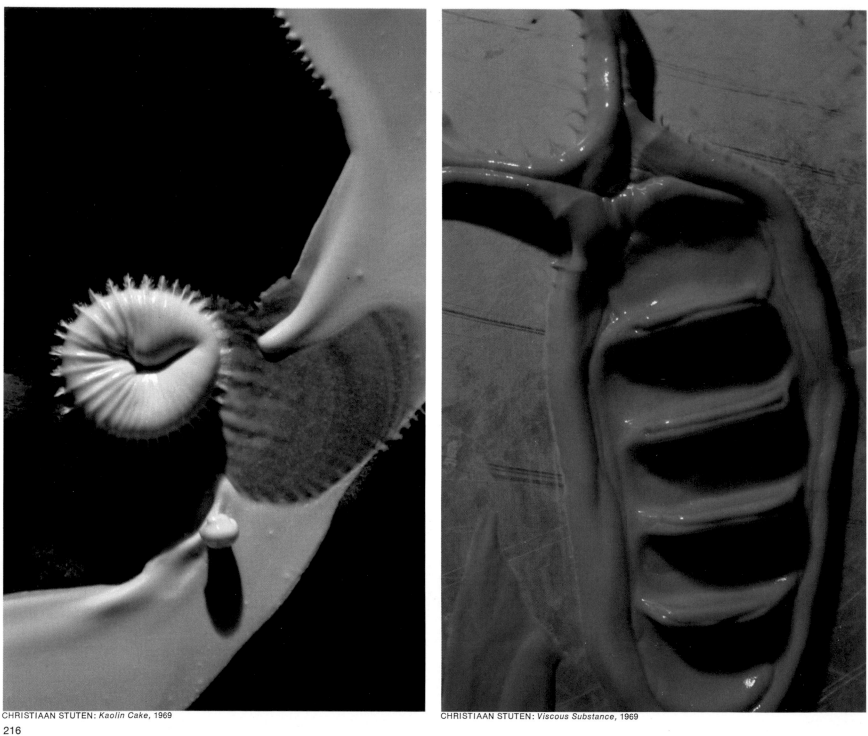

CHRISTIAAN STUTEN: *Kaolin Cake*, 1969

CHRISTIAAN STUTEN: *Viscous Substance*, 1969

The pictures on these and the following pages were shot for purely pragmatic reasons—to aid scientist Hans Jenny in his study of the effects of rhythmic vibration—but they caught some moments of uncanny visual magic. Jenny has found that a liquid, powdery or viscous substance, when placed on a vibrating membrane, performs in very strange ways. Paste, for instance, may suddenly gather itself into the shape of a sort of a ribbed cake *(opposite, left)* under the influence of vibrations. In a viscous liquid, vibrations may produce waves *(opposite, right)* that line up in their own special channel. If the rate or amplitude of vibration is changed, entirely different patterns may emerge.

Even more unexpected is the behavior of an ordinary drop of water that is made to vibrate. The four pictures at upper right show the drop becoming hexagonal, square and triangular, its shape depending on the rate of oscillation. At bottom, a pulsating soap bubble has developed shimmering facets, like a liquid diamond. And on the following pages, the quick shutter of a camera has caught the spectacle of a viscous liquid leaping about as if it were enacting some unearthly ballet. □

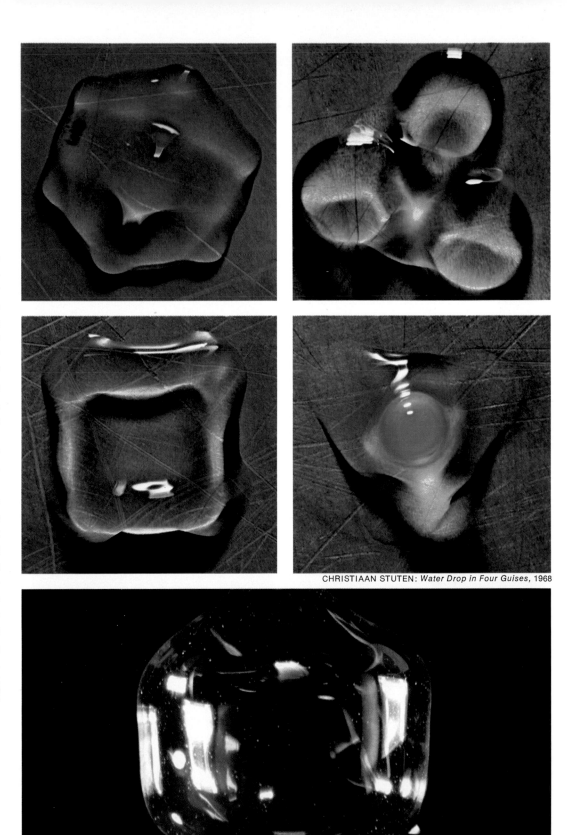

CHRISTIAAN STUTEN: *Water Drop in Four Guises,* 1968

CHRISTIAAN STUTEN: *Bubble Dance,* 1968

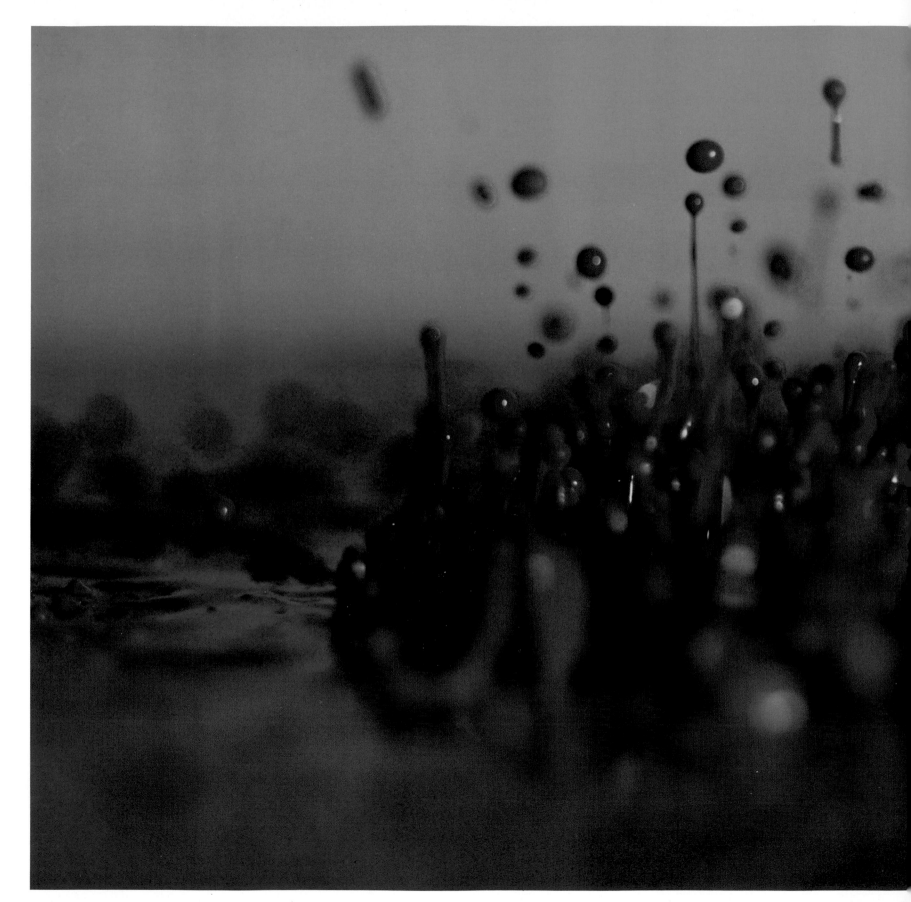

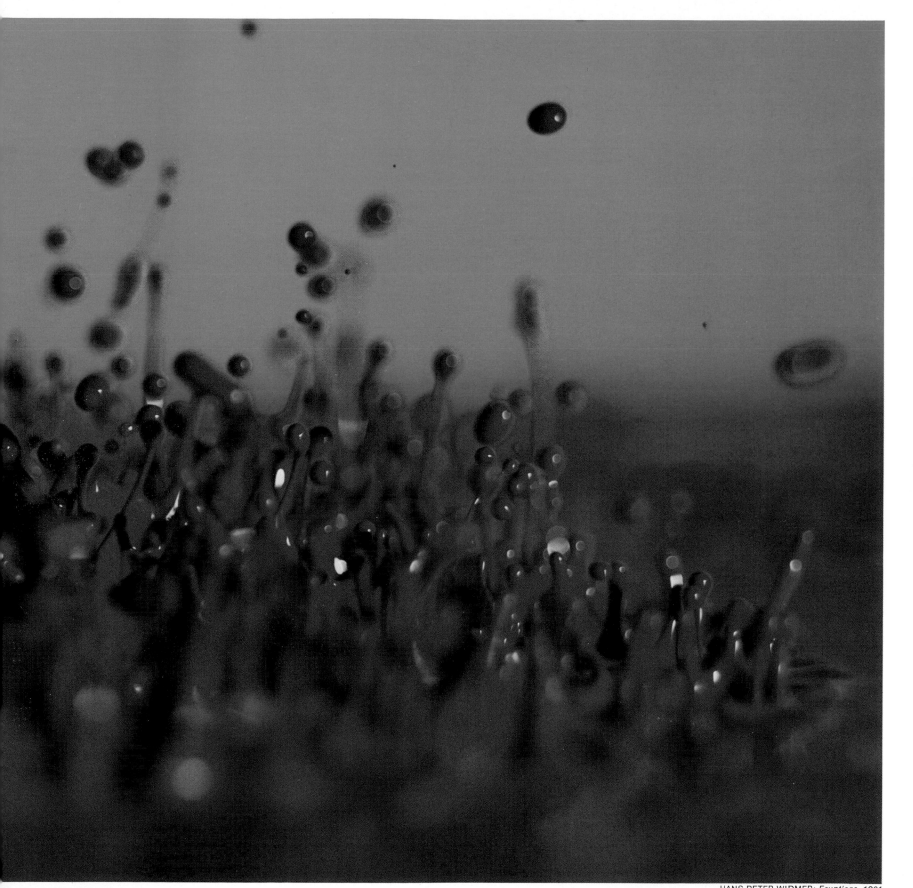

HANS PETER WIDMER: *Eruptions,* 1961

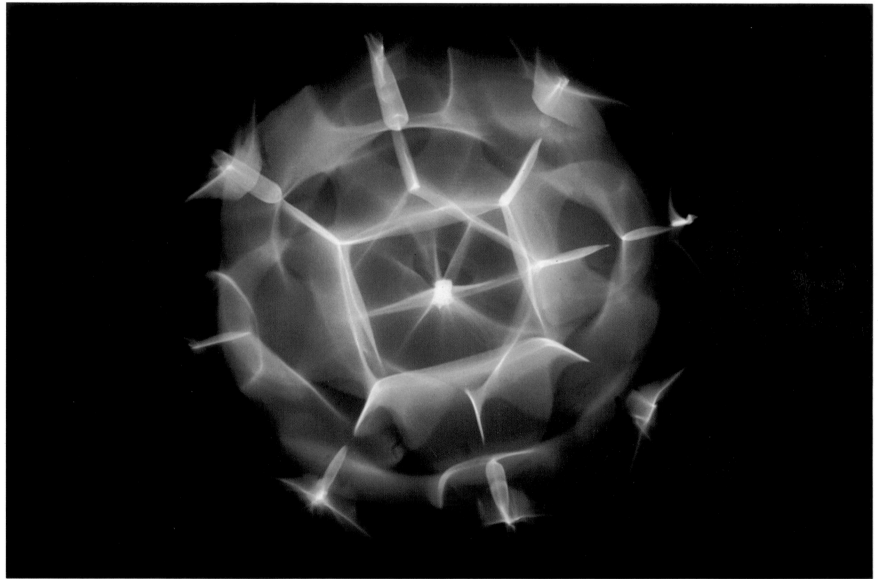

CHRISTIAAN STUTEN: *Water Areas*, 1970

Motorized Cameras

The 35mm Nikon F is fitted with a motor that automatically trips the shutter, advances the film, resets the shutter and makes another shot in rapid sequence, so long as the button is pressed. Most cameras can be fitted with automatic timers that will start and stop the camera for pictures at long intervals. Also available are remote-control releases and special camera backs, like the one shown on the Nikon, that hold longer-than-usual rolls of film to enable a number of pictures to be taken in sequence without reloading. Since motorized cameras are expensive—they cost anywhere from $700 to $1,500, depending on accessories—some of the larger camera stores rent them by the day ($50 to $100) or week ($80 to $200).

Dramatically unusual pictures like a number of those in this book can often be made without large investments in special gear. All it takes for the unique tones of infrared pictures is a roll of infrared film. Excellent underwater shots require only a camera housing, available for as little as $40 *(page 228),* and larger-than-life pictures are possible with metal rings, called extension tubes, that sell for $5 to $25 *(page 224).* Time-lapse photographs, like those of the blooming rose in Chapter 1, are, however, major exceptions. Such pictures, made at intervals to record the stages of a slow process, can be taken with no special equipment but a clock —the photographer returns to his camera when the clock reminds him. But this is so clumsy that most time-lapse sequences are made with costly motorized cameras like those listed below.

make and model	film size	motor	exposures per second (maximum)	power source	lens mount	accessories available
Alpa 10d	35mm	accessory	1	A.C. or nickel-cadmium battery	Alpa bayonet	timers; remote control
Beseler Topcon Super D	35mm	accessory	3	A.C. or nickel-cadmium battery	Topcon, Exakta bayonet	250-exposure film back; remote control
Zeiss Ikon/Voigtländer Contarex SE	35mm	built-in	2	2 1.5V batteries	bayonet	timer
Hasselblad 500EL	2¼ x 2¼	built-in	1	nickel-cadmium batteries	bayonet	12-exposure film back; 70-exposure film back; timer
Honeywell Pentax Spotmatic	35mm	accessory	3	nickel-cadmium battery	Pentax screw	250-exposure film back; timers
Leica M4	35mm	accessory	2½	A.C. or 8 AA batteries	Leica bayonet	remote control
Minolta SR-M	35mm	built-in	4	A.C. or 8 AA batteries	Minolta bayonet	250-exposure film back; remote control
Nikon F	35mm	accessory	4	8 AA batteries	Nikon bayonet	timer; wireless remote control
Robot Star 90	35mm[1]	built-in	7	spring motor	screw	timers; remote control

[1] *Special Estar base film required*

Photomacrography

There is an unusually wide choice of ways to adapt a camera for taking pictures magnified up to about 30 times life size. The simplest method is provided by supplemental close-up lenses, which screw into the camera lens like filters; they are available in several magnification powers, and two of them can sometimes be used together. With a camera having a removable lens, extension tubes provide an inexpensive means to obtain magnified pictures. The lens is taken off the camera, the tube (or combination of tubes) attached to the lens mount and the lens attached to the tube. This extends the lens a greater-than-normal distance from the film, enlarging the image. The tubes provide only a few choices of extension distances—and magnifications. With a 35mm single-lens reflex, greater versatility can be obtained by replacing the camera lens with a macro lens *(below)*, which is specially designed for life-size and larger pictures when used with an extension bellows *(opposite);* this set-up gives a broad range of adjustments in the distance between lens and film, and a broad range of magnifications.

Equipment that magnifies the image also magnifies blurring caused by camera movement, making a sturdy support essential. The ones that are listed on page 226 enable the camera to be aimed straight down, as is usually necessary for photomacrography. A cable release helps prevent the accidental movement that can occur at the moment when the shutter is triggered.

Macro Lenses

These lenses for 35mm SLRs give life-size pictures when attached directly to the camera, and greater magnifications when extended by tubes or bellows. A selection, priced between $80 and $225, is listed below. Many, like the Micro-Nikkor Auto at left, have automatic diaphragms—the aperture stays wide open during focusing, then closes to a previously selected f-stop when the shutter is released. Others are "preset"—the aperture is closed manually to a previously selected f-stop.

make and model	focal length	diaphragm	maximum aperture	cameras accommodated
Alpa Macro-Switar	50mm	automatic	f/1.9	Alpa
Macro Auto Topcor	58mm	automatic	f/3.5	Beseler Topcon D-1, Super D
Macro Canon FL	50mm	automatic	f/3.5	Canon FP, FT-QL, FX; Pellix QL, TL-QL
MC Macro Rokkor	50mm	automatic	f/3.5	Minolta SR
Micro-Nikkor Auto	55mm	automatic	f/3.5	Nikon F, Nikon Photomics, Nikkormat, Nikkorex
Super Makro-Kilar	90mm	preset	f/2.8	most SLRs with adapters
Super-Macro-Takumar	50mm	automatic	f/4	Pentax H1a, H3v, Spotmatic, SL
Travenar	50mm	preset	f/2.8	Praktica, Exakta
E. Zuiko Auto Macro	38mm	automatic	f/3.5	Olympus-Pen F, FT, FV

Extension Bellows

Bellows are inserted between a lens and a camera body to move the lens out from the film and increase image size. Because their accordion pleats can be expanded continuously over a considerable distance, they permit the photographer to choose any desired magnification within a wide range. Most, like the Minolta Bellows III at right, are adjusted with a knob controlling a gear on a track; some have two controls, one for coarse adjustments, another for fine ones. Extension bellows like those listed below cost from $25 to $210.

make and model	maximum extension	cameras accommodated
Accura Bellowsmate	150mm	Nikon, Nikkormat, Minolta SR, Pentax, Yashica, Canon, Mamiya, Praktica, Topcon, Exakta
Alpa Combextan Bellows	300mm	Alpa
Canon Bellows FL	142.5mm	Canon SLRs
Hasselblad Extension Bellows	202mm	Hasselblad 500C
Honeywell Bellows Unit I	136.5mm	Pentax
Konica Extension Bellows II	240mm	Konica Autoreflexes A, T
Leicaflex Focusing Bellows-R	140.2mm	Leicaflex
Minolta Bellows III	175mm	Minolta SRs
Miranda Focabell S	120mm	Miranda
Nikon Bellows Attachment Model III	183mm	Nikon F, Nikon Photomics, Nikkormat
Novoflex Extension Bellows Model S	150mm	Exakta, Praktica, Minolta, Miranda, Nikon F
Olympus-Pen FT Bellows Attachment	98.8mm	Olympus-Pen F, FT, FV .
Spiratone Macrobel	175mm	most 35mm SLRs
Topcon Extension Bellows Model IV	182mm	Beseler Topcon Super D, D-1

Camera Stands

A vibrationless support is essential for photomacrography because any blur caused by motion is magnified along with the image. Two types of stand are available (a representative selection covering a price range of $24 to $130 is listed at left below). One, called a pod (below), resembles a tripod but has four legs; it points the camera straight down, and its height adjustment is limited. The second type (left) holds the camera clamped to a column rising above a baseboard, like an enlarger. It is rigid, and versatile as well, since the camera can be raised, lowered and tilted to almost any position. On some, like the one shown, accessory lights can be attached to the column or the baseboard. The column type of support is also useful for photomicrography, since the microscope can be set on the baseboard while the camera is held by the column clamp.

make and model	type	maximum camera height	maximum area covered	remarks
Alpa Macrofix Stand	column	24″	8½″ x 12¾″	optional light unit
Canon Copy Stand 3F	column	29″	16″ x 24″	
Canon Handy Stand F	pod	23″	10½″ x 15½″	
Konica Copy Stand	column	32″	11″ x 14″	
Leica Auxiliary Reproduction Unit	pod	20⅞″	8¼″ x 11⅝″	
Leica-Leicaflex Copying Stand	column	31¾″	14¼″ x 19¾″	
Minolta Copy Stand II	column	22¾″	11¼″ x 8″	
Miranda Copy Stand	column	26½″	13″ x 18″	optional light unit
Nikon Repro-Copy Outfit Model PFB	column	29″	16¼″ x 24⅓″	
Olympus-Pen F Copy Stand	column	33″	15″ x 18″	optional light unit
Pentax Copipod	pod	22″	8⅝″ x 13″	
Topcon Copy Stand	column	19¼″	7½″ x 11″	
Zeiss Ikon/Voigtländer Table Reproduction Stand	column	27½″	11″ x 16½″	optional light unit

Microscope Adapters

Attached to a standard laboratory microscope at right, a 35mm Canon FT-QL camera has been fitted with a Canon adapter that slips over the eyepiece and tube of the microscope. It also has two specially made accessories: a right-angle viewer (top) that simplifies viewing and focusing, and just below it, an auxiliary exposure meter that increases the sensitivity of the camera's built-in meter. Listed at right are microscope adapters available for $20 to $40.

make	cameras accommodated
Accura	Alpa, Canon, Leicaflex, Minolta, Miranda, Pentax, Petri, Topcon
Alpa	Alpa
Canon	Canon FT-QL, FX, FP; Pellix QL
Konica	Konica Autoreflex-T, Auto-Reflex
Minolta	Minolta SR-T
Miranda	Miranda Sensomat
Nikon	Nikon F, Nikkormat, Nikkorex
Olympus-Pen	Pen FT, FV
Pentax	Pentax Spotmatic, SL, H1a, H3v
Petri	Petri FT-EE
Rollei	Rolleiflex 3.5E, 3.5F, Rollei-Magic
Topcon	Beseler Topcon C, D-1, Super D
Yashica	Yashica J, TL, TL-Super; Praktica
Zeiss Ikon/ Voigtländer	Icarex

Anything that can be seen through a microscope can also be photographed, magnified as much as the microscope's power. Usually the camera lens is removed, but this is not essential. The basic equipment required is a simple adapter to fit the camera to the microscope eyepiece. A cable release is also needed to prevent vibration when the shutter is tripped. It is advisable to use fast film—color or black-and-white—when shooting live specimens so that short exposure times can prevent blurring caused by sudden movement. Illumination is crucial in photomicrography since sufficient light must reach the film through the microscope's eyepiece. Best results are obtained by using a microscope with a lighting unit built into its base. Two special photomicrographic cameras that cost less than $70 each—they are little more than light-excluding film holders—are listed below, along with Polaroid's unique MP-3 (about $500), a complete system that can be used for both photomacrography and photomicrography.

Special Cameras for Photomicrography

make and model	film size
Nikon M-35S Dark Box	35mm
Polaroid ED-10 Instrument Camera	Polaroid 3¼ x 4¼ (color or black-and-white)

Macro/Micro System

make and model	description
Polaroid MP-3	Multipurpose camera for conventional and Polaroid films in six sizes; basic unit includes baseboard, 38-inch-high column, four lamps, camera body; 75mm, 105mm, 127mm lenses available; accessories include microscope adapter

Underwater Photography

Some cameras, lighting units and exposure meters are made waterproof for use on land or under the sea. But most photographers simply encase standard gear in special housings. These housings are watertight down to maximum depths recommended by the manufacturer. Cameras are usually sent to the manufacturer for proper fitting.

Plastic housings are the least expensive and most widely available; metal ones are sturdier and generally can be used at greater depths. On some housings, the port in front of the camera lens is shaped to compensate for the distorting properties of the water.

Most underwater gear is made not by camera manufacturers but by specialists; their locations are given in the charts. They can alter housings to fit models other than those listed, and many will design special housings.

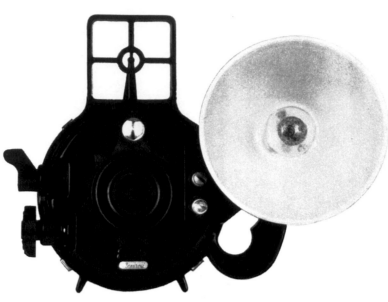

Cameras and Housings

The least expensive (about $60) of amphibious cameras is the fixed-focus Mako Siluro, shown at left equipped with a detachable flash unit. The other two amphibious cameras listed are more versatile, more intricate—and more costly (up to around $950). The camera housings listed are equally variable in capability and price. Those providing external controls that operate more than just shutter release and film advance are preferable for scuba-diving, since exposure settings can then be adjusted on the spot immediately after a meter reading is taken.

camera make and model	maximum depth	construction material	film size	lens	shutter speeds	remarks
Mako Engineering (Miami, Florida), Siluro	100 ft.	plastic	120 & 220	NA	1/55 sec.	detachable flash reflector
Nikonos II	160 ft.	metal and plastic	35mm	35mm f/2.5	1/30 to 1/500 sec.	80mm close-up lens; flashgun, filter, external viewfinder available
Real Eight Ocean Systems (Miami, Florida), Model 185	300 ft.	aluminum	35mm	21mm f/2.2	1/15 to 1/125 sec.	flashlight battery-powered motor; total depth of field

housing make and model	maximum depth	construction material	cameras accommodated	remarks
Anchor Shack (Hayward, Calif.)	400 ft.	aluminum	Nikon, Canon, Pentax, Minolta, Yashica	
Bamboo Reef of San Rafael (San Rafael, Calif.)	300 ft.	aluminum	Bronica models S, C, and S-2	adaptable to 50mm or 75mm Nikkor lens
Ikelite (Indianapolis, Ind.)	200 ft.	plastic	Kodak Instamatic, Olympus, Beseler Topcon, Mamiya-Sekor, Yashica	
Hasselblad	NA	NA	Hasselblad 500-C and Super Wide C	underwater distortion corrector port, 12 or 70 exposure magazines
Giddings Underwater Enterprises (San Francisco, Calif.), Niko-Mar II	315 ft.	aluminum	Nikon, Pentax, Canon, Nikkormat, Mamiya-Sekor	
Rolleimarin	300 ft.	aluminum	Rolleiflex 3.5F	external controls for shutter speed, focus, film advance, flash; turret for close-up lenses and filters
Sea Research & Development, SeaCase	200 ft.	plastic	Kodak Instamatic	external flash cube system
Sea Research & Development, Sea glove	200 ft.	plastic	Nikon F, adaptable to other cameras	lens port corrected for underwater distortion

NA - information not available

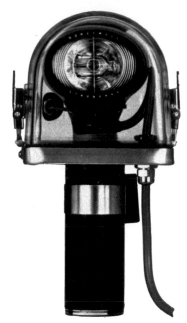

Lighting Units and Housings

At depths below about 30 feet, daylight is so weak that a flash—electronic or bulb—or floodlamp is needed for underwater photography. Housings will waterproof standard units such as the Honeywell Strobonar 700, shown above inside an Ikelite housing. Special amphibious light units are also available; in general, the higher the power specification —watt-seconds for electronic flashes—the brighter the illumination provided.

light unit make and model	type of light	maximum depth	construction material	light output	power source
Anchor Shack (Hayward, Calif.), Hydro-Blitz	electronic flash	300 ft.	aluminum	50 to 200 watt-secs.	rechargeable nickel-cadmium battery
Bamboo Reef of San Rafael (San Rafael, Calif.)	flood	200 ft.	aluminum	100 watt	rechargeable nickel-cadmium battery
Birns & Sawyer (Los Angeles, Calif.)	flood	500 ft.	aluminum	150 to 300 watts	nickel-cadmium battery
Mako Engineering (Miami, Fla.)	flood	200 ft.	aluminum	600-watt flood 800-watt spot	nickel-cadmium battery
Nikonos	flash	160 ft.	aluminum	#6 bulb	22½-volt battery
Rolleimarin	flash	300 ft.	metal	#5 bulb	22½-volt dry battery
Sea Research & Development (Bartow, Fla.)	electronic flash	500 ft.	plastic	50 watt-secs.	4 penlight batteries
	electronic flash	500 ft.	aluminum	50 watt-secs.	self-contained 6-volt nickel-cadmium battery
	flood	350 ft.	aluminum	250 watt	nickel-cadmium battery

housing make and model	type of light	maximum depth	construction material	units accommodated
Anchor Shack Mini-Strobe	electronic flash	250 ft.	aluminum	Honeywell Strobonar 300, 330
Anchor Shack Hydro-Strobe	electronic flash	200 ft.	aluminum	Honeywell Strobonar 600s, 700s
Bamboo Reef of San Rafael (San Rafael, Calif.)	flood	200 ft.	aluminum	Sylvania Sun Gun
Ikelite (Indianapolis, Ind.)	electronic flash	300 ft.	plastic	Honeywell Strobonar, Vivitar

Exposure Meters and Housings

Plastic housings that permit such standard exposure meters as the Sekonic L-86, shown above, to be taken underwater cost $10 to $20. For underwater work a "direct-reading" meter is best. Such a meter's pointer indicates f-stops, rather than light-intensity, giving correct exposure immediately (assuming shutter- and film-speed dials are preset). One amphibious meter is the direct-reading Sekonic L-164 II described in the list at right.

make and model	maximum depth	construction material	meters accommodated
Bamboo Reef of San Rafael (San Rafael, Calif.)	200 ft.	plastic	housing for Sekonic L-28 C
Giddings Underwater Enterprises (San Francisco, Calif.)	315 ft.	aluminum	housing for Weston Pixie Meter
Nikon	160 ft.	plastic	housing for Sekonic L-86 meter
Kanematsu-Gosho (New York, N.Y.), Sekonic L-164 II	300 ft.	plastic	self-contained amphibious reflected meter with direct readings; ASA 6 to 12,000; shutter speeds from 1/2000 sec. to 1 sec.; apertures from f/1 to f/64; CdS cell

Bibliography

General

Begbie, G. Hugh, *Seeing and the Eye*. Natural History Press, 1969.

Blaker, Alfred A., *Photography for Scientific Publication*, W.H. Freeman, 1965.

Engel, Charles E., ed., *Photography for the Scientist*. Academic Press, 1968.

Focal Press Ltd., *Focal Encyclopedia of Photography*. McGraw-Hill, 1969.

Muybridge, Eadweard:
Animals in Motion. Dover, 1957.
The Human Figure in Motion. Dover, 1955.

*Ruechardt, Eduard, *Light, Visible and Invisible*. University of Michigan Press, 1958.

Stroebel, Leslie, *View Camera Techniques*. Hastings House, 1967.

†Tolansky, Samuel, *Revolution in Optics*. Penguin, 1968.

Electronic Flash and High-Speed Photography

Edgerton, Harold E., *Electronic Flash, Strobe*. McGraw-Hill, 1970.

Edgerton, Harold E., and James R. Killian Jr., *Flash!* Charles T. Branford, 1954.

†Gaunt, Leonard, *Electronic Flash Guide*. Focal Press, 1969.

Greenewalt, Crawford H., *Hummingbirds*. Doubleday, 1960.

Karsten, Kenneth, *Science of Electronic Flash Photography*. Amphoto, 1968.

Luray, Howard, *Strobe—the Lively Light*. A.S. Barnes, 1963.

†Miller, Charles E., *Handbook of High-Speed Photography*. General Radio Company, 1967.

Nilsson, N. Robert, and Lars Högberg, eds., *High-Speed Photography*. John Wiley & Sons, 1968.

Saxe, Raymond F., *High-Speed Photography*. Focal Press, 1966.

†VanVeen, Frederick, *Handbook of Stroboscopy*. General Radio Company, 1966.

Photomacrography and Photomicrography

†Cosslett, Vernon E., *Modern Microscopy, or Seeing the Very Small*. Cornell University Press, 1966.

Eastman Kodak:
†*Close-Up Photography*. Eastman Kodak, 1969.
†*Photography Through the Microscope*. Eastman Kodak, 1966.
†*Photomacrography*. Eastern Kodak, 1969.

†Klosevych, Stanley, *Notes on Microscopy and Photomicroscopy Seminars*. Canada Department of Agriculture, 1968.

†Möllring, F.K., *Microscopy from the Very Beginning*. Carl Zeiss.

Schenk, R., and G. Kistler, *Photomicrography*. Chapman and Hall, 1962.

Carl Zeiss:
†*Equipment for Polarized-Light Microscopy*. Carl Zeiss.
†*Phase Contrast and Interference Contrast*. Carl Zeiss.

Aerial and Astronomical Photography

Bergamini, David, and the Editors of TIME-LIFE BOOKS, *The Universe*. TIME-LIFE BOOKS, 1970.

Cortright, Edgar M., ed., *Exploring Space with a Camera*. U.S. Government Printing Office, 1968.

Deuel, Leo, *Flights Into Yesterday: The Story of Aerial Archaeology*. St. Martin's Press, 1969.

Eastman Kodak:
†*Astrophotography with your Camera*. Eastman Kodak, 1968.
†*Kodak Data for Aerial Photography*. Eastman Kodak, 1969.

Menzel, Donald H., *A Field Guide to the Stars and Planets*. Houghton Mifflin, 1964.

Muirden, James, *The Amateur Astronomer's Handbook*. Thomas Y. Crowell, 1968.

Newhall, Beaumont, *Airborne Camera: The World from the Air and Outer Space*. Hastings House, 1969.

Owings, Nathaniel A., *The American Aesthetic*. Harper & Row, 1969.

Paul, Henry E., *Outer Space Photography for the Amateur*. Amphoto, 1967.

Vaucouleurs, Gérard de, *Astronomical Photography: From the Daguerreotype to the Electron Camera*. Macmillan, 1961.

Underwater Photography

Dobbs, Horace, *Camera Underwater: A Practical Guide to Underwater Photography*. A.S. Barnes, 1962.

Frey, Hank, and Paul Tzimoulis, *Camera Below: The Complete Guide to the Art and Science of Underwater Photography*. Association Press, 1968.

†Greenberg, Jerry, *Underwater Photography Simplified*. Seahawk, 1969.

X-ray, Ultraviolet and Infrared Photography

†Bleich, Alan Ralph, *The Story of X-Rays*. Dover, 1960

Eastman Kodak:
†*Applied Infrared Photography*. Eastman Kodak, 1968.
†*Infrared and Ultraviolet Photography*. Eastman Kodak, 1963.
Radiography in Modern Industry. Eastman Kodak, 1970.
†*Ultraviolet and Fluorescence Photography*. Eastman Kodak, 1968.

Matthews, Sydney K., *Photography in Archaeology and Art*. Humanities Press, 1968.

†Simon, Ivan, *Infrared Radiation*. D. Van Nostrand, 1966.

Periodicals

Modern Photography, The Billboard Publishing Co., New York City.

Photographic Applications in Science, Technology and Medicine, Photographic Applications in Science and Technology, Inc., New York City.

Popular Photography, Ziff-Davis Publishing Co., New York City.

Scientific American, Scientific American, Inc., New York City.

* Also available in paperback.
† Available only in paperback.

Acknowledgments

For the help given in the preparation of this book, the editors would like to express their gratitude to the following: Mortimer Abramowitz, Superintendent of Schools, Great Neck Public Schools, Great Neck, New York; Norbert S. Baer, Institute of Fine Arts, New York University, New York City; Lloyd M. Beidler, Professor of Biophysics, Department of Biological Science, The Florida State University, Tallahassee, Florida; Richard J. Boyle, Curator of Painting, Cincinnati Art Museum, Cincinnati, Ohio; Marguerita Braymer, President, Questar Corp., New Hope, Pennsylvania; Thomasine C. Brooks, Librarian, Phillips Library, Harvard College Observatory, Cambridge, Massachusetts; Central Skindivers, New York City; William J. Daly, Photographic Department, Kanematsu-Gosho, Inc., New York City; Harold E. Edgerton, Institute Professor Emeritus, Massachusetts Institute of Technology, Cambridge, Massachusetts; Rhodes Fairbridge, Professor, Department of Geology, Columbia University, New York City; Douglas Faulkner, Summit, New Jersey; Harold Forgosh, District Sales Manager, Scientific In-

strument Division, Bausch & Lomb, Inc., New York City; George Frye, Willoughby-Peerless Camera Stores, New York City; H. Lou Gibson, Fellow, Biological Photographical Association, Rochester, New York; Fritz Goro, Chappaqua, New York; Kenneth Goss, Chief Photographer, Lockwood, Kessler & Bartlett, Syosset, New York; Joseph L. Gossner, New York City; Crawford H. Greenewalt, Wilmington, Delaware; Sarah J. Hill, Professor, Whitin Observatory, Wellesley College, Wellesley, Massachusetts; Caroline K. Keck, Professor, State University College, Oneonta, New York, and New York Historical Association, Cooperstown, New York; Gyorgy Kepes, Director, Center for Advanced Visual Studies, Massachusetts Institute of Technology, Cambridge, Massachusetts; Lewis Koster, Manager, Graphic Services, Rockefeller University, New York City; Henry M. Lester, New York City; Robert Mark, Professor, Department of Civil Engineering, Princeton University, Princeton, New Jersey; Robert E. Mayer, Photographic Services, Bell & Howell, Chicago Illinois; Irving Mehler, Photographic Products Division, Honeywell, Inc., New York City; Erwin W. Müller, Evan-Pugh Research Professor of Physics, The Pennsylvania State University, University Park, Pennsylvania; Al Nordheden, New York Horticultural Society, New York City; Robert G. Norwick, E. T. Howard Co., Inc., New York City; Elwood Ott, Manager of Photographic Product Sales, Aero Service Corporation, Philadelphia, Pennsylvania; William T. Reid, Senior Fellow, Batelle Memorial Institute, Columbus, Ohio; Richard's Sporting Goods, Inc., New York City; C. L. Smith, Department of Icthyology, The American Museum of Natural History, New York City; Robert F. Smith, Department of Technical Photography, Brookhaven National Laboratory, Upton, New York; Klaus Spiegel, Carl Zeiss, Oberkochen, West Germany; Erna B. Vasco and Henry Weber, Carl Zeiss, Inc., New York City; Murray Weinberg, Allied Impex Corporation, Carle Place, New York; Ralph Weiss, New York City; Charles Woodward, Director of Photography, Lockwood, Kessler & Bartlett, Syosset, New York; Charles Wyckoff, Applied Photo Sciences, Needham, Massachusetts.

Picture Credits *Credits from left to right are separated by semicolons, from top to bottom by dashes.*

Index

Numerals in italics indicate a photograph, painting or drawing of the subject mentioned.

Printed in U.S.A.